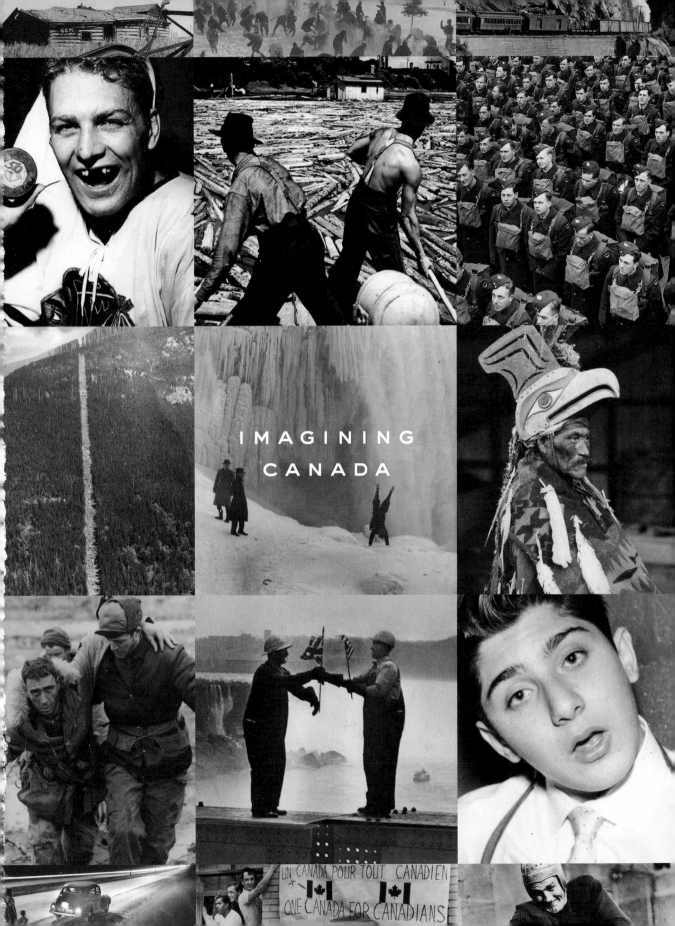

IMAGING
CANADA

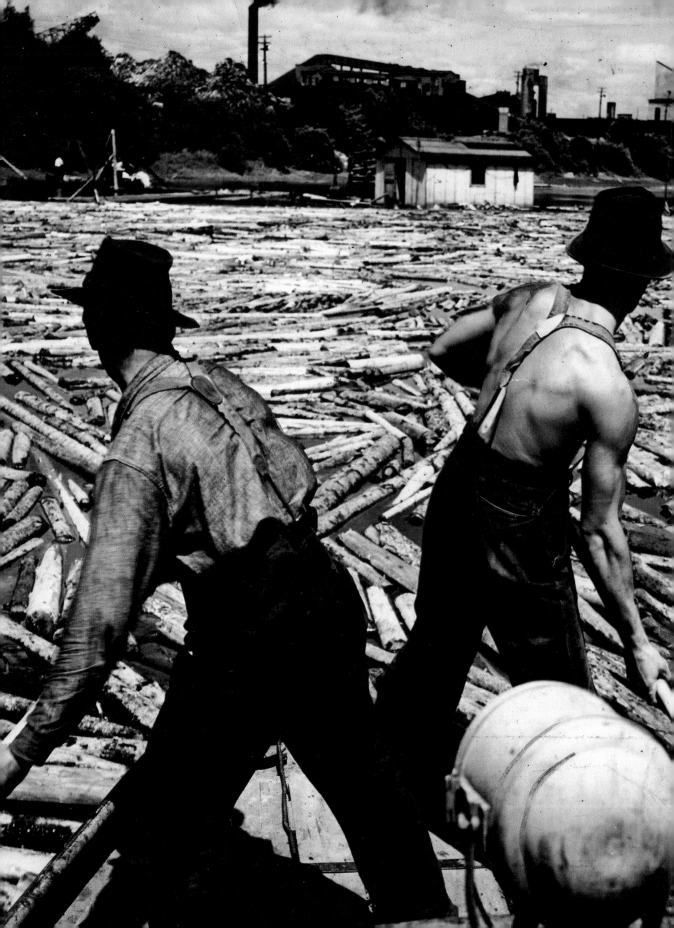

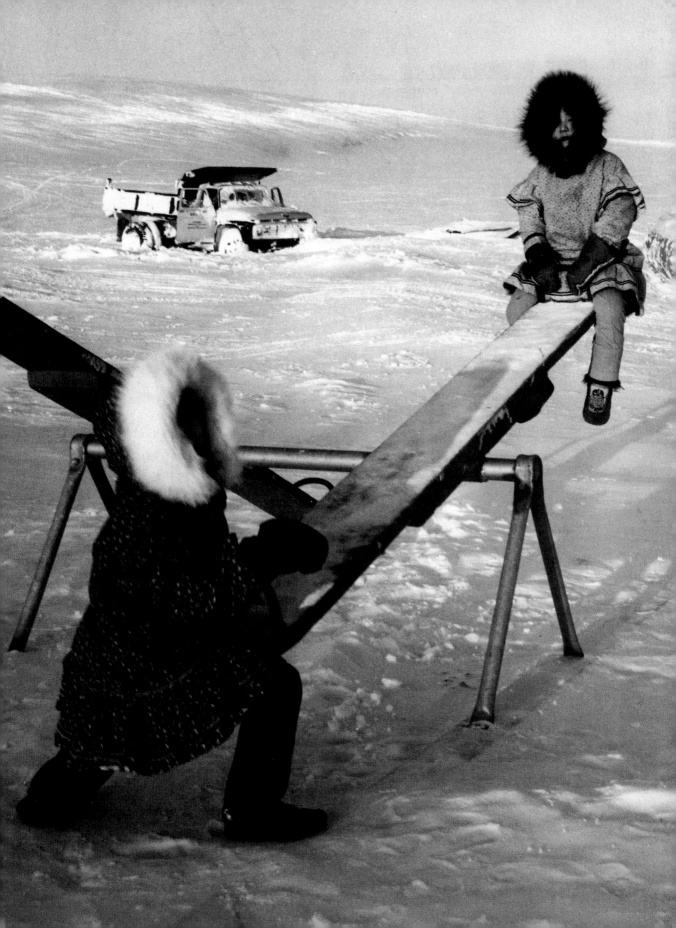

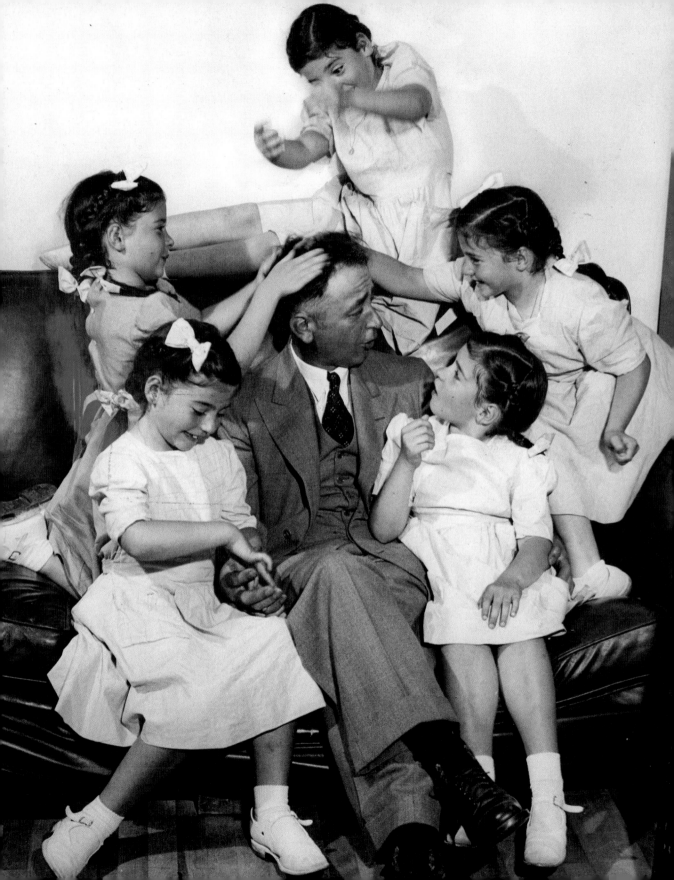

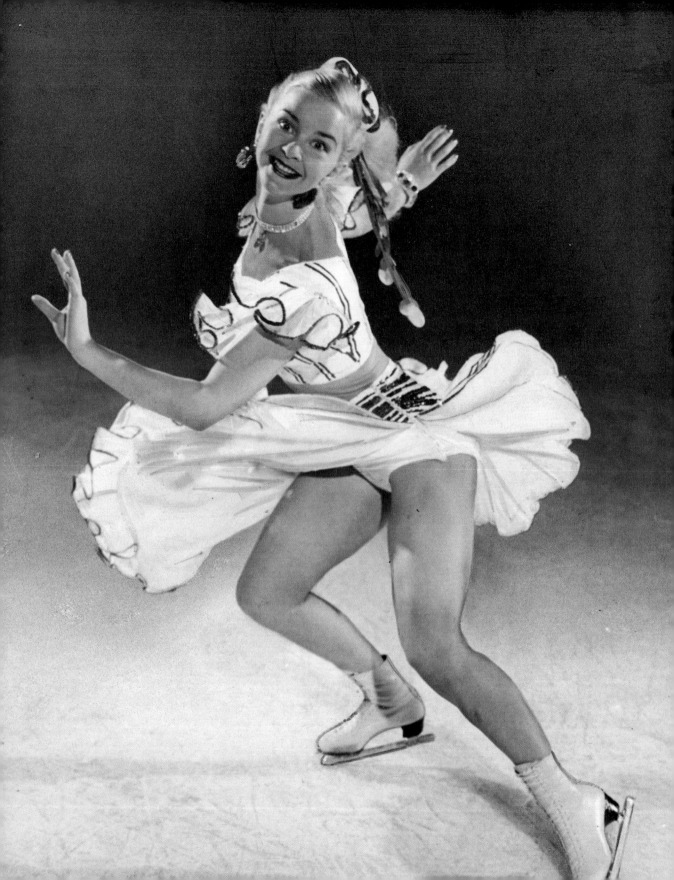

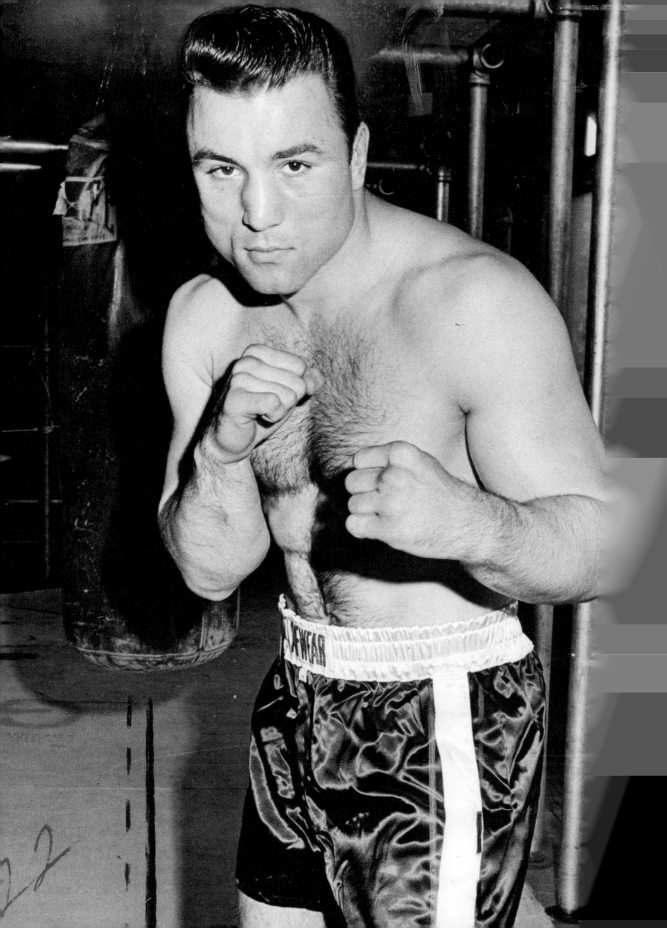

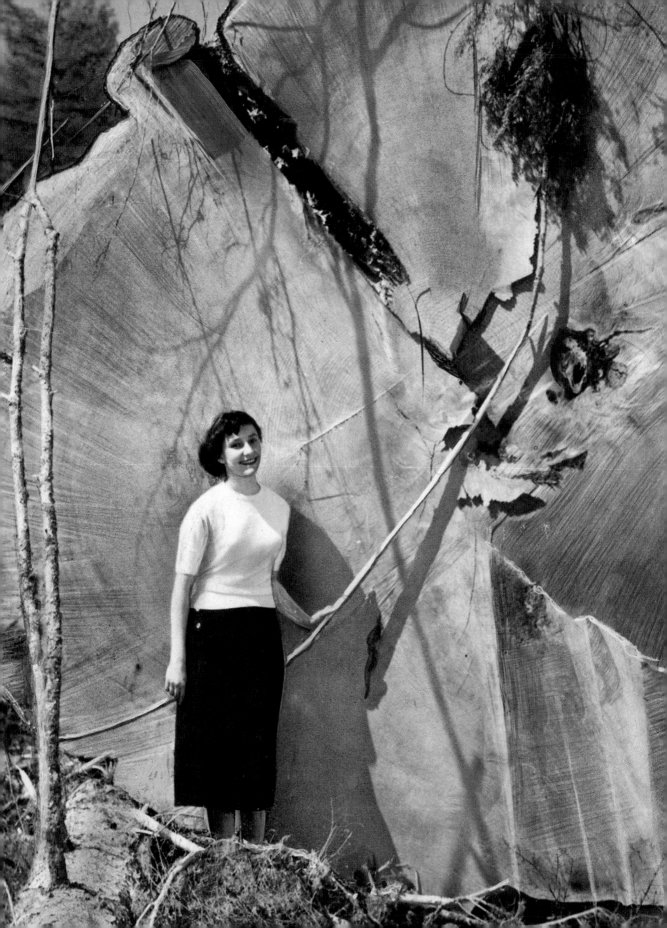

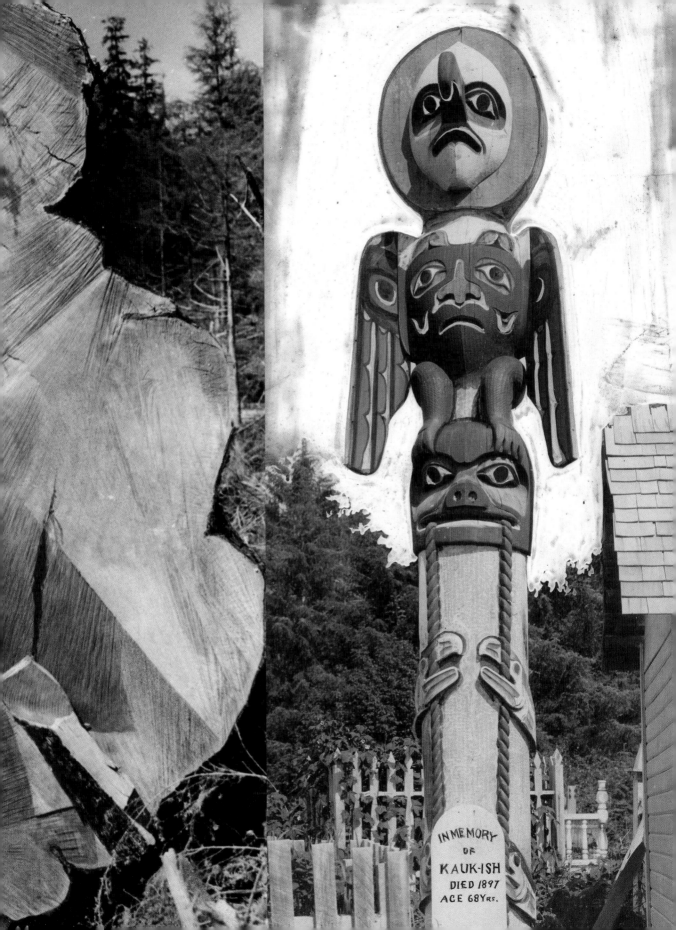

IN MEMORY
OF
KAUK-ISH
DIED 1897
AGE 68 YRS.

IMAGINING

A CENTURY OF PHOTOGRAPHS

CANADA

PRESERVED BY The New York Times

EDITED BY WILLIAM MORASSUTTI

DOUBLEDAY CANADA

LIBRARY AND ARCHIVES CANADA CATALOGUING IN PUBLICATION

Imagining Canada : a century of photographs preserved by the New York Times / edited by William Morassutti.
Includes photographs preserved by the New York Times.
Issued also in electronic format.
ISBN 978-0-385-67709-7

1. Canada--History--Pictorial works. 2. Canada--Social life and customs--Pictorial works.
I. Morassutti, William II. New York Times Company
FC59.I43 2012 971.0022'2 C2012-902439-2

PRINTED AND BOUND IN CANADA

Published in Canada by Doubleday Canada,
a division of Random House of Canada Limited

Visit Random House of Canada Limited's website: www.randomhouse.ca

10 9 8 7 6 5 4 3 2 1

CONTENTS

PHOTOGRAPH BY

The New York Times

Times Square

New York City, U.S.A.

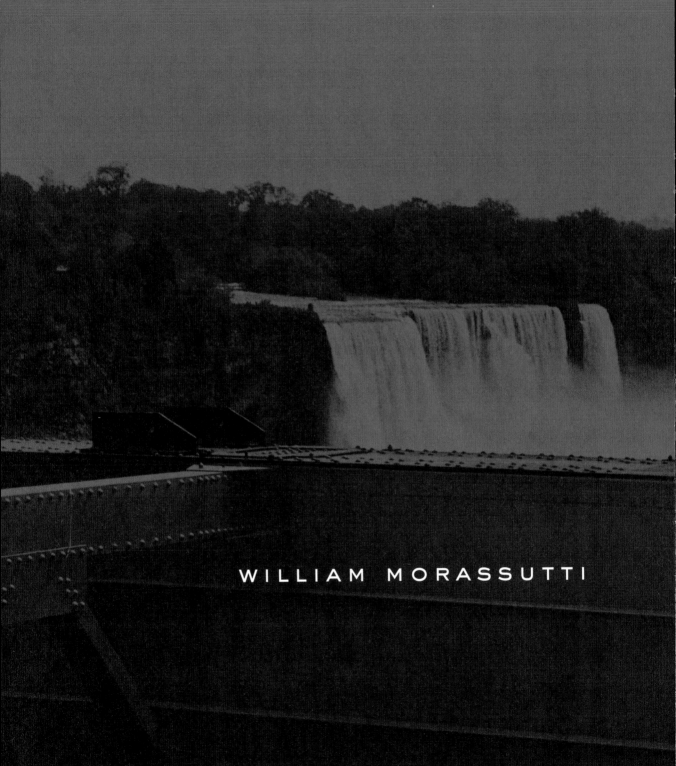
WILLIAM MORASSUTTI

IMAGINING
CANADA

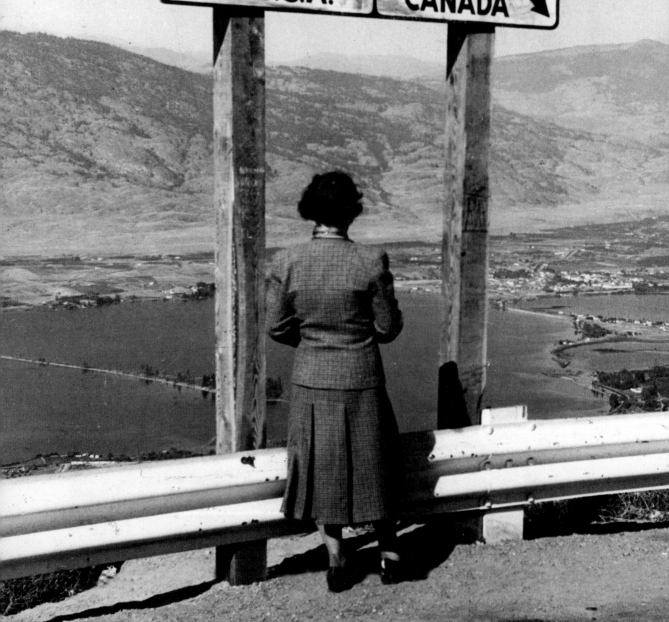

CANADIANS ARE SEASONED AFICIONADOS
OF EVERYTHING U.S.A. WE CAN MIMIC IT,
BREAK IT DOWN, INFILTRATE IT.

CANADA HAS ALWAYS been awash in America. America is in our pores, our blood. In fact, if we were to microscopically examine the empty spaces between the synapses and receptors of Canadians, we'd find memories of American sunsets and rocket ships and jazz recordings and household appliances piled high.

This isn't to say that there are no purely Canadian sacraments. For instance, Canada's epic hockey victories over Russia occupy holy ground in our collective consciousness. When I was in grade four, teachers stopped classes and wheeled TV sets into the gym so that we could watch the final games of the 1972 Summit Series. It was big. It was ours. Years later, the Americans ingeniously manufactured their own transcendent hockey moment. During the 1980 Winter Olympics, a U.S. squad of amateurs and college kids shocked the sports world by upsetting a state-of-the-art Soviet team 4 to 3 in a dramatic come-from-behind victory. The win was dubbed the "Miracle on Ice." It shouldn't have happened—there should have been tariffs or quotas in place to safeguard our ritualistic, soul-stirring hockey triumphs over Russia. Worse still, Disney's feature film *Miracle*, starring Kurt Russell as coach Herb Brooks, grossed about $65 million worldwide. So it's not like the Americans were content to simply take our thing. No, they took our thing, packaged it in red, white, and blue, and then went out and sold it globally. To think of manifest destiny as a military policy is to miss the point.

Americans, whatever their flaws, are creators of the world's most vital mythology. Canadians are seasoned aficionados of everything U.S.A. We can mimic it, break it down, infiltrate it. By age thirteen, the average Canadian teenager has a doctorate-level grasp of American pop culture—an often unconscious yet nonetheless intricate

A lookout point over the Okanagan Valley in British Columbia, in 1958.

THE EYE-CATCHING, CROP-MARKED,
INSPIRING, OCCASIONALLY HEARTBREAKING
PHOTOS COLLECTED IN THIS BOOK SPEAK VOLUMES,

understanding of its exoteric and esoteric forms, textures, symbols. Our proximity to America means we're more likely to get hooked on American exports. Daily hits of junk food, mobile apps, television shows, and celebrity updates rain down on our tense, sensitive, upturned faces, and yet curiously, we're also more immune than other nations to the seductive pull of the American dream.

Not surprisingly, when Americans pay attention to us it's deeply gratifying—embarrassingly so. We're thrilled, for instance, by William Shatner's long career. Americans like him, see, and he's Canadian, so it's like we're all okay—us!—in our sensible shoes, with our well-regulated financial system, clean cities, nice manners. Like Shatner, we're kind of cool, too, by extension. Same thing with the successes of Jim Carrey, Celine Dion, Steve Nash, Ryan Gosling, Mike Myers, Justin Bieber . . . even Alex Trebek! Do you know how much he makes for each episode of *Jeopardy*? The amazing thing is, many Canadians do know.

It's become an important part of our lore.

So that's the dynamic—we gaze across a see-through border (on the edge of our seats, wide-eyed, transfixed) as if America were a multi-zillion-dollar Hollywood blockbuster. We are the Etruscans to their Roman Empire.

How fascinating, then, to discover that they've been looking at us all the while. And not just looking at us but taking photographs of us—documenting Canadians and our Canadian way of life over the course of the entire twentieth century. Further, it hasn't merely been "America" observing us but America through the lens of *The New York Times*, arguably the world's most prestigious journalistic institution.

Imagining Canada has its genesis in the approximately twenty-two thousand photographs that make up *The New York Times* photo archive of our nation, a resource purchased in 2009 by Canadian businessman Christopher Bratty. At the time that Bratty made the purchase, I was editor-in-chief of the web-only *TORO Magazine*, a

AS DO THE EXTRAORDINARY ESSAYS THAT ACCOMPANY THEM.

digital lifestyle publication that he and I co-founded in 2008. Bratty told me that he'd purchased the archive for altruistic purposes, intending to eventually donate it to a Canadian university or cultural institution. He realized that it was an invaluable record of Canada's social, cultural, economic, and political evolution.

In July 2010, we began to publish a "photo of the day" on *TORO*'s homepage. One year later, we'd amassed approximately thirteen million pageviews, making the photos the magazine's most popular content by far. It's not hard to understand why the images elicited such a response. The size, scope, and diversity of the archive photographically mirrors the size, scope, and diversity of Canada itself. Our great vistas emerge in all their pristine glory. Canadians from across the country are depicted on the land—drilling, mining, harvesting—intent on finding a way to survive in a raw, frigid, continent-sized country. Portraits of distinguished Canadian and international statesmen abound, along with refreshingly

informal snapshots of the British royal family. The archive brims with images of Canada's famed artists and influential thinkers—not to mention sports legends of all stripes. There are photos of national heroes, too, such as Billy Bishop. The historic sweep of these pictures highlights our dramatic demographic changes, in tandem with the trials, tribulations, and triumphs of Aboriginal peoples. Some of the most riveting images in this collection depict Canadians at war. Stirring, tragic, grand, these photos are certainly relevant and evocative enough to merit a book of their own.

Later in 2010, *TORO* launched an exhibition of some of the photos during the opening days of the Toronto International Film Festival. The event resulted in more than a hundred pieces of media coverage and ninety million media impressions. These results got us thinking. If the images were connecting so powerfully with our readers and generating such strong interest from national media, wouldn't a book be equally valued?

There's not much else to say. The eye-catching, crop-marked, inspiring, occasionally heartbreaking photos collected in this book speak volumes, as do the extraordinary essays that accompany them. The authors, fittingly, are as varied a group as the citizens of this country. We've assembled journalists, historians, bestselling authors, academics, sports commentators, activists, and political leaders. Their words speak for themselves. Increasingly, our country has learned to speak for itself. No, we won't go to war in Iraq. Yes, we will set a record for gold medals by a host nation at a Winter Olympics. No, we won't succumb to the global economic crisis. We are coming into our own, and making up some ground on our neighbours to the south.

Our relationship with America has been—and continues to be—deep, complex, and compelling. And while the American mythos may still dominate in some arenas, a new generation is rising, a chorus of young Canadian voices representing every nation on earth. But for those voices to create their brave new world, they need to know this country's past and its accomplishments. This book—equal parts photo anthology, essay collection, and historical chronicle—is also a torch (yes, of liberty) that we pass to a new generation.

Paul-Maurice Patenaude, in the United States, is shaking hands with his son, Louis, in Canada. Mr. Patenaude owned a bar called the Halfway House, which was constructed on the Canada–U.S. border. Mr. Patenaude separated the two countries with a solid black line that ran from the jukebox to the front door.

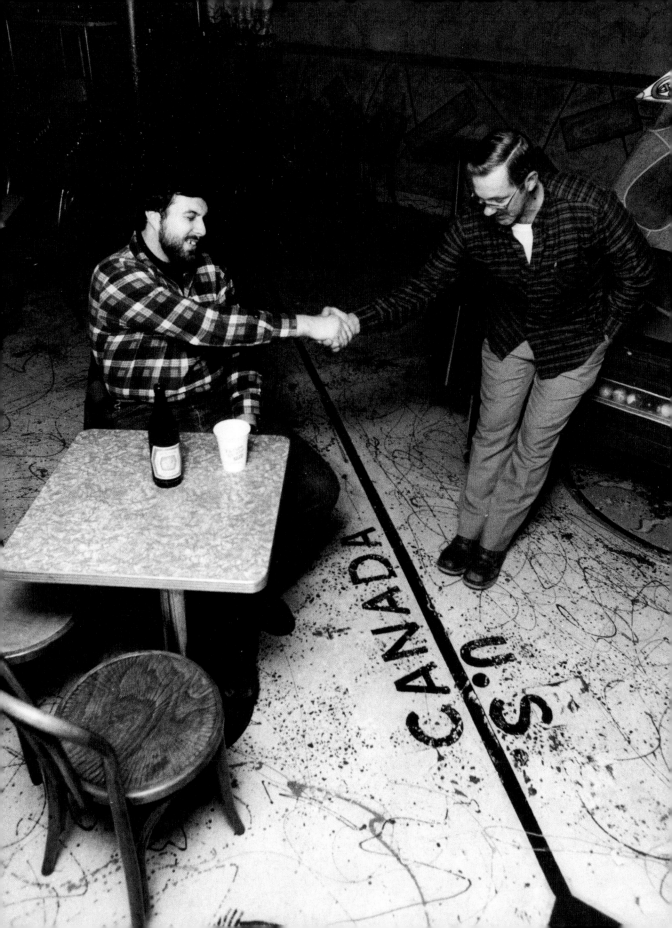

LANDSCAPES

IAN BROWN

FAR AND WIDE

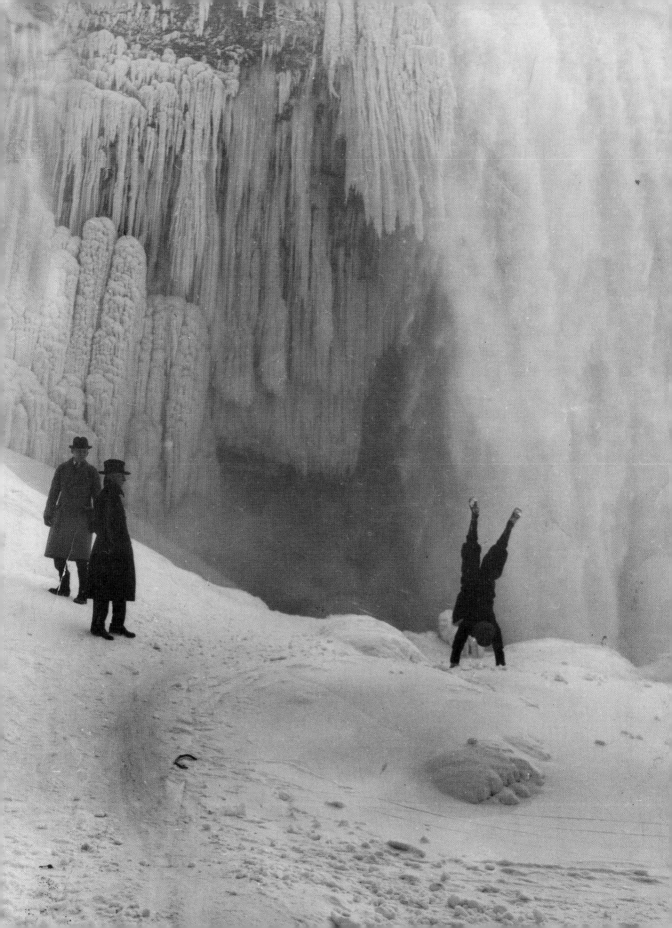

THE PHOTOGRAPHS IN THIS ARCHIVE MAKE YOU FEEL
THE PHYSICAL AWE THAT THE CANADIAN LANDSCAPE
ONCE INSPIRED, BEFORE TELEVISION AND THE INTERNET
MADE SUCH WONDERS EASILY ACCESSIBLE, BACK WHEN
IF YOU WANTED TO SEE AND FEEL SOMETHING IN REAL TIME,
YOU HAD TO GO THERE.

THE INSTANT CONCLUSION you reach looking at the Canadian landscape photographs in *The New York Times* archive is this: Canada is a very big country. Not just overall big, which it is, but big in its details. That was Canada's image in the world after its formal creation as a nation, after the building of the transcontinental railway system and the completion of the Trans-Canada Highway. It is our size that made us unique: we were the second-largest country on the map (usually pink, because we were a member of the British Commonwealth), a vast place that was mostly wilderness, but where the wilderness became reachable, thanks to mass transportation. We were a country where there were still wide, uninterrupted plains and boundless forests, endless fields of snow and untrammelled mountains, ice packs and fish (all of which have begun to disappear in the years since). Canada was a country with a new and unformed history, a virtual teenager compared to the United States, and an infant compared to Europe. It was still possible to believe one could be part of that history.

The photographs in this archive make you feel the physical awe that the Canadian landscape once inspired, before television and the Internet made such wonders easily accessible, back when if you wanted to see and feel something in real time, you had to go there. These are photographs on a grand scale, filled with distance, shot by photographers who had to make their way into the Canadian wilderness to get a glimpse of it to take away. The country that emerges feels about ten years old, the age I was when everything seemed astonishing.

Most of these photographs are perforce of iconic Canadian scenes—the Athabasca Glacier, Lake Minnewanka at Banff, Niagara Falls. Many of these portraits have become clichés, touristic stock images. But these are the originals that helped create the clichés,

A boy does a handstand by Niagara Falls in January, 1924.

and they are saved from that lowly status by the fact that a) they are in black and white, which links them instantly to the history of photography, and b) they somehow retain their original sense of wonder.

The image of the Banff Springs Hotel seen from the southwest, nestled like a pendant in the cleavage of the Bow Valley, is iconic for a reason. It conveys everything we once longed to say about the place we lived: *Look! Grand comforts in the middle of the grandest nature. Nothing like it anywhere.* The hotel and the valley still appear that way today, give or take a few buildings.

Back in the 1920s, *The Times* expressed astonishment that human beings actually lived in such a frozen expanse as the Canadian North. Sealers traversing the Arctic ice in the 1930s were engaged in "a perilous crossing," *The Times* notes. Another caption from this series of photos describes the sealers as "Jumping From One Small Block to Another, a Feat in Which They Become Expert. Their Colorful and Adventurous Work, However, Takes a Toll of

Scores of Lives Each Year." And it's true: If you look closely, you can see just how perilous this crossing is; three men are in mid-jump from one floe to another and look on the verge of falling into the icy waters.

One of my favourite Canadians landscape photographs from this collection is the indoor-outdoor swimming pools, fed by the hot springs at the Banff Springs Hotel, with what looks to be Mount Rundle in the background. Swimming pools in the mountains have been a favourite of photographers since the invention of photography: the contrast of the cold, snow-clad mountains with the warm, bathing-suit-clad swimmers speaks to the contradiction that gives depictions of the natural landscape their power: the intimacy of the personal against the majesty of nature.

I especially like to look at the photographs of places in Canada I myself have been that *The Times* managed to get to as well. I think this speaks well of both of us. One photograph of horse packers and their dogs making their way across the Saskatchewan

Glacier in Banff National Park, Alberta, reminds me of the first time I saw this landscape—how remote it was and how endless. The peak in the distance is a day away on skis, longer by horse. Byron Harmon, the first great photographer of the Canadian Rockies (the Ansel Adams of his day, but preceding Adams by thirty years) and the inspiration for many of the Western shots *The Times* photographers later reproduced, made the first photographic records of the Saskatchewan Glacier. In the 1920s, Harmon hooked up with Lewis Freeman, an American travel writer and filmmaker, to photograph Mount Columbia. They took two guides, a string of pack horses, a radio, a typewriter, eight thousand feet of film stock, and a flock of carrier pigeons (in case they got into trouble). In seventy days they travelled eight hundred kilometres. On their very last day on top of the world, their food spent, the clouds finally cleared for the first time, for forty minutes— just long enough for Harmon to snap his pictures of the great peak. Freeman claimed

it might be the first patch of clear sky in those parts for several years.

Harmon also loved to tour the back- country of the Rockies on skis, taking pictures of skiers. One of his most iconic photographs depicts a band of skiers schussing down a slope—a picture that is quite intentionally echoed in a later, equally beautiful photograph *The Times* published in the 1970s of heli-skiers in the Monashees, three ranges of mountains west of the Rockies. In *The Times* photograph, tiny people balance on the delicate edge of fate and possible avalanches as they drop down the face of a steep and deep slope in one of the snowiest places on earth. It's a shocking feat, even if they did get there by helicop- ter—the brilliant new idea of Hans Gmoser, the Canmore-based founder of the now world-renowned Canadian Mountain Holidays.

But landscape isn't just unpopulated wilderness. Look at the photo of what seems to by an idyllic town on a river. Do you recognize the city? This is not 1938; it's 1953,

a mere fifty-nine years ago. It's Calgary, near the downtown. It's unrecognizable in this photo. Today, the city stretches in an almost unimaginable sameness of monster homes and die-cut suburban cul-de-sacs well into the foothills of the Rockies. When you see what a tree-laced beauty the city once was, and what it might have been, the loss feels immense. The landscape is not just a record of where we are, but also of who we were, and of what we are becoming. I would say the prognosis is not great.

What's most surprising to me about the Canadian landscape, at least as recorded in the pages of *The Times*, is how personal it is, despite its massive, unyielding scale. This is because any place you are forced to survive in also forces you to get to know it. From this knowledge is born in turn a stubborn respect and love for even the most barren lands. I have spent an hour gazing at one photograph in particular, of RCMP officers on snowmobiles driving off into nowhere, at Pond Inlet on Baffin Island. You could write an entire play inspired by that picture, based

on the relationship between the three officers and their place within the surrounding community, somewhere way up there in the barrenness of the Arctic Circle.

This being Canada, a lot of the photographs are images of our infamous whiteness. In 1898, for instance, during the Klondike Gold Rush, the line of men climbing over Chilkoot Pass was literally miles long. If you stepped out of line to rest, you could wait hours before anyone would let you back in line. Even the railway ride from Skagway to Whitehorse was hair-raising, 110 miles across harrowing ravines and mountain terrain in a narrow-gauge railway car. After the railways came roads, but the early ones were no favour to anyone. In 1923, for instance, *The Times* published a photograph of the new Banff–Windermere Road, under a caption blithely singing the ease of travelling by car. Never mind that cars then averaged a blowout every twenty miles, just look at the road! One car is completely broken down; the cars behind it are afraid to try to pass in the oncoming lane for fear of

6

slipping off into oblivion. But by 1957, a mere thirty-five years later, motoring is a breeze, and the picturesque rest stop has become a promotional tool.

It's a surprise, of course, that photographs deemed suitable for a staid and "objective" newspaper such as *The New York Times* are so deeply evocative. But that is how deeply the Canadian landscape can reach into even the most blasé tourist or observer. Canada exists by dint of its geography, survives in spite of its climate and its topography. The trick has always been to turn it to our (or someone else's) advantage, and these photographs are proof of that. They're an impartial bystander's record of a country's efforts to come to terms with its physical nature.

Overleaf (left): An idyllic scene in Lake Minnewanka, Alberta. *(Right)* Hikers at the foot of Athabasca Glacier in the Columbia Ice Fields in Jasper National Park, Alberta, 1988.

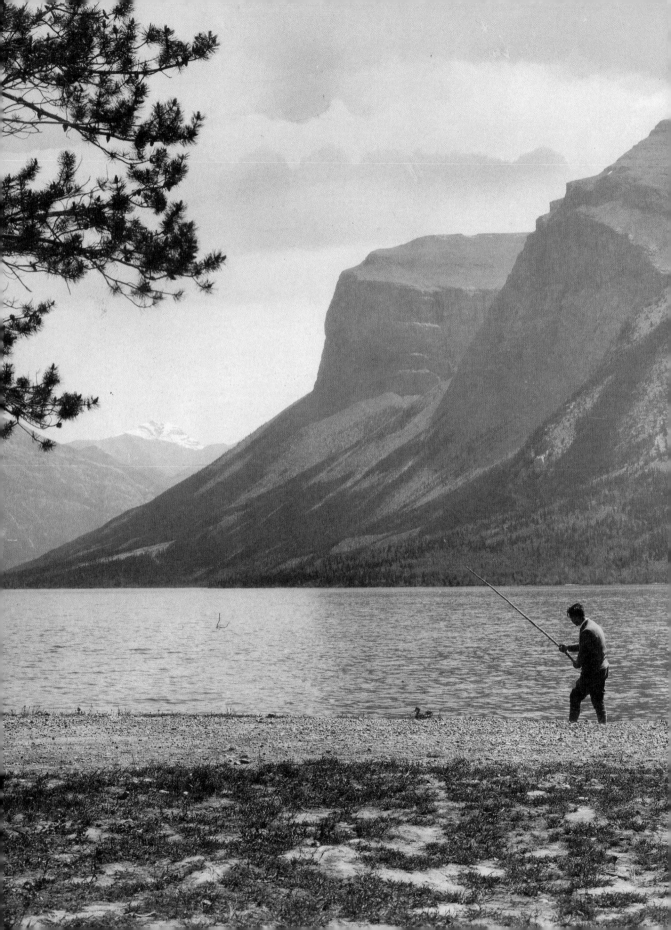

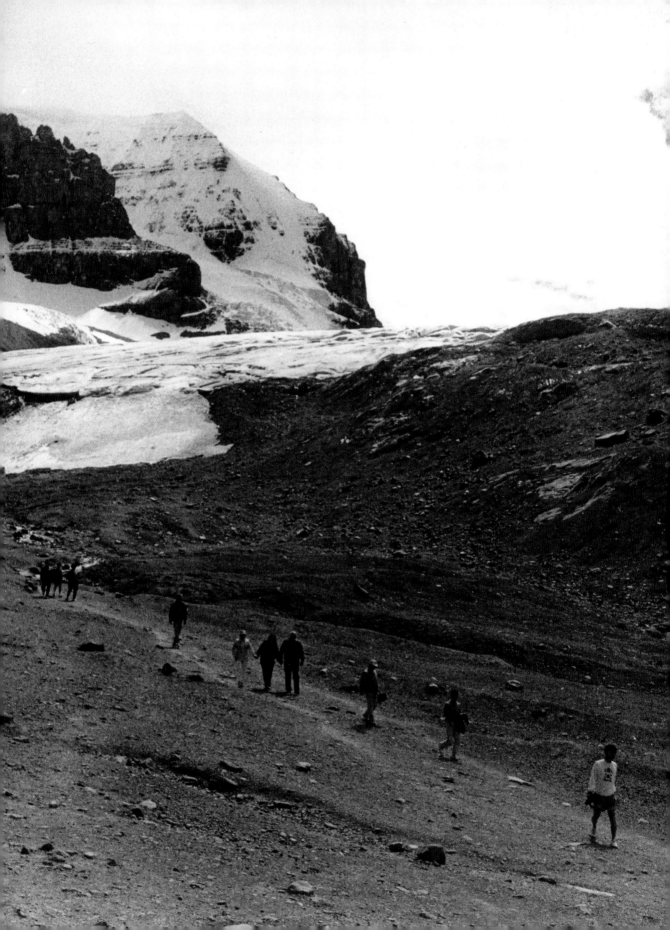

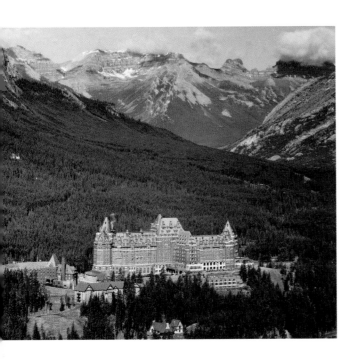

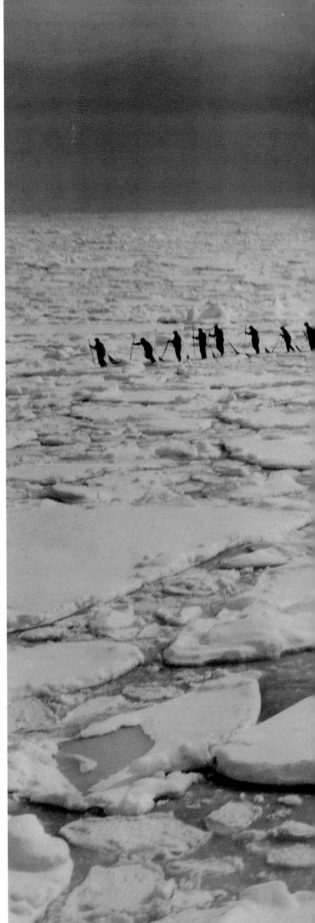

(*Above*) Banff Springs Hotel, situated in the valley of the Bow River, circa 1961. The opening of the hotel in 1888 marked a new era of tourism in the Canadian Rockies.

(*Opposite*) These sealers off the coast of Labrador were photographed and filmed by Varick Frissell in 1930. Frissell joined the crew of the SS *Viking* for its annual seal hunt, but the ship got trapped in ice. Later, in 1931, dynamite being used by the film crew ignited, destroying the *Viking* and killing twenty-seven men, including Frissell.

A PERILOUS CROSSING OF THE ICE FIELD

SEALERS

Jumping From One Small Block to Another, a Feat in Which They Become Expert. Their Colorful and Adventurous Work, However, Takes a Toll of Scores of Lives Each Year.

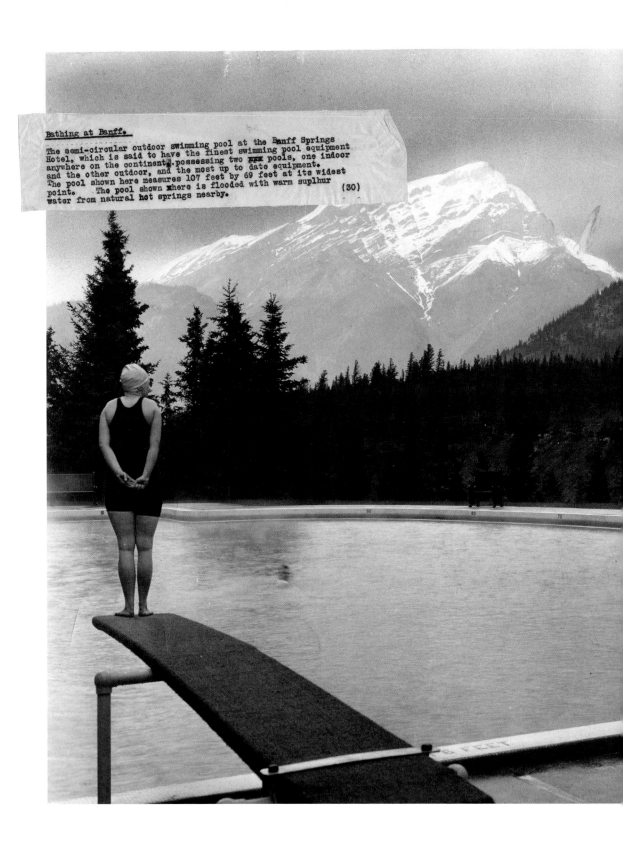

Bathing at Banff.

The semi-circular outdoor swimming pool at the Banff Springs
Hotel, which is said to have the finest swimming pool equipment
anywhere on the continent. possessing two gas pools, one indoor
and the other outdoor, and the most up to date equipment.
The pool shown here measures 107 feet by 69 feet at its widest
point. The pool shown where is flooded with warm suplhur
water from natural hot springs nearby. (30)

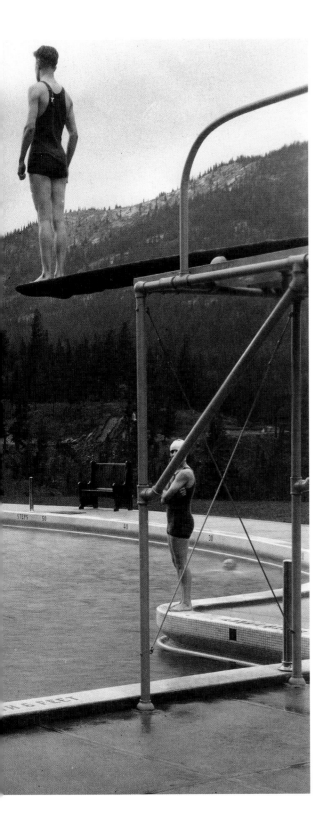

At Banff Springs Hotel, bathers enjoy a warm-water pool flooded by natural hot springs.

(Overleaf) A horseback party explores the Saskatchewan Glacier in Alberta in 1933.

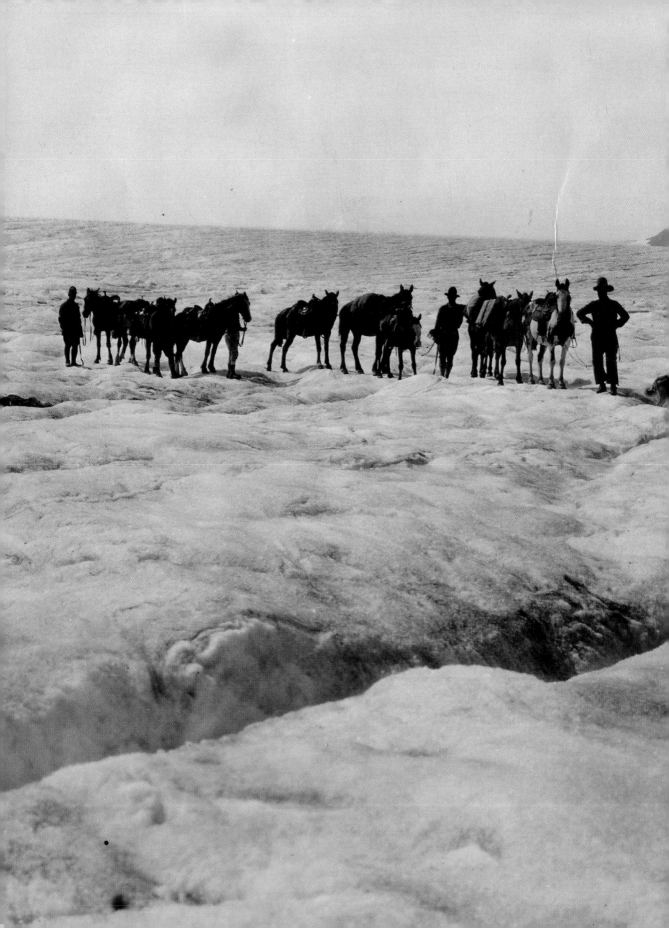

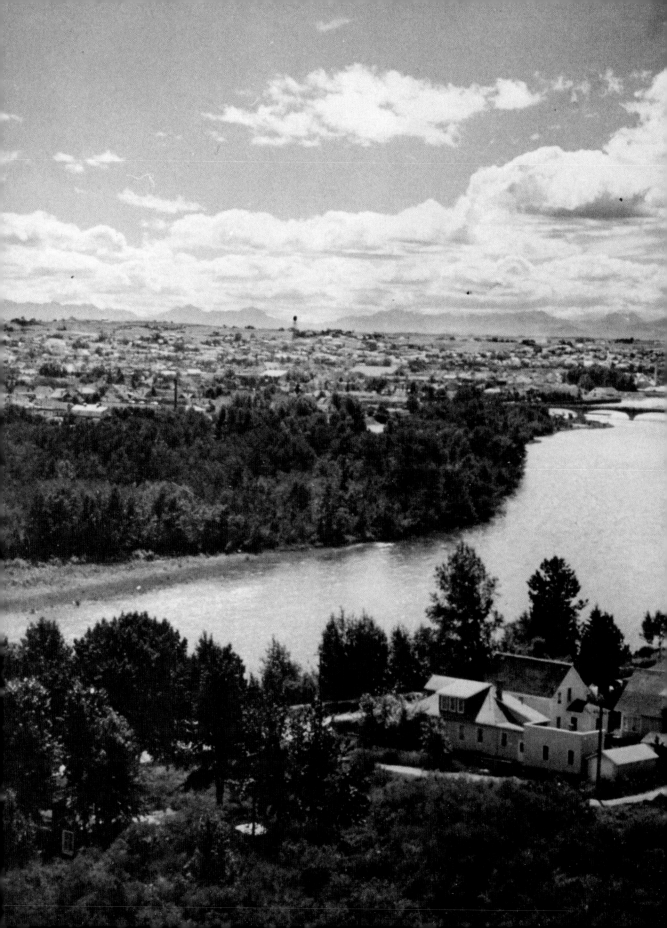

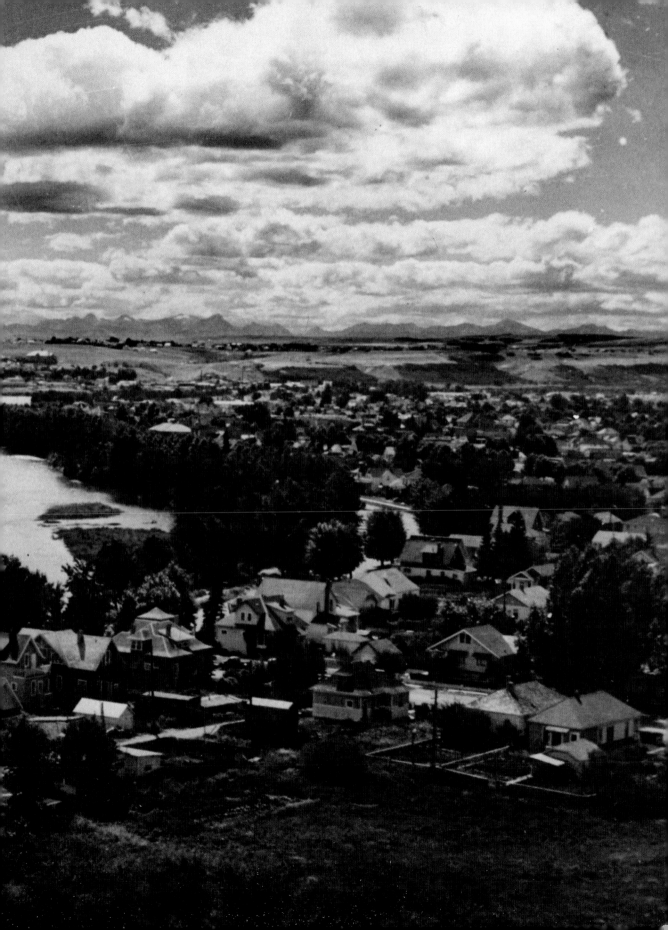

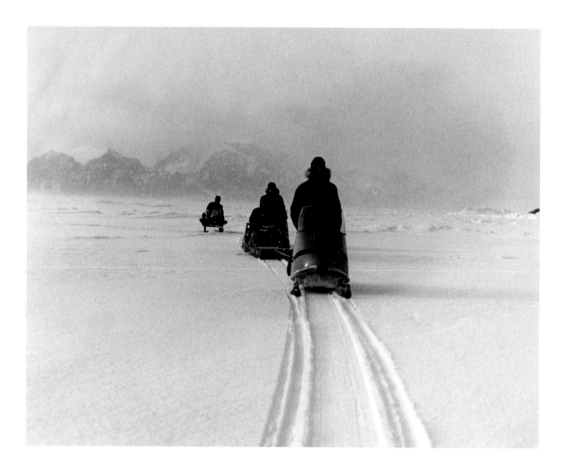

(*Above*) In 1973, an RCMP snowmobile patrol crosses Pond Inlet, Baffin Island, some 600 kilometres north of the Arctic Circle.

(*Preceding Page*) Calgary, Alberta, in 1953, on the banks of the Bow River. The Rockies can be seen in the background.

(*Opposite*) A group of skiers descends a run in the Monashee Mountains of British Columbia in 1978. The Monashee Mountains are only accessible by helicopter, and are commonly called "the steepest and the deepest."

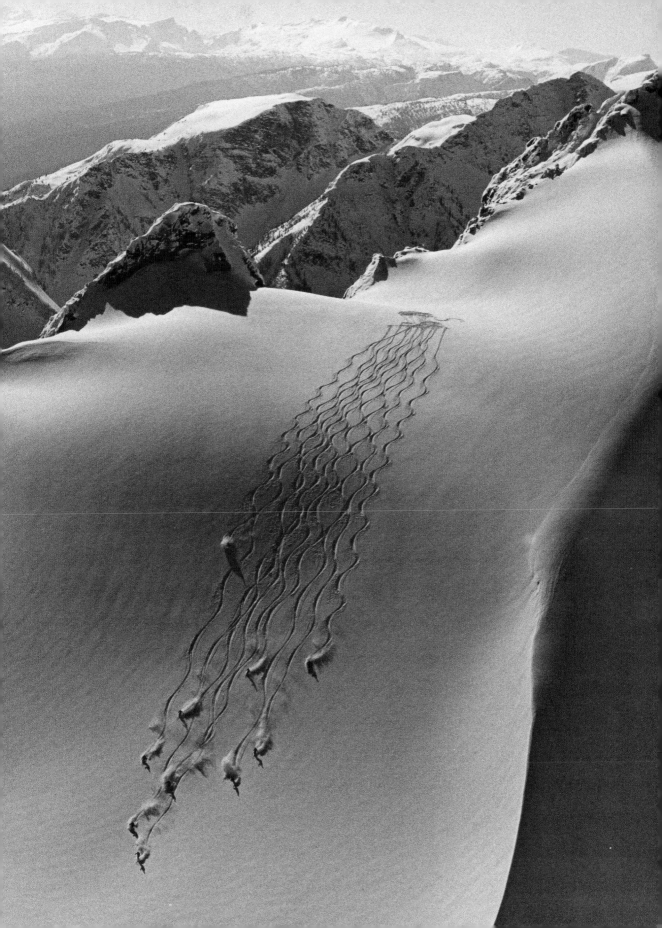

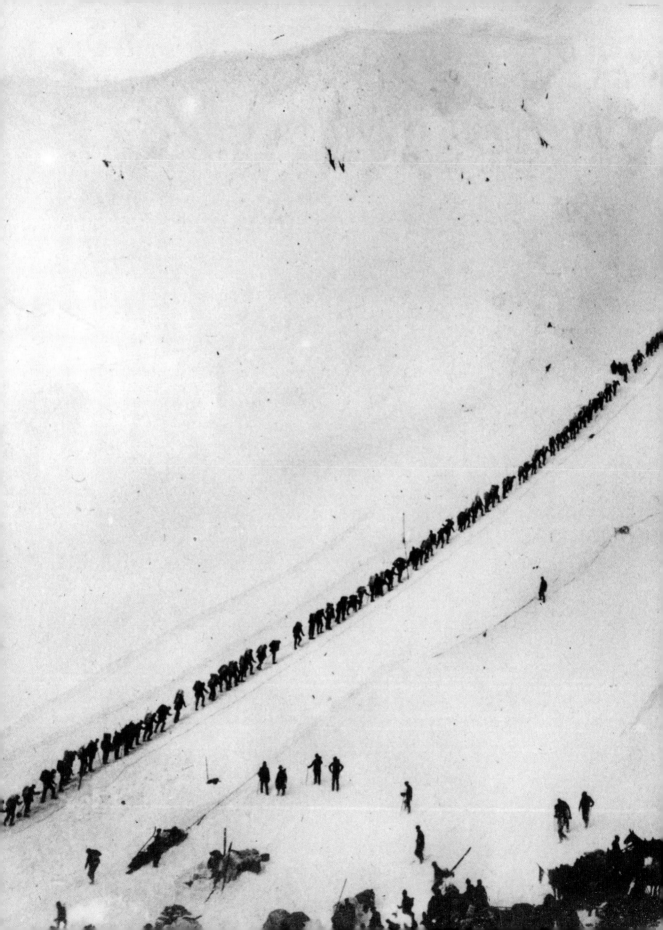

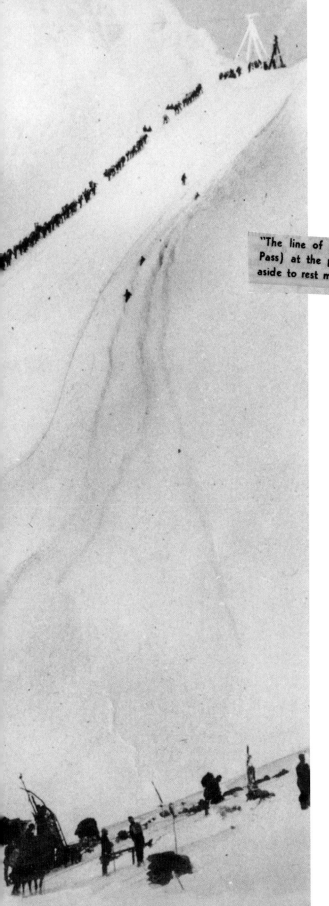

"The line of dark-clad men inched up the mountain (Chilkoot Pass) at the pace of the slowest climber. A man who stepped aside to rest might wait hours for a chance to get back in line."

During the Gold Rush in the late 1890s, climbers make a treacherous trip up the "Golden Staircase" at Chilkoot Pass.

(*Overleaf*) Steamer passengers riding from Skagway, Alaska to Whitehorse, in the Yukon, in 1947.

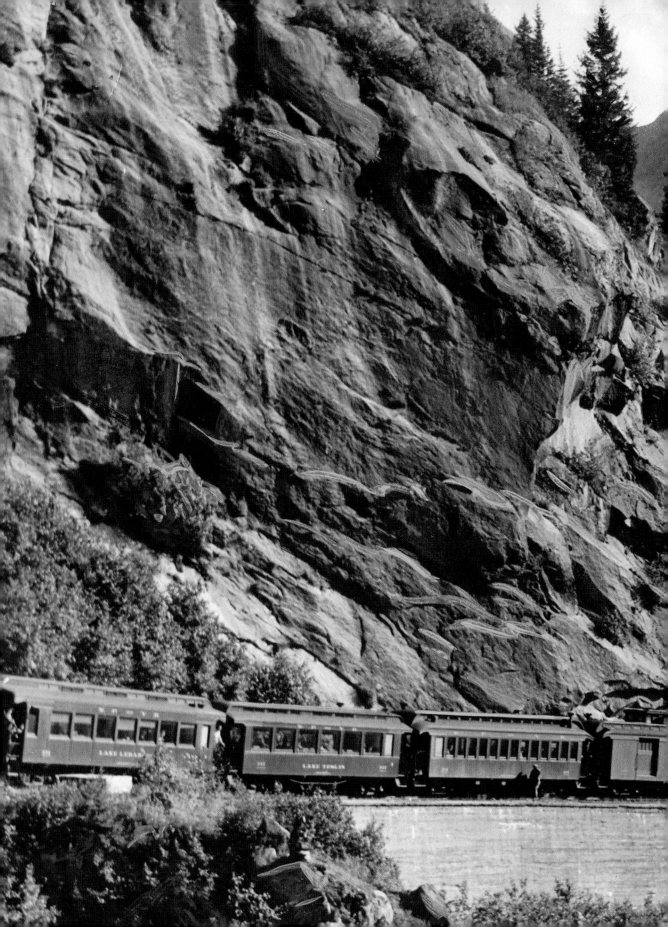

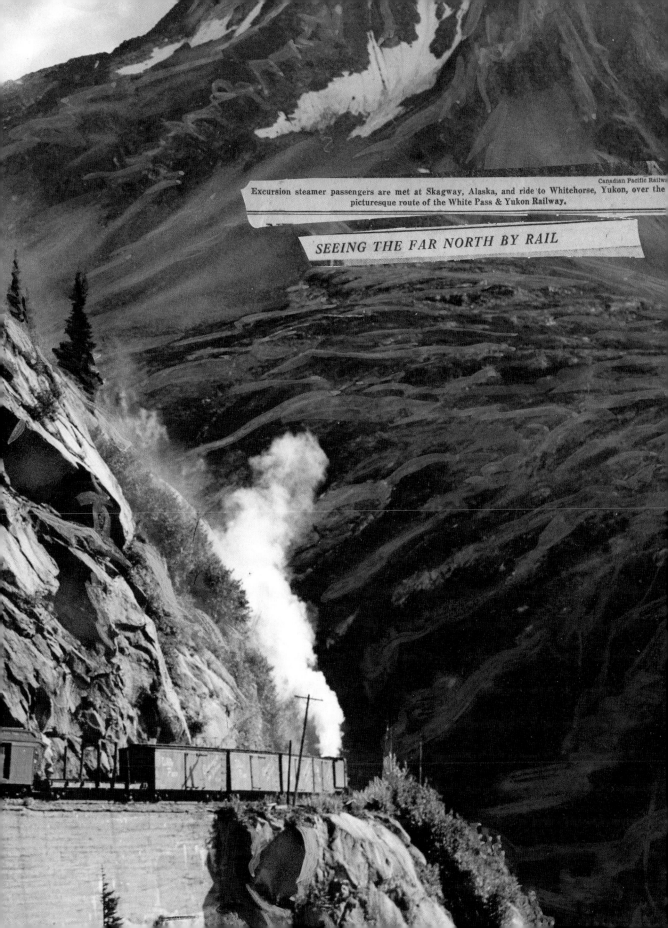

Canadian Pacific Railway

Excursion steamer passengers are met at Skagway, Alaska, and ride to Whitehorse, Yukon, over the picturesque route of the White Pass & Yukon Railway.

SEEING THE FAR NORTH BY RAIL

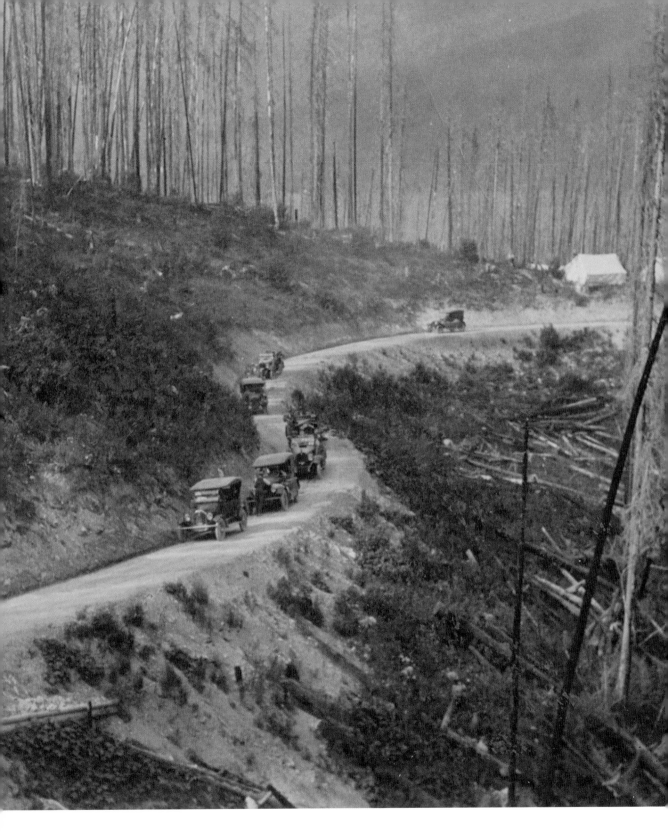

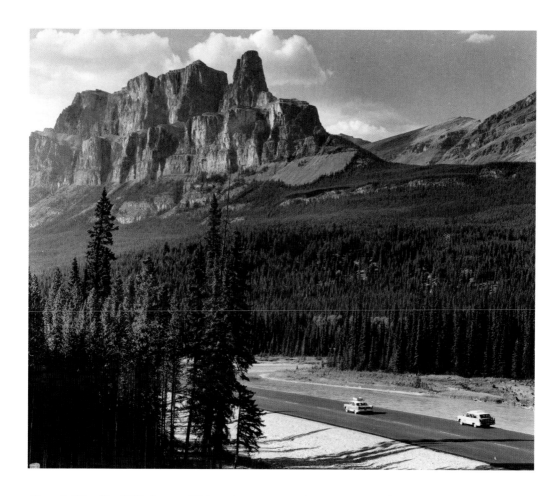

(Opposite) The "Banff-Windermere Highway,"
the first road that crossed the Rockies, officially
opened on June 30, 1923.

(Above) Mount Eisenhower towers over the road in
Banff National Park in Alberta, circa 1961.

(Overleaf) A view of Peyto Lake and valley, from the
Banff-Jasper highway.

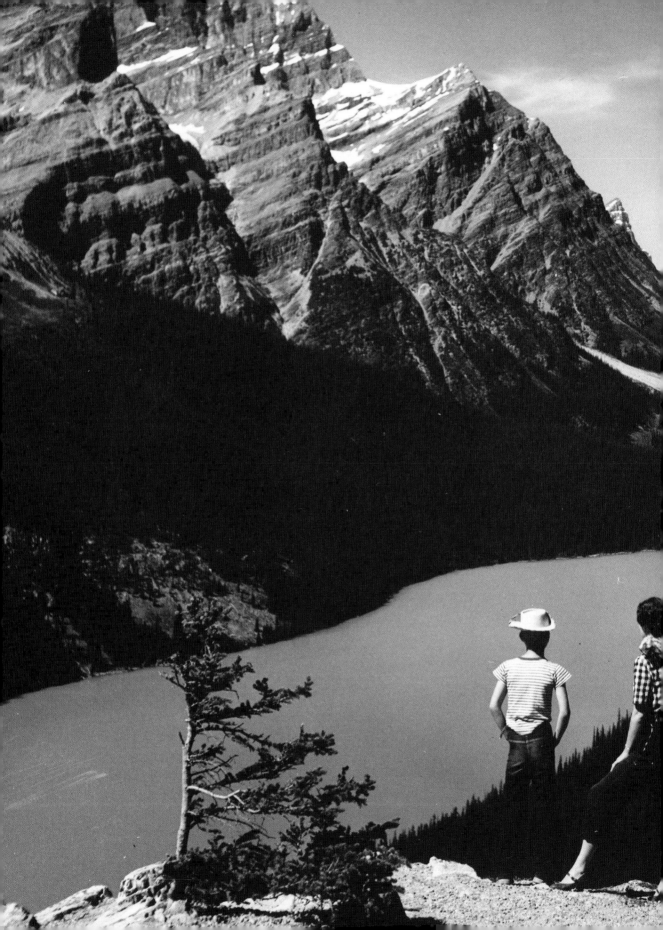

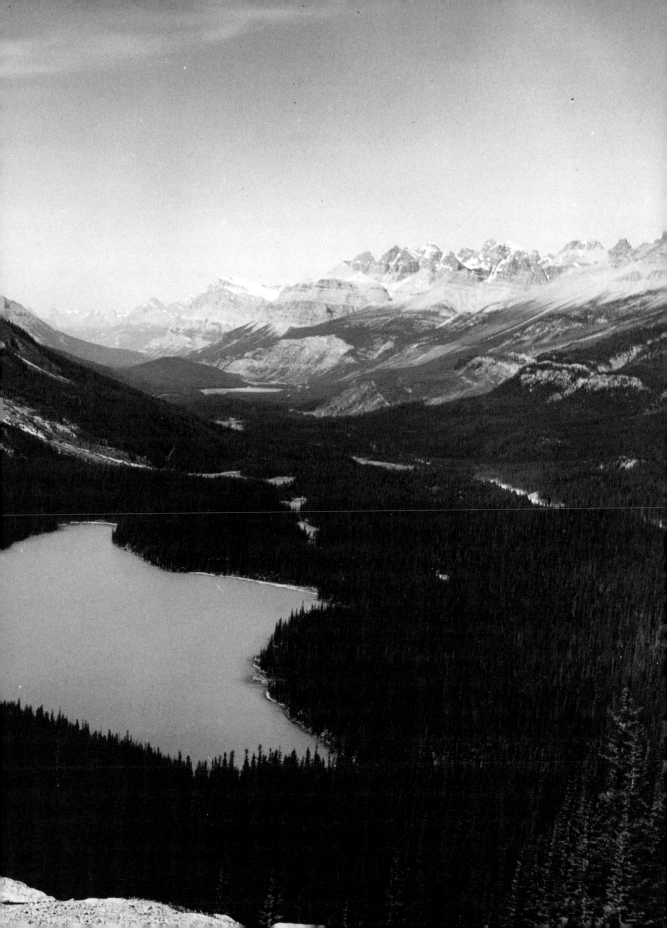

SHAWN ATLEO
NATIONAL CHIEF OF THE
ASSEMBLY OF FIRST NATIONS

FIRST NATIONS

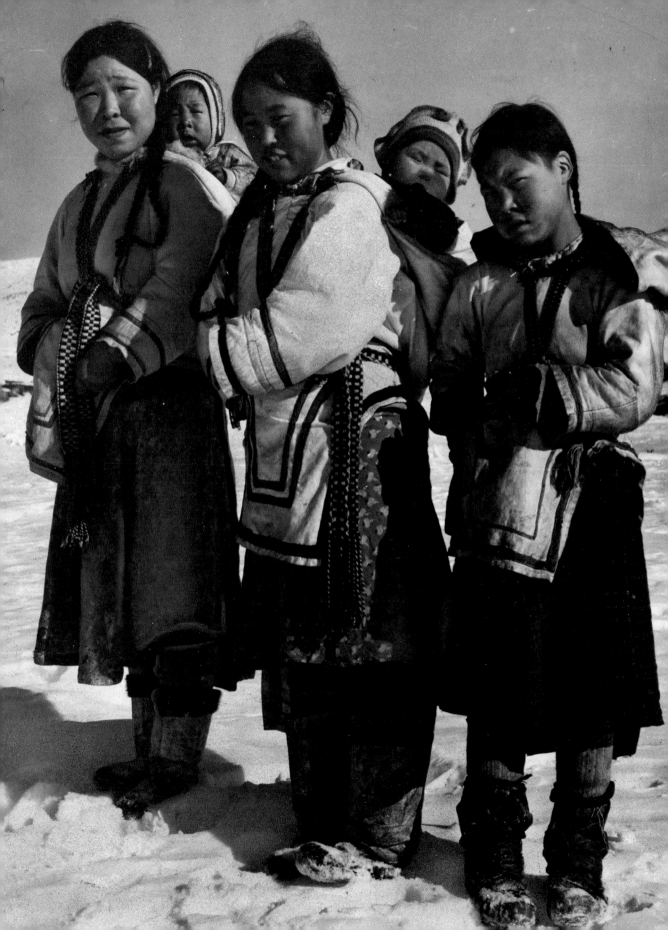

AM THE HEREDITARY CHIEF connected through generations and centuries to our own Nuu-chah-nulth governance systems, knowledge, and world view. My grandmother and great-aunts formed the matriarchal core of our society. Growing up, I was taken aside to learn from her and from all of the elders—to learn our sacred traditions and responsibilities. This was the work of the elders, holding fast to our identity, our rights, and our responsibilities. Their lives were lived during the time of these photos. The images reveal many of the incredible challenges they faced. Indeed, even in my comparatively short lifetime, I have experienced utter misunderstanding and a complete lack of respect and recognition for our Nuu-chah-nulth traditions and ways of life.

These photos from *The New York Times* from the 1920s through to the 1980s speak not only of the general stereotyping of Canada as remote but to a far more troubling portrayal of the indigenous peoples— the first peoples, the peoples with inherent knowledge of their lands and territories, of systems of government, trade, and economy that existed for thousands of years before European settlement. These photos reflect false romantic visions, mocking both the sacred traditions and the ceremonial dress of our First Nations. The attitudes reflected in these photos shaped decades of disastrous public policy in our country and across North America and represent a terrible loss to all Canadians—a loss of the real history and richness of this land.

We see vividly depicted the missed opportunity for understanding and the total lack of respect when ancient art, rich in story and a unique world view, is dismissed as "crude rock carvings." Art that has survived

Three women pose for a photograph at Clyde Inlet on Baffin Island, December 28, 1952. The U.S. Coast Guard travelled from their icebreaker *Eastwind* to Clyde Inlet via helicopter. They were asking the community for help in arranging dog sleds for a hydrographic survey.

for a thousand years in Europe and elsewhere is guarded, as it ought to be, as a cultural treasure, an affirmation of nationhood, culture, and identity. Yet as depicted here, a miner casually sits on the art itself, a hammer ready to obliterate this voice and story from the past—another attempt to erase, ignore, and dismiss the reality of indigenous peoples throughout Canada.

We also see images of proud leaders connected to centuries-old hereditary lines of successful governance systems. With no attempt to identify nationhood, role, or responsibility, regalia is labelled "costume," and the prevailing assumption is that their dress is intended for the entertainment of others. A photo of one of our leaders described as "making a picturesque caddy" is viscerally disturbing, a racist reference that undermines and degrades every one of us.

These images also tell important stories about the implementation of the Indian Act, the denial of our traditions, the restrictions placed on—and the eventual elimination of—the indigenous economy. Notice the Hudson's Bay factor with his stern gaze as he appraises the furs brought to him by First Nations hunters. The photo does not even reveal the faces of the owners of the resource, nor does the caption accompanying it give their names. This tells the familiar story of unfair dealings and inequity.

Consider the bewildered and offended faces of our peoples receiving a ballot box stamped with "Dominion of Canada," with instructions from a foreigner on how we must now conduct elections—a paternalistic attempt to obliterate centuries of our own leadership and governance and to deny promises made through treaties and alliances of mutual respect. All of these images document what the Royal Commission on Aboriginal Peoples, after careful study and analysis, decisively concluded in 1996 are policies and approaches that utterly failed our peoples.

Even more tragic are the images of residential schools. Apparently playful captions describe seemingly innocuous

events, highlighting hygiene and cleanliness as if these were lessons forwarding this noble cause of "civilizing." We know the tragic, deeply painful reality behind these pictures—our children were ripped from their families, their languages and cultures decimated. They were victimized through physical, psychological, and sexual abuse. Our children suffered and even died in these schools; parents, devastated by loss, never recovered. This legacy of loss continues to oppress our communities.

We see collected here other images of "authority," as with the photo of the Royal Canadian Mounted Police unloading supplies at Ellesmere. The divide between indigenous and "authority" is painfully evident. While an indigenous man shoulders a heavy load, officers stand back, observing and relaxing.

In contrast, images of traditional work, of gatherings, of family, and of our craftsmen and artists hint at the true story of our people. Looking beyond the captions, we can see our ancestors as members of proud and independent Nations. We see evidence of the importance of family and we see tremendous pride and great skill in commerce, art, and hunting.

As I reviewed these photographs, I was reminded of the words of my late grandmother. As she sat with me in the House of Commons in 2008 witnessing the historic apology offered by the prime minister of Canada to survivors of residential schools, she turned to me and said, "Grandson, now they are finally beginning to see us."

At that moment, a peaceful calm and happiness washed over both of us—the knowledge that, at last, in the final years of her long and incredibly rich life, she had the opportunity to witness a modest measure of justice for her and for so many of her generation. Optimism was, in that moment, a possibility. Perhaps the next generation could live in an era of true reconciliation and experience the opportunity to fulfill their personal and collective potential as indigenous peoples and as Canadians.

I encourage everyone to truly observe these images and all images of indigenous peoples, from the beginning of Canada and long before. Through reconciliation and justice, we can look anew at the history of relations between settler governments and indigenous peoples. If we take this time and care, we will be enriched by the incredible history and enduring legacy of the indigenous world view—a world view that values the land and our place in it, that emphasizes the interconnection between all things, and that recognizes our responsibility to one another. This is my hope and humble request—an invitation to all Canadians to *see* us, and ultimately to join us, in a celebration of the indigenous heritage and the future of Canada.

Magistrate Harry Nosworthy "swears in one of the Eskimos as an election officer," states the caption from August 8, 1953. The Inuit election officer remains unnamed, as do the other men in the background. In the Northwest Territories, the Royal Canadian Air Force delivered ballot boxes and instructed residents on voting procedures for the coming federal election. Two days later, Prime Minister Louis St. Laurent led his Liberal Party to its fifth consecutive majority government.

Inside the trading post at the Eskimo settlement, Magistrate Harry Nosworthy leaves ballot boxes and election documents. He explains election procedures and then swears in one of the Eskimos as an election officer. In the northwest territories of the Yukon and the MacKenzie River, the Royal Canadian Air Force is carrying out similar operations on an even larger scale

Canadian National Film Board

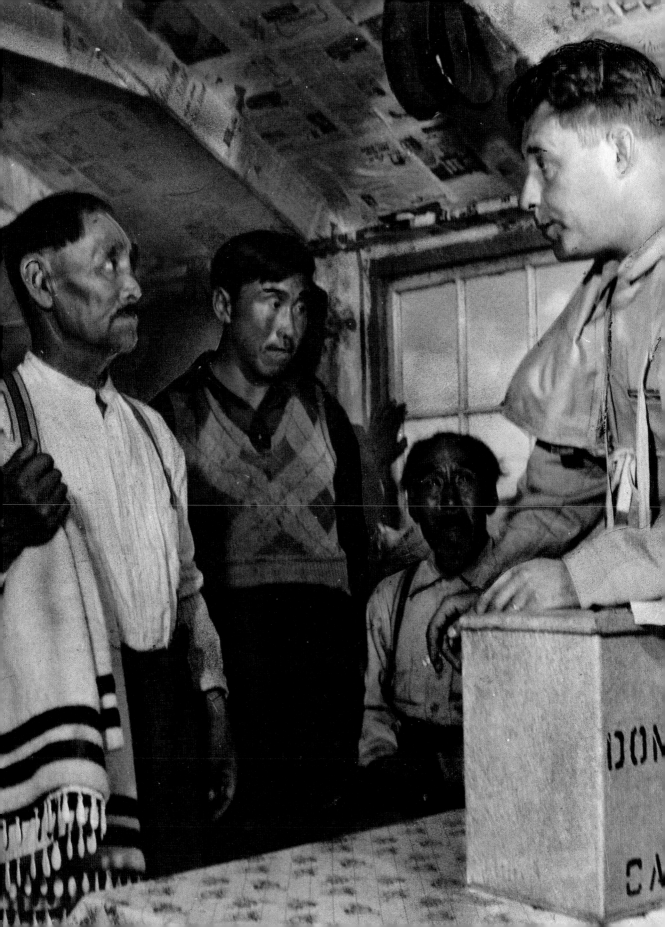

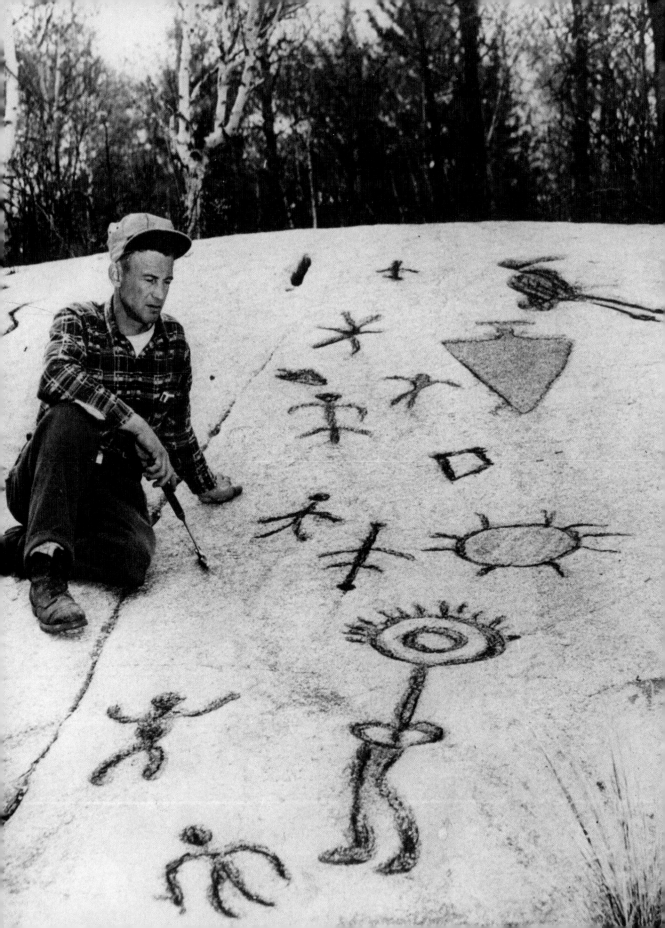

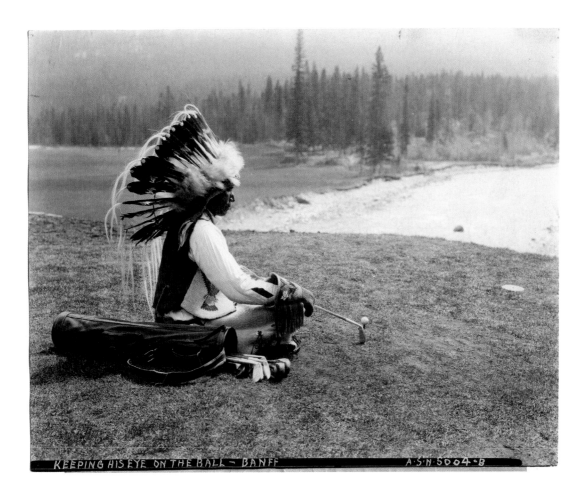

KEEPING HIS EYE ON THE BALL - BANFF A·S·N·5004·B

(Opposite) Everett Davis, a mine employee of Industrial Minerals of Canada, poses with pre-Columbian petroglyphs carved by the Algonquian people between A.D. 900 and 1400. The location of the carvings had been lost until a prospecting party found them in 1954. The 990 carvings show images of shamans, animals, reptiles, and a dominant figure whose head apparently represents the sun. Today, these petroglyphs constitute the largest grouping of ancient First Nations rock carvings in Ontario. They are part of Petroglyphs Provincial Park, which has been designated a National Historic Site of Canada.

(Above) Taken in 1929, this photograph of a chief of the Nakoda people of Alberta was meant to promote tourism to Banff, Alberta. "John Hunter" is an anglicized name.

GOLFING IN THE CANADIAN ROCKIES HAS ITS ILLUSIONS: CHIEF JOHN HUNTER, a Full-Blooded Stoney Indian, Makes a Picturesque Caddy on the Banff Course. (Canadian Pacific Photo.)

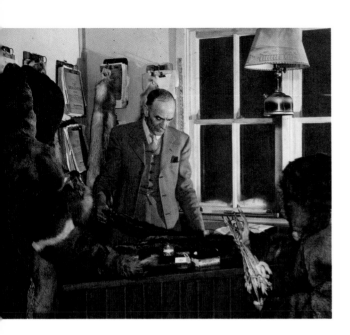

Unnamed Cree trappers bring red fox pelts to a fur
trader at the Lac La Ronge, Saskatchewan, Hudson's
Bay outpost in 1958. A newspaper photo stylist has
touched up the fur with feathery brush strokes to
enhance the reproduction quality.

Viscount Willingdon, governor general of Canada
from 1926 to 1931, is given the name Chief Morning
Light at the 1928 Calgary Stampede. He is shaking
hands with Chief David Bearspaw, also known as
Chief Hector Crawler, head chief of the Nakoda
people from 1915 to 1956. Behind Willingdon is
Tatanga Mani (1871–1967), also known as Chief
Walking Buffalo.

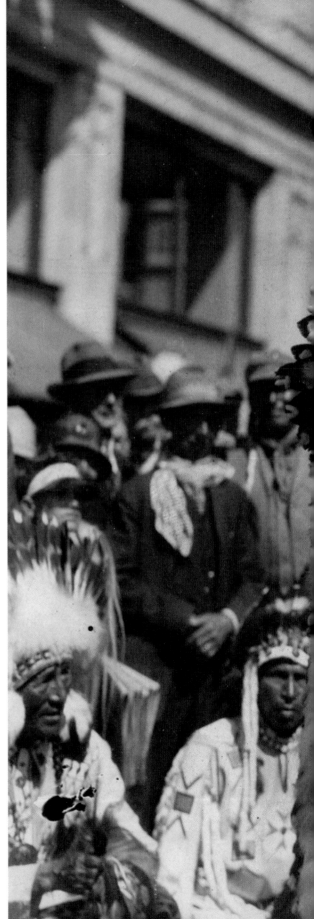

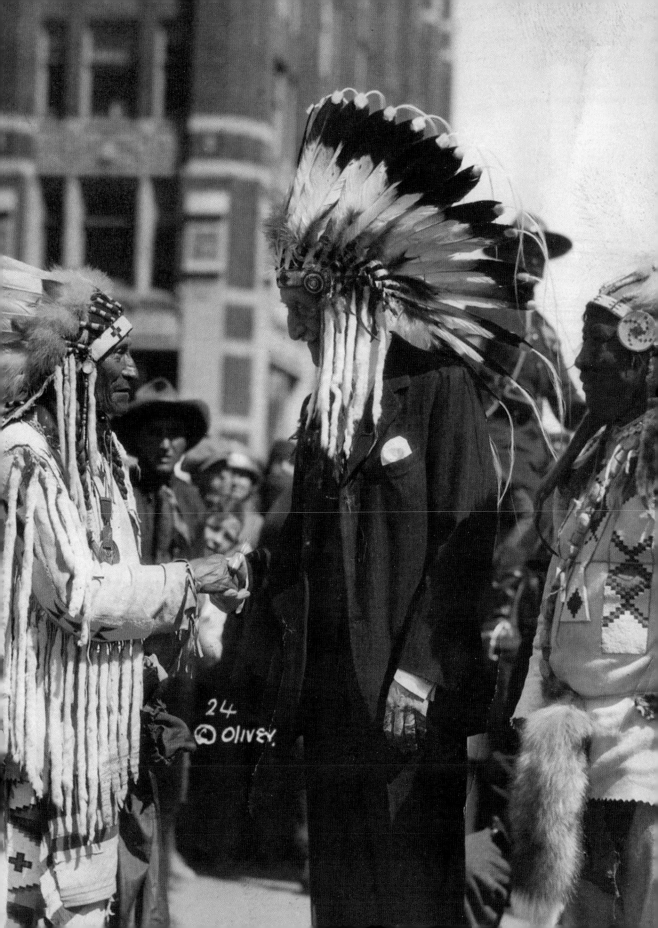

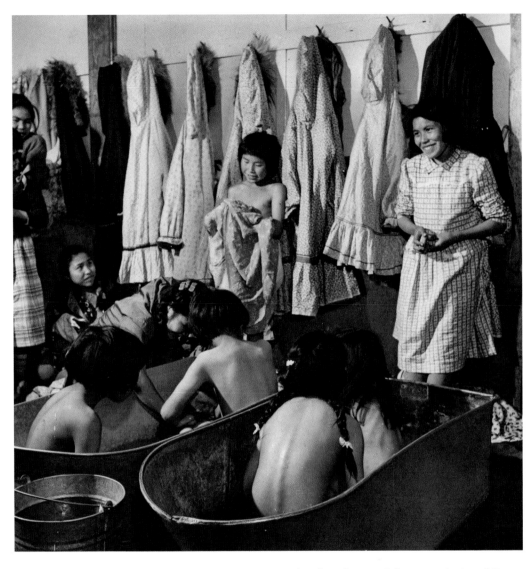

In this photo from 1956, four young Inuit and First Nations girls bathe in two galvanized metal tubs, each holding about three inches of water. They are students at All Saints School, an Anglican residential school in Aklavik, situated on the Mackenzie Delta above the Arctic Circle. The photo was taken before the government relocated most of the population to a new town farther north.

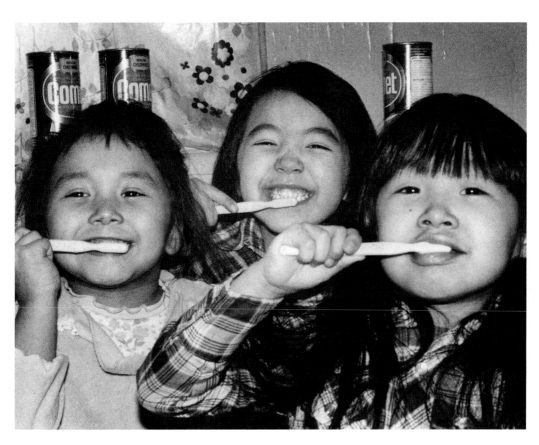

In 1982, three young Inuit girls from Qarmartalik
School in Resolute Bay, a small village on Cornwallis
Island in Nunavut, are instructed to brush their teeth
and smile at the camera. Today, the school has
approximately sixty students.

Kindergartners and first-graders demonstrate their knowledge of personal hygiene.

The New York Times,

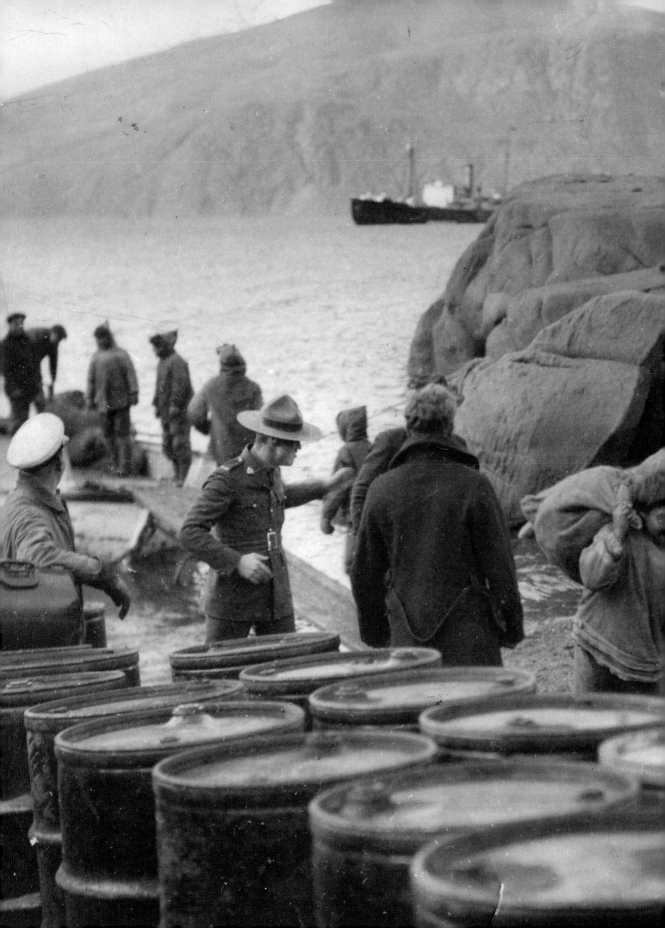

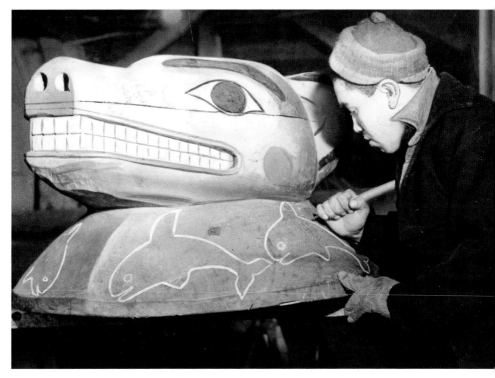

A young First Nations carver prepares the headpiece for a totem pole in 1941. He carves a border of orcas, or killer whales, a creature revered in Pacific Northwest First Nations culture.

RCMP officers oversee a group of Inuit men carrying heavy sacks of supplies up from a dock on Ellesmere Island in the Canadian Arctic in 1933. A relief ship can be seen in the harbour.

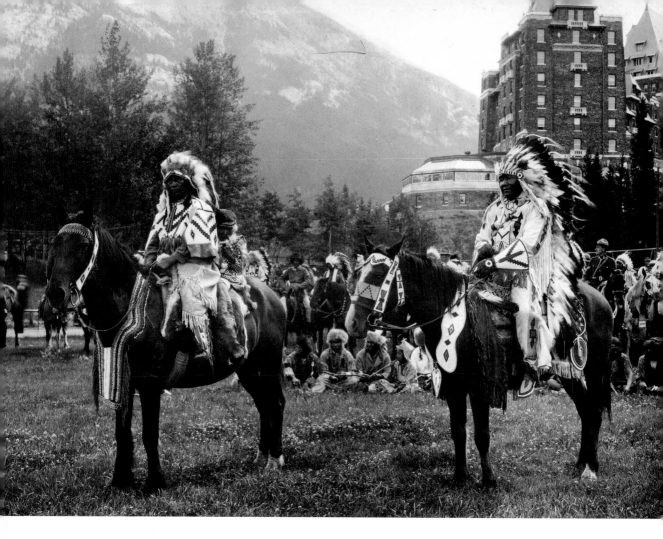

(Above) The 1932 "winners" in "the Well-Dressed Family class" of an "Indian fashion show," surrounded by other members of the Nakoda tribe—or Stoney Indians as they were sometimes called. The original caption identifies Chief Judas Hunter (right), his wife (left), and their daughter, Shining Star Hunter, seated behind her on the horse. What was omitted from the caption was the reporter's commentary on the event. The reporter described the display of "amazing buckskin and beadwork costumes . . . for the inspection of the paleface elite who are vacationing at the Banff Springs Hotel in the Canadian Rockies."

(Opposite) A chief of the Nuu-chah-nulth people wears a magnificent carved Thunderbird headdress and a cloak with eagle feathers in 1929 in Tofino on Vancouver Island, British Columbia. The photo's original caption refers to exclusive fishing rights allegedly granted to the chief's people. Until contact with Europeans, the Nuu-chah-nulth had sustainably fished the Pacific Northwest for countless generations.

A HAT FIT FOR A KING: CHIEF JOSEPH JOHN in Full Regalia and Feathers, Photographed at Tofino, Vancouver Island, Where His People Have the Exclusive Right to Fish Unobstructed in the Seal Fishing Waters of the North Pacific.
(Times Wide World Photos.)

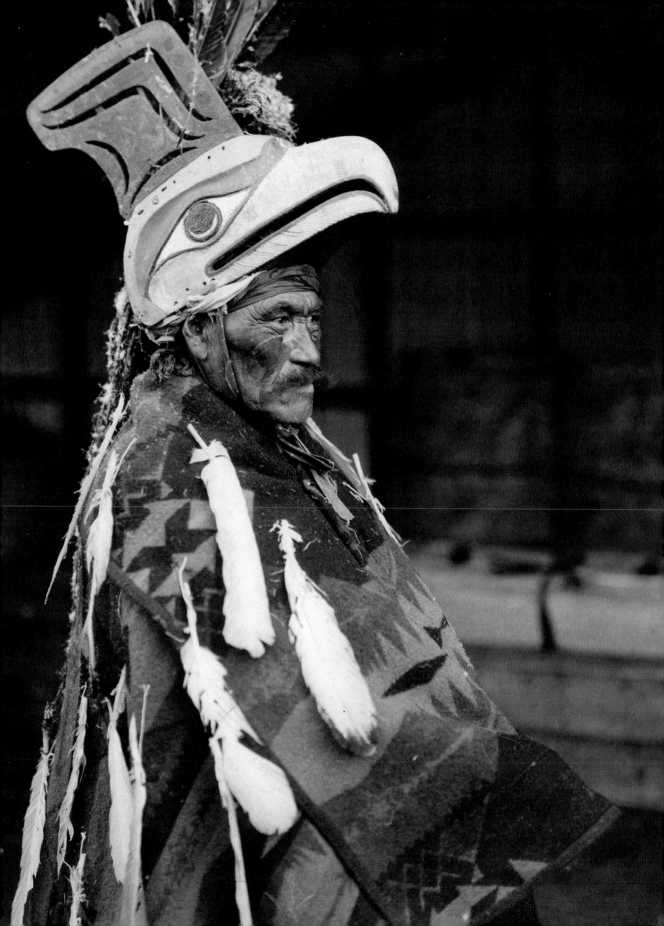

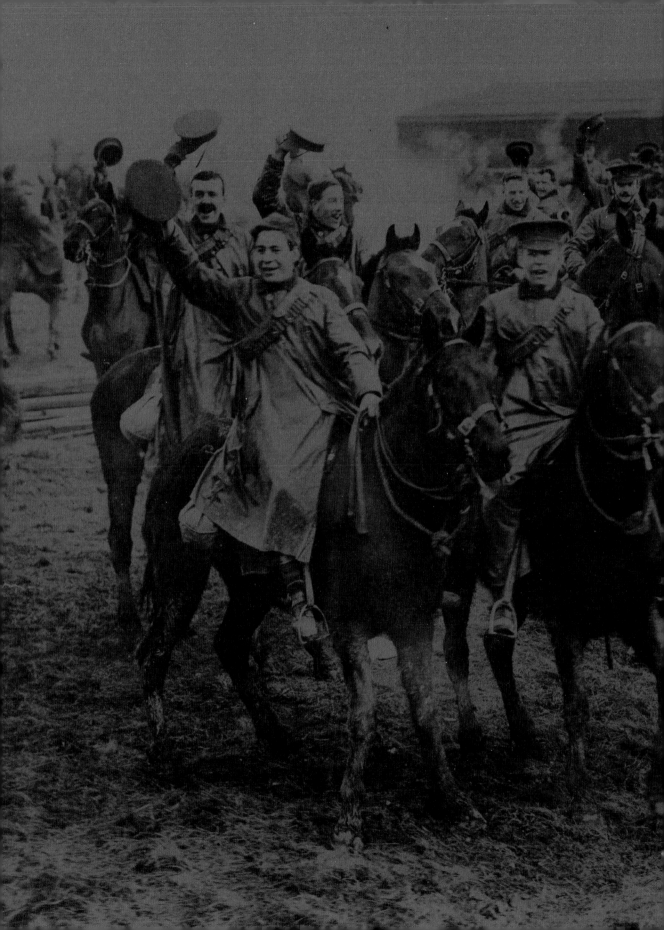

TIM COOK

A WARRIOR

NATION

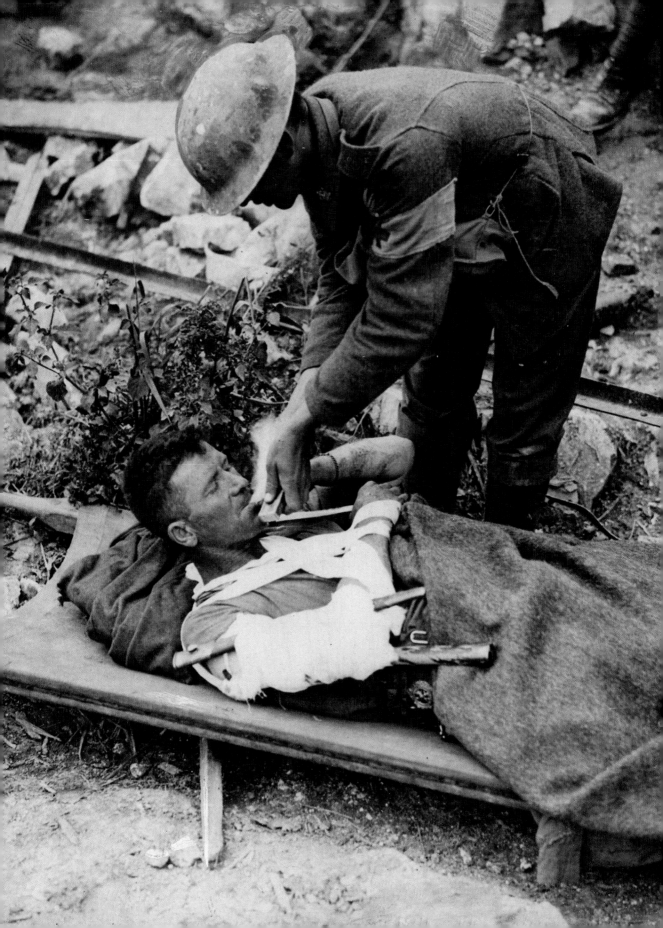

W E ARE A COUNTRY that has been shaped by war. War has acted as a rough—sometimes even brutal—engine of change. During our nation's early history, trade and security alliances resulted in countless skirmishes and battles, with the French and English empires solidifying for supremacy alliances with Aboriginal bands. These low-simmering but often deadly conflicts culminated in the Seven Years War, with Britain's victory over France in 1763 determining, for a time, the fate of North America.

British North America's wars of survival against the United States, first during the American Revolution (1775–1783) and then during the War of 1812, could have resulted in the British colonies being swallowed by the behemoth to the south. But victory ensured British survival, although throughout the nineteenth century, the supposedly undefended border along the forty-ninth parallel was anything but that—heavy fortifications, canals, and military roads all protected against the threat of cross-border raids.

The disparate colonies of British North America had many reasons to join Confederation, but Britain's desire to avoid the costly defence of Canada was a significant factor, especially after the brutal American Civil War (1861–1865) proved the United States could raise million-man armies from its civilian base.

The Fenian raids by Irish-American veterans across the common border in 1866, and periodically after that, stirred up more fear than wanton destruction, but Canadian militiamen were killed in battles to defend Canadian soil, and the invasion persuaded Nova Scotians and New Brunswickers to elect pro-Confederation governments. The

A bayonet scabbard and the handle of a trench-digging tool were used as a splint for a Canadian soldier after his upper arm was damaged by shrapnel. Lying on a stretcher and awaiting evacuation from a First World War front line in the fall of 1918, he smokes a cigarette lit by a stretcher bearer.

very fabric of the country that was to become Canada was forged by war, conflict, and the struggle for survival.

Canada pacified the West in 1870, post-Confederation, and then put down Louis Riel's uprising a decade and a half later. The paramilitary North-West Mounted Police and the Yukon Field Force policed our vast territory, while the Fisheries Protection Service acted as a coast guard against voracious American fisheries. Civilian soldiers formed urban and rural militia regiments that were the first line of defence in a land war against American invaders, with only a tiny permanent force of professional soldiers established from the early 1870s.

Canada's military role changed in the twentieth century. No longer at risk of American takeover, and under the protection of the all-powerful British Royal Navy, the country began to provide security to other nations beyond its borders. In the South African War (1899–1902), more than seven thousand Canadians marched alongside

British forces. It was a long, dirty, and dangerous campaign, but Canadians made a name for themselves as tough and resilient warriors.

But nothing prepared Canada, or the world, for the Great War. A third of the Dominion's adult male population defended the British Empire. No one foresaw that much of the war on the Western Front would be fought in defending rat-infested trenches. Hundreds, sometimes thousands, of lives were lost daily to shellfire, sniper bullets, and poison gas. However, during this industrial war of staggering proportions, the Canadian soldier endured. The nation stepped out onto the world stage and was recognized for its service and sacrifice. Canadian soldiers earned an elite reputation as shock troops in battles at Ypres, the Somme, Vimy, and during the Hundred Days Campaign. But the losses were over-whelming. By war's end, more than sixty thousand Canadians had been killed over-seas, and several thousand more died from their war wounds after their return home.

During the war, the nation came together like never before, especially in support of the soldiers and their dependants. But the divisive conscription crisis of 1917 nearly shattered the peace at home, setting region against region, family against family, friend against friend. The war years also brought short-term changes to Canadian society, such as the prohibition of alcohol and women working in munitions factories, and there were permanent changes, such as the introduction of income tax and women receiving the right to vote.

Wars are fixed in time and place. But the memories of conflicts change as we march forward, remembrance used (and sometimes abused) by future generations who find new meanings in old battles. Wars, and especially the Great War, remain critical mythmaking events that unify our sense of nationhood. Iconic battles, such as the Battle of Vimy Ridge, have become emblematic of Canadian nationalism. Yet how did Vimy transform in our consciousness from a costly four-day battle at the midpoint of the war to become a symbol of nation building? This is both a complicated and a nuanced evolution, one that is grounded in Canada's desire to make meaning out of the terrible losses of the war. This is not to say that Vimy is not important, but *when* it became important to Canadians requires some unravelling of the historical thread. Walter Allward's stunning memorial on Vimy Ridge's slopes and the 1936 official pilgrimage that saw more than six thousand veterans unveil it serve as proof of our desire to uniquely commemorate our war history. History books, films, plays, novels, classroom teachings, and governments all highlight what we should remember and shape how we remember it.

Almost a hundred years later, the Great War has lodged itself in our collective consciousness, and the same process is occurring with the Second World War, which was even more tremendous in its global destructiveness. There were few battlegrounds where the 1.1 million Canadians in uniform did not serve, fight, and die. In support of those who sacrificed,

the Canadian home front produced an avalanche of war *matériel*—from trucks to bombers, tanks to machine guns. Canada was truly an arsenal of democracy.

In this industrial war, war machines—tanks, U-boats, and bombers—dominated the battlefields. Democratic, Communist, and Fascist governments put millions of their citizens into navies, armies, and aerial armadas. Yet in the photographs that capture this planet-wide conflict, it's the faces of individuals that hold our attention, and we long to hear their mute testimony. These are ordinary men and women caught in a maelstrom of conflict and destruction. How they rose to the challenge defined both victory and defeat.

Canada emerged from the Second World War bloodied and with more than forty-five thousand dead, but as a nation that was also prosperous and influential. Gone were the days of cowering isolationism, where our reputation was based on little more than moralizing speeches. After 1945, Canadians, backed by a robust diplomatic core and an

effective armed force, sought a role in the international sphere.

Canada became a compulsive joiner, especially in the realm of security and defence. The nation's early history was defined by London and Paris, but after the Second World War, Canadian politicians and military planners sought to protect the Dominion by committing it to alliances. NORAD drew Canada into joint North American defence against the Soviet threat during the Cold War, while NATO helped to pull the country away from the American orbit.

These alliances have offered Canada protection but have also required action, leading to our participation in defence commitments and even wars. Canada's much-vaunted peacekeeping forces have been deployed to protect our allies and our own self-interests. Nonetheless, Canada's reputation as a nation of peace remained intact.

It seems that while Canadians are seekers of peace, we are also willing to stand and fight when necessary. Military operations

against Iraq (1990–1991) and Serbia (1999), as part of coalition United Nations or NATO forces, concluded the final carnage-filled decade of the twentieth century. During these years, Canadians attempted to restore order or protect the weak in the lawless societies of Somalia, the Balkans, and Rwanda. We were not always successful. Now, into the twenty-first century and after the epoch-changing shift of 9/11, Canada has taken part in the long and costly mission in Afghanistan, which put an end to the belief by many—both in Canada and around the world—that the frozen land of the maple leaf consisted only of peacekeepers.

How others see us—not just the British and Americans but also the rest of the world—influences what we as a people decide is important in our history. Photographs contribute to our collective memory, but images can also reveal important absences and inaccuracies. Will Canadians, for instance, ever reclaim D-Day after Steven Spielberg's blockbuster film *Saving Private Ryan* failed to recognize that British and Canadians landed and fought on that bloody day? We can't expect Americans to accurately present our past, so if we don't do it, we will sweep ourselves into the dustbin of history.

War has profoundly shaped Canada. It has brought out the best in Canadians, as we supported service personnel overseas, but it has also fed intolerance and prosecution of minority groups, such as Ukrainian Canadians, Japanese Canadians, and Muslim Canadians. War is not the primary driving force in Canadian culture and society, nor in our development, but it plays an unmistakable role during multiple turning points in our history. We can be proud of our collective history of peace-keeping, but we should remember that we are also a nation of warriors.

53

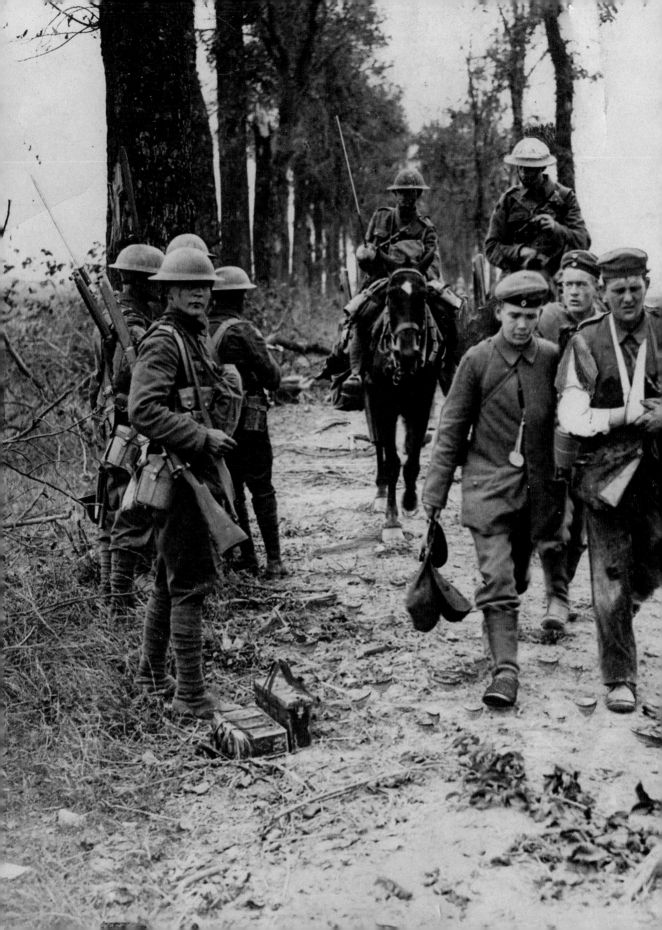

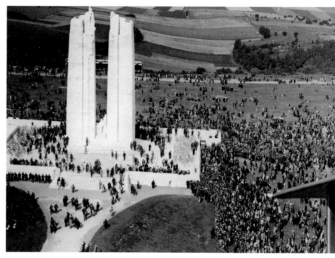

(Above) On July 26, 1936, only four months before his abdication, and after having been king for just six months, Edward VIII presided over the unveiling ceremonies at the Canadian National Vimy Memorial in France. Thousands of Canadians attended the ceremony. The site is dedicated to the memory of Canadian Expeditionary Forces killed in France during the First World War. The memorial stands on 250 acres of land gifted to Canada by France and regarded today as Canadian soil. Restored in 2007, the powerfully commanding sculpture at Vimy Ridge is the largest monument to fallen Canadians anywhere in the world.

(Opposite) On August 8, 1918, at the Battle of Amiens, four German prisoners (one of them injured) are directed into a Canadian camp on the Western Front by two soldiers of the Canadian Cavalry Brigade. Four Canadian infantrymen step aside to let them pass.

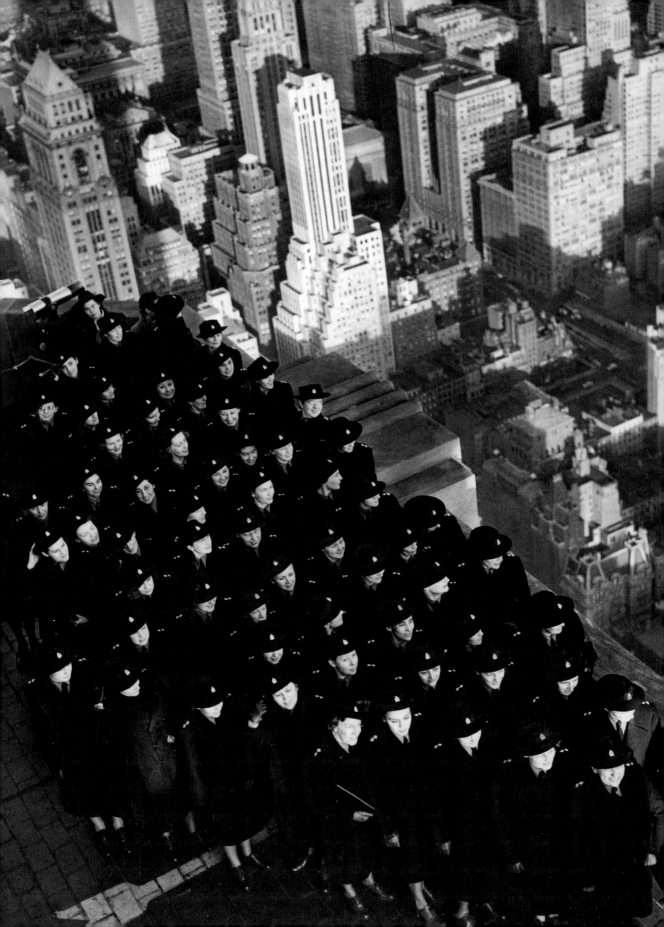

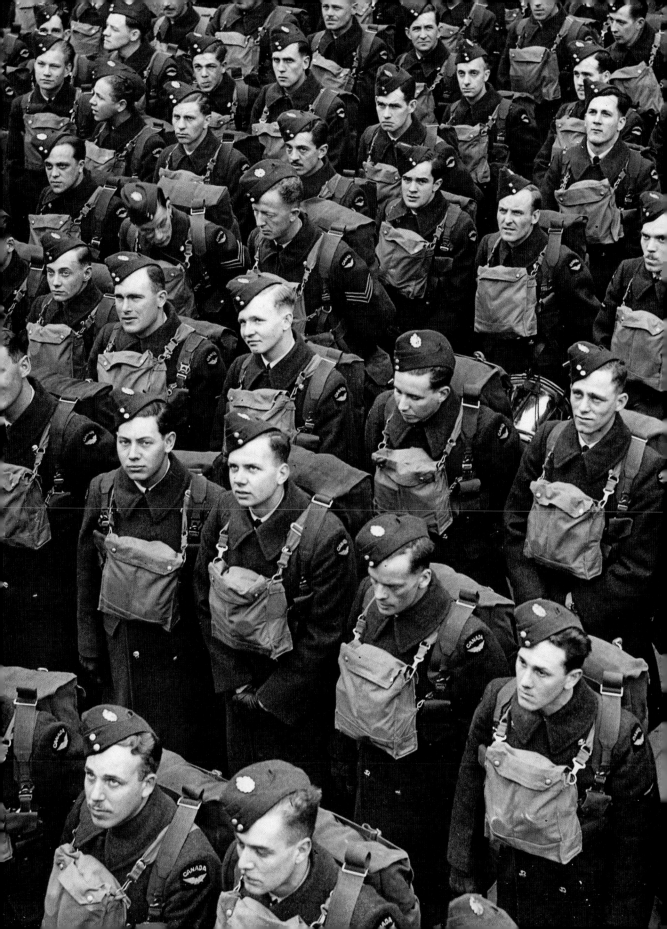

WHERE THE ROAD BRANCHED
A scene at the Pere Marquette railroad station in Windsor, Ont., as the Essex Scottish started on journey to the battlefields of Europe
Times Wide World passed by Canadian censor

After escorting convoys in the northern Atlantic in early 1943, a Royal Canadian Navy destroyer returns to Canada so completely covered in ice that it required tremendous manoeuvring skill to prevent it from capsizing.

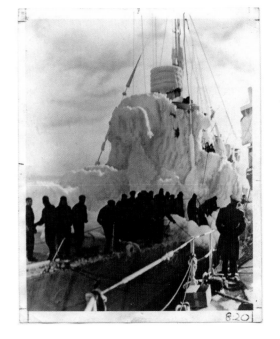

Preceding Page (left): A group of first lieutenants in the Canadian Army Medical Corps organize themselves into rows on the observation deck of the Empire State Building. Headed by Gladys J. Sharpe, matron of the Toronto Military Hospital, this was the second contingent from a total of three hundred nurses sent to work in South African hospitals in February 1942. *(Right)* Grim-faced after a long sea voyage, the first squadron of the Royal Canadian Air Force arrives in England in the early months of 1940, a few months before engaging the enemy in the skies over Europe.

(Opposite) Fathers in the Essex Scottish Regiment completing training in Windsor, Ontario, hold their children one last time as they depart by train for their next stage of training, at Camp Borden, an army base in Simcoe County, Ontario. After more training at Camp Borden in the summer of 1940, these men travelled to England and then on to the battle front.

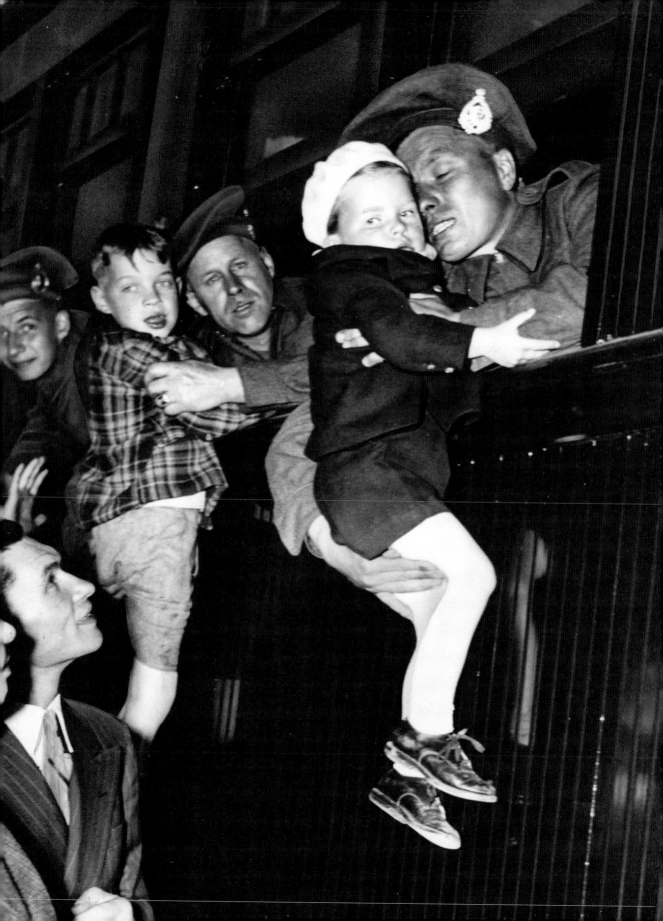

Three years before the surrender of Japan in 1945, Japanese-Canadian internees from British Columbia incarcerated in an Alberta "relocation camp" read *The Evening Telegram*. More than twenty-two thousand Japanese Canadians were interned in such camps in the 1940s, often forced to work and to hand over their property to the government.

A GLIMPSE OF THE WAR FROM THE CANADIAN ROCKIES

Japanese, removed from vital defense zones on the Pacific Coast to the interior of Alberta, where they are employed on road projects, read the news of the fighting front.

The New York Times, Passed by Canadian censor

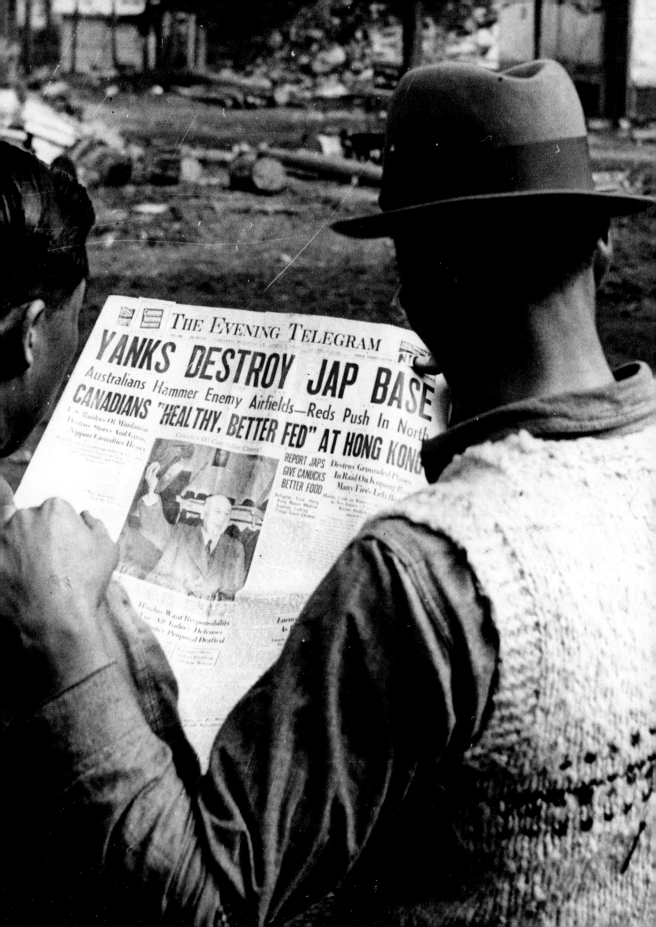

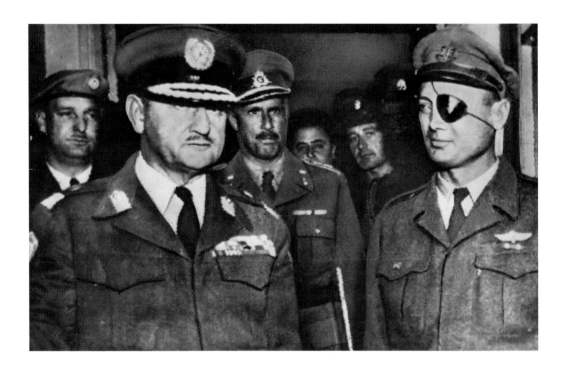

Maj. Gen. E. L. M Burns *(left)* was an advisor to the
Canadian government on disarmament. He is seen
here in 1957 conferring with Israeli Chief of Staff Maj.
Gen. Moshe Dayan *(right)*. At the time, Burns was
Chief of Command of the U.N. Emergency Force.
The two men discussed plans for Israeli withdrawal
from the Gaza Strip and for U.N. peacekeeping
forces to move in.

(Right) In mid-June of 1951, days before Korean
peace talks are proposed, and yet two years before
fighting came to an end, a comrade-in-arms helps a
wounded Canadian soldier to a medic tent behind
the front lines. Approximately twenty-five thousand
Canadian army and navy personnel fought with
U.N. forces to protect the Republic of Korea against
invading North Korean forces.

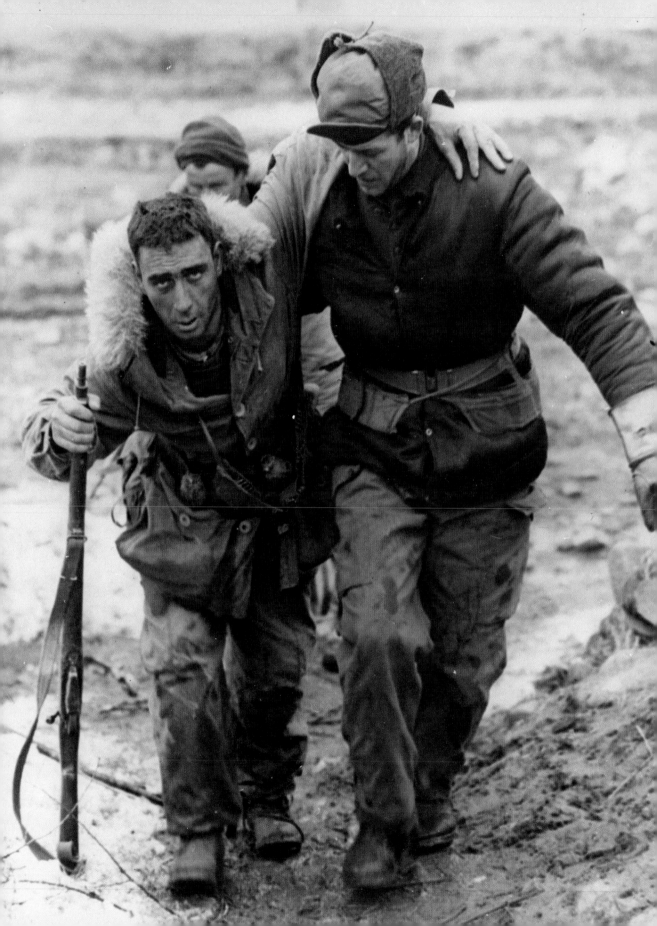

LISA MOORE

THE WAR

MACHINE

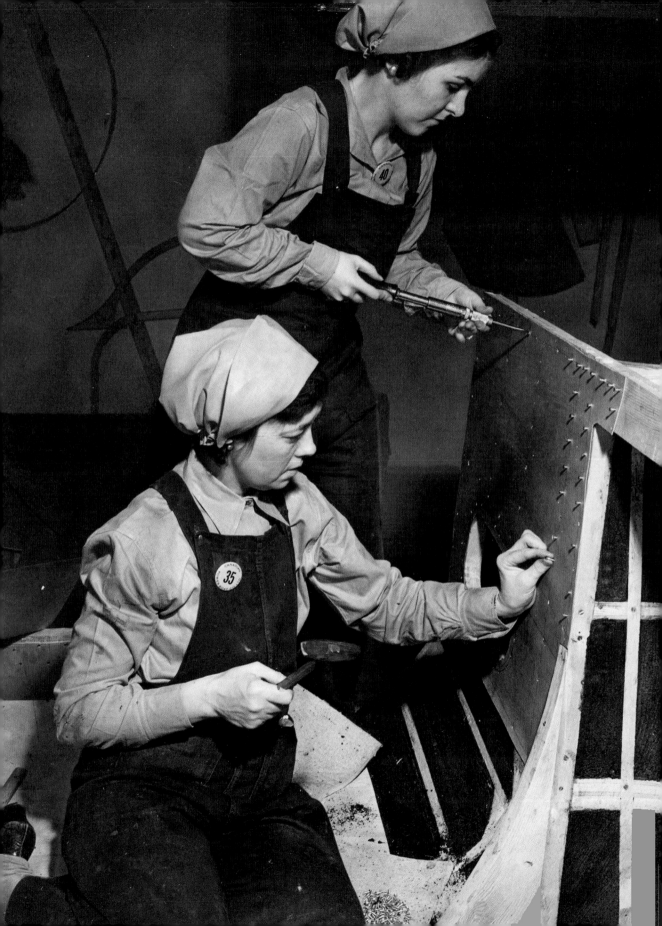

THEY ARE YOUNG AND ATTRACTIVE, DARK HAIR SPILLING
FROM BENEATH THEIR KERCHIEFS, DARK EYEBROWS CURVING
UPWARD AT THE TEMPLE. THEY LOOK ENOUGH ALIKE
THAT THEY MIGHT BE SISTERS.

THE FLOOR OF A CANADIAN munitions factory is crowded with young women in sturdy, button-down white smocks and kerchiefs that are knotted neatly on the tops of their heads. (See opening image in red on pages 64–65.) Most of the women sit at rows of double-sided wooden cubicles, facing each other, their eyes downcast. They are engaged in their work, producing propellants of quick-fire cordite, to be used in heavy-calibre land and naval gun shells.

One of the young women, in the middle of the floor, has abandoned her desk, stopping to share a joke with her co-worker. She is smiling broadly or laughing. In the far corner of the room, three or four women have turned abruptly from their stations. Something at the front of the room has caught their attention. Though they are out of focus and obscured by shadow, these women are the only subjects in the photograph to engage the viewer directly.

The two women in the foreground of the photograph are the real subjects of the image. They are young and attractive, dark hair spilling from beneath their kerchiefs, dark eyebrows curving upward at the temple. They look enough alike that they might be sisters. They are busy slipping explosives into specially prepared silk bags.

The woman on the left stretches over the table in front of her, reaching for an igniter. She does not engage the camera, but there is something in her expression that suggests she is aware of it. She is almost smiling, or trying not to smile; her glance flits to the side, self-conscious and knowing.

There is a cloistered austerity in the stiff, clean uniforms the women wear. How strange it is, now, to see the thorough gender division evident here, row upon row of young women working together, without the presence of a single man. The cartridges

The war brought new demands on Canadian women. Here, two women use plywood to insulate a motor torpedo boat frame in Montreal, 1941.

these women are constructing are about the size of a loaf of bread or a round of bologna, and the silk casings—silk being one of the few materials that burns without leaving the residue that is a fire hazard—seems too delicate and feminine a fabric, associated as it is with intimate undergarments or lavish evening gowns, and it is a strangely incongruous material for the crude and destructive weaponry the women are assembling.

To the right of the woman arranging the propellants on the table, the other young woman has just tied a ribbon on one of the silk bags encasing a cartridge. She has been caught, perhaps accidentally, in a moment of circumspection. She has finished preparing this particular bomb and her hands rest on it; her expression is soft and a little lost. In some ways this look of interiority is a key opening all these archival images for contemporary viewers.

In the cheerful and well-lit explosives factory, only this young woman's face hints at the gravity of the handiwork in which she and her co-workers are engaged. Her lost expression provides the only authentic entry point into the subtly manipulative image; her look hints at the devastation these bombs are designed to create. We are reminded of why men are absent. They have gone overseas to fight; they may kill or be killed, blown apart by such bombs, stabbed by bayonets like the ones featured in the training photographs, or shot through with bullets.

There is a peculiar atmosphere of innocence throughout these archival photographs depicting Canadians preparing for the war overseas. This innocence may be purposefully fashioned by the American lens, a comment on Canadianness, or it may simply be a result of the distance from the front evident here. The war must have seemed a long way away.

The photograph of the young female workers in the explosives factory was taken on March 25, 1942. None of the young women in this photograph could have imagined the horror to be unleashed over Hiroshima or Nagasaki in the near future.

THERE IS A PECULIAR ATMOSPHERE OF INNOCENCE
THROUGHOUT THESE ARCHIVAL PHOTOGRAPHS DEPICTING
CANADIANS PREPARING FOR THE WAR OVERSEAS.

Instead there seems to be suspension of disbelief, throughout the archival collection, concerning the explosives, bayonets, gas masks, rifles, and uniforms on proud display. There is an earnest, put-on optimism about the allied efforts; a conspicuous absence of anxiety pervades.

The young women in the explosives factory are content, in this photograph, as are the soldiers in other photographs here, to participate in a kind of theatre, a propaganda effort, crafting patriotism and Canadian identity through the power of the image.

Perhaps it is the contemporary viewer who can't help but imbue any propagandistic archival image, such as these, with a certain innocence. Knowing what has happened over the interceding years stains each image with a visual irony as jaundiced as sepia. The past always seems complete in such a photograph, a finished moment without the open, endless possibility of the present or the future. The images try for spontaneity, the subjects attempt to appear energetic and ready, available and unafraid, but it's impossible for the contemporary viewer not to read the earnest camaraderie, brave faces, and faux objectivity of newspaper reportage turned propaganda as profoundly naive.

The young men and women shown here have not experienced public surveillance cameras, cellphone photos, and Facebook. They are not accustomed to the constant digital recording of daily life, and wear an uneasy attitude toward the camera, even as they pretend not to notice it. The formal elements of the photographs, the coy refusal of the subjects to engage the viewer, the blocking in group shots designed to suggest a casual gathering, the lighting crafted to appear natural, the half-posed work postures—all of this seems prim and old-fashioned when one considers the casual horror and shock inflicted by more modern images of war, such as the deadening ubiquity of those snapshots of torture from Abu Ghraib, Iraq.

The weapons built and employed in these photographs are handcrafted and blunt.

They are human in scale, easily hefted to the shoulder or carried under the arm. They bring these soldiers face to face with the enemy. The war in these photographs will be fought on the ground, or closer to the ground, the targets are smaller in scope, also more human in scale—and yet there are hints of what's to come: the rows and rows of gas masks that suggest the mass and faceless destruction future technology will make possible. In view of the weapons to come—nuclear bombs, robotics, men and women in the Nevada desert operating drones on computer screens resembling video games, triggering weaponry via satellite—the bayonets and cordite cartridges wrapped in silk shown in these images cannot but appear quaint. The faith that the men and women shown here hold in these weapons can frighten the contemporary viewer.

What the viewer must look for in these carefully staged images are the expressions of self-consciousness or the accidental confrontation of the viewer, moments of disengagement, an interiority, or turning away from the crowd, unexpected hilarity or loss. Those moments when the subject glances through the layers of years and the archival dust, the sophisticated craft of propaganda, to address the viewer with a knowing look or a question: how will this all turn out?

(Opposite) In Montreal in 1917, women take over the jobs of men at the car shops of the Canadian Pacific Railway.

Overleaf (left): Women gather around a commanding officer who teaches them how to ride a motorcycle in November of 1940. *(Right)* Members of the Princess Patricia's Light Infantry set sail from Victoria for France in November of 1939—three months after Britain and France declared war on Germany, and two months after Canada did. Canada's entry marked the country's first independent declaration of war.

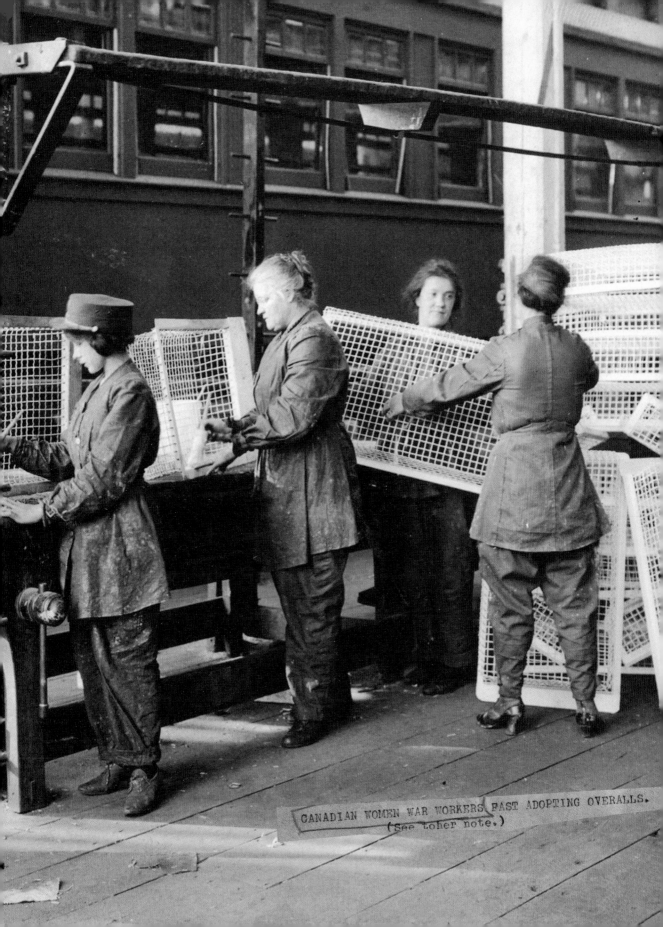

CANADIAN WOMEN WAR WORKERS FAST ADOPTING OVERALLS.
(See toher note.)

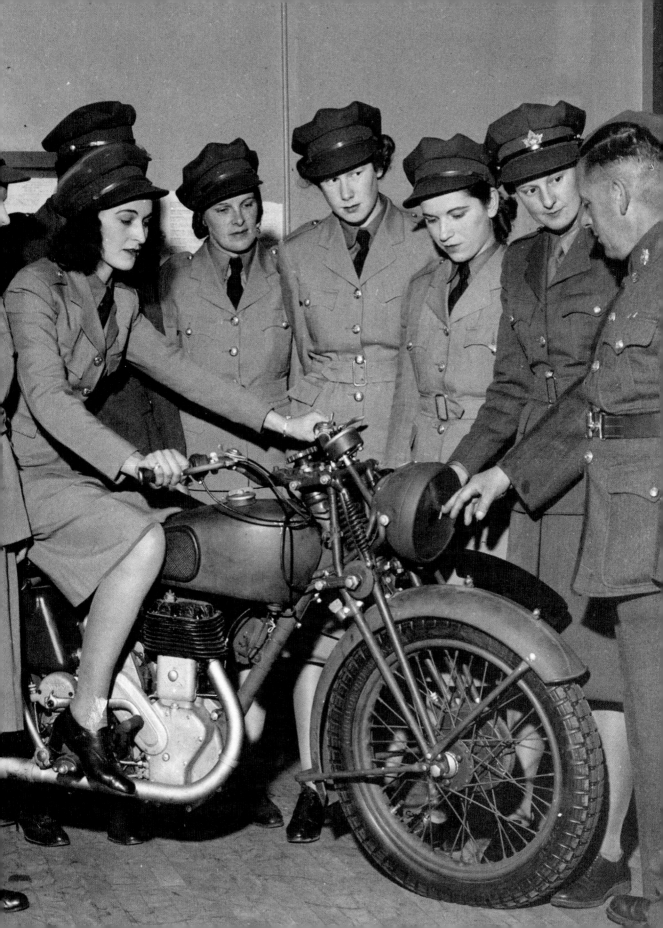

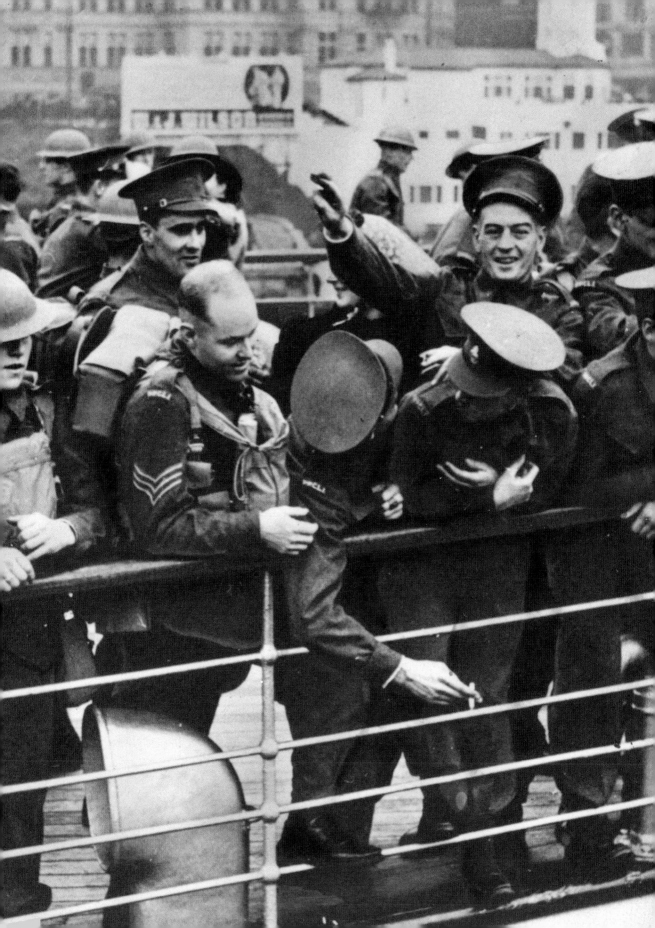

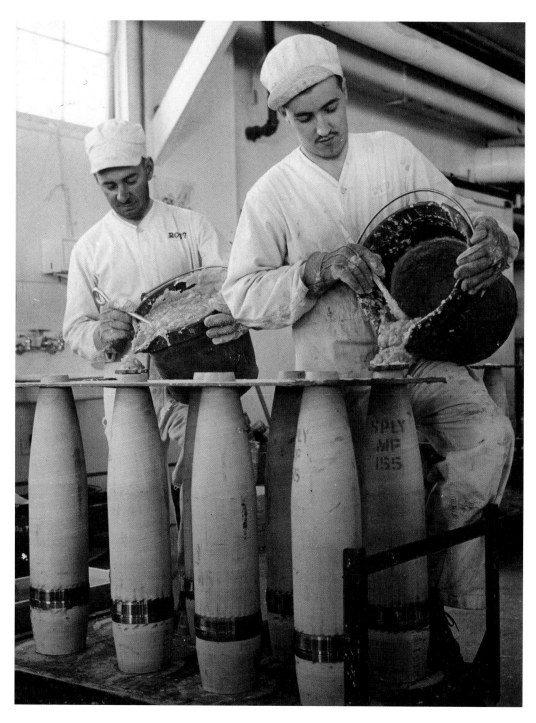

Two men carefully pour TNT into heavy shells for the war effort in March 1942.

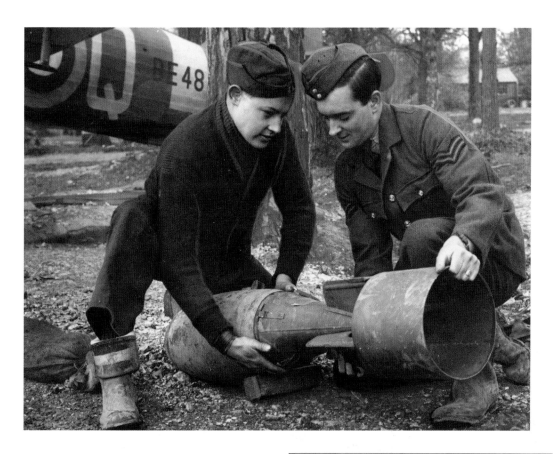

(Above) Soldiers fasten a tail fin to the body of a bomb before loading it onto a plane in 1942. Used frequently by the British and American armies as well as the Canadian forces, the shell of the bomb could be filled with white phosphorus. In 1980, these incendiary weapons, designed to start fires, were banned by countries that had signed the United Nations Convention on Certain Conventional Weapons.

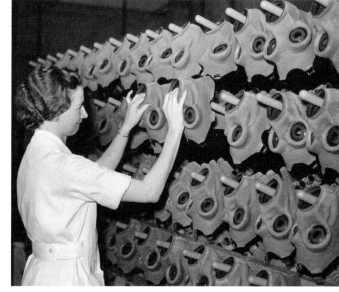

Headpieces for gas masks hang in rows at a munitions factory in 1940. The masks were then fitted with eyepieces, mouthpieces, and other parts to protect the soldiers.

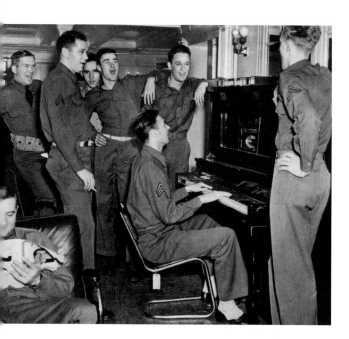

(Above) At a Newfoundland army base in 1941, a
group of American and Canadian soldiers gathers
around a piano.

The National Resources Mobilization Act was
enacted to increase military productivity both in
Canada and abroad. Under the act, more than
150,000 men underwent training for defence duties.
This image depicts men awaiting induction at a
Chatham, Ontario, training centre.

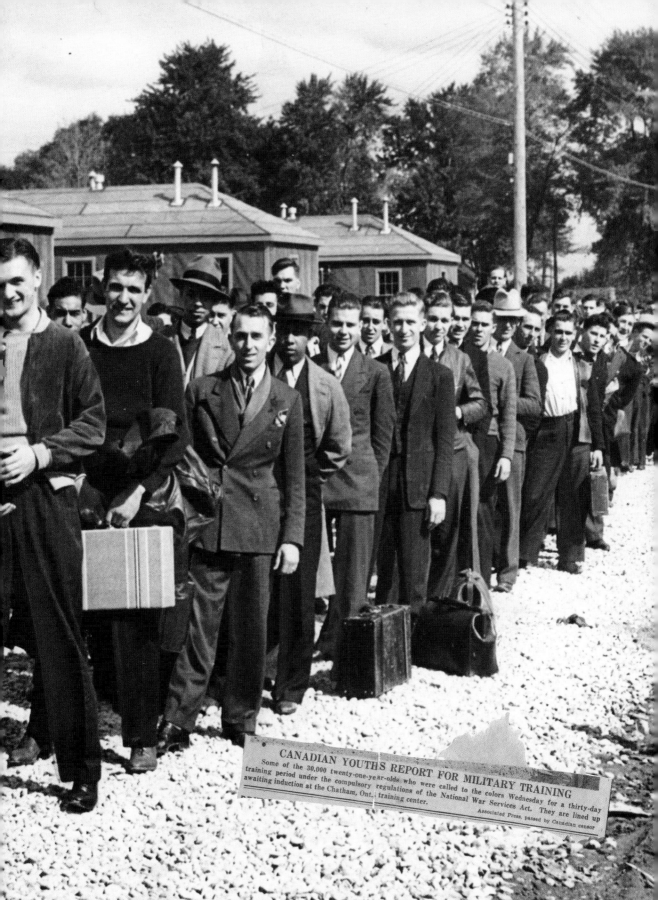

PETER C. NEWMAN

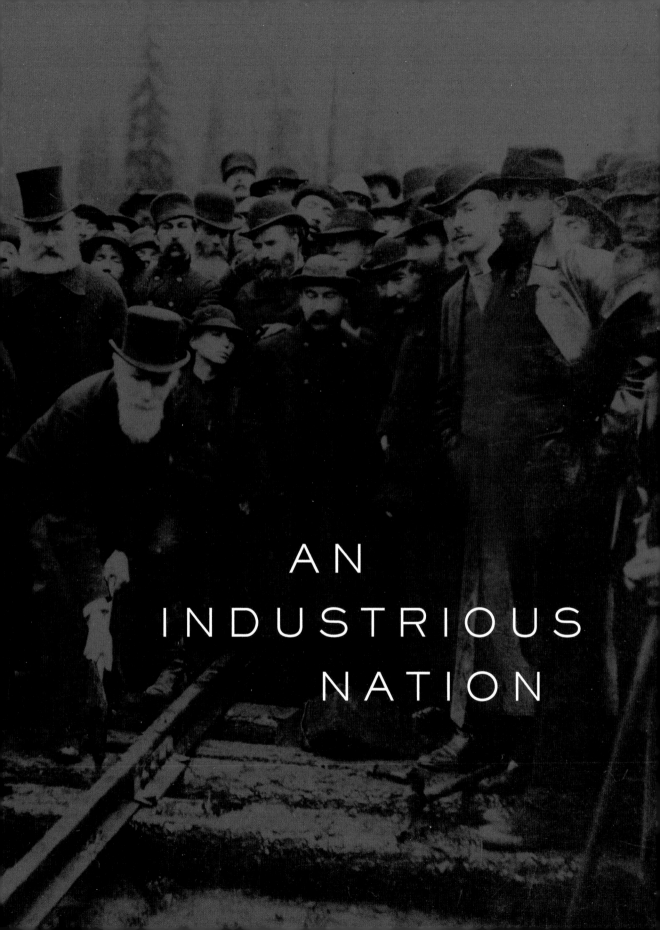

AN
INDUSTRIOUS
NATION

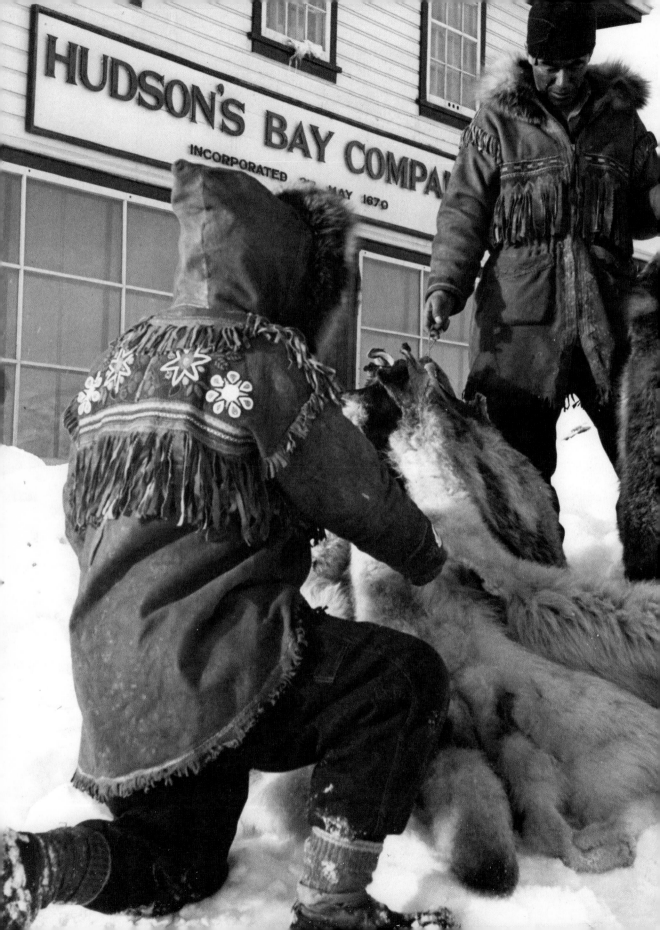

A S A WRITER OF CREATIVE non-fiction, I try to make facts dance, to describe "felt life," operating at the edge of literacy where facts and feelings meet. When I was asked to make a selection of snapshots of Canadian industry from *The New York Times* archives and provide an essay to accompany them, I was happy to be commenting on my favourite medium. I judge my subjects not by what they say but by their body language. Why? It's the only language that doesn't lie. And that's equally true for pictures such as those that follow.

The first shot I chose is the defining photograph of Canada coming of age by connecting its coasts with ribbons of steel—the Last Spike. Here was Canada, a new Dominion in the making, still bearing the oxymoronic title of a "self-governing colony." In this iconic photo, Montreal financier Donald Smith is the gentleman wearing the stovepipe hat, hammering into place the final spike of the Canadian Pacific Railway (it took two tries), at Craigellachie,

in the Monashee Mountains, on November 7, 1885. A taciturn Scot, he typically said nothing to mark the ceremony. It was the train's anonymous conductor who best caught the spirit of the occasion, when, at the end of the ceremony, he swung aboard the passenger coach, shouting, "All aboard for the Pacific!"

Six days later, Louis Riel was hanged in Regina, which unintentionally opened the West for peaceful settlement. (A compelling rebel in a nation of cloying conformists, Riel became the model Canadian martyr: a deluded mystic who died prematurely by pretending to be sane.) The CPR quickly became a hated symbol of Eastern influence across the West. A typical story of the time goes like this: A farmer returns home to find that his wife has run off with the hired man,

PUBLISHED IN N
FINANCIAL
MARCH 29, 1987

In the late 1940s, trappers in Manitoba arrive at a Hudson's Bay Company outlet with wolf and fox pelts.

THEIR LIFE FORCE WAS EXPRESSED LESS IN WORDS
THAN IN DEEDS—THE COMPASSION AND HUMOUR
THEY FELT FOR ONE ANOTHER WHEN THERE WAS
NOTHING ELSE AVAILABLE TO SHARE.

his crops have been destroyed by gophers, and the barn has burned down. Unable to deal with the triple tragedy, the farmer dashes up a hill overlooking the farm, waves his fist, and shouts, "Goddamn the CPR!"

Long before the railways tamed the West, most of Canada was a game preserve owned by the Hudson's Bay Company. A humungous land grant from King Charles II of England in 1670 meant the Hudson's Bay Company owned one-twelfth of the world's earth surface. Its territory included nearly a thousand "forts," which were really trading posts where native trappers came to exchange pelts for rifles, cooking pots, blankets, and other amenities. Through the polished-brass telescope of imperial history, the HBC appears as a majestic, fiercely patrician enterprise. But for the generations of fur traders on the ground, the reality was often harsh and disillusioning. The HBC dominated their lives—and understandably they had some fun making up new twists of what its initials stood for, such as the Hungry Belly Company.

Historians saluted its longevity by referring to it as being Here Before Christ. And native women dubbed it (and its traders) the Horny Boys' Club.

The next photo is a vision of plenty and the spontaneous blossoming of humanity caught in a moment's creative impulse. The booming fisheries, as pictured (particularly cod), were everything to the Newfoundlanders, a truly great people. To be a Newfie is to be a survivor—not by trying to outlive others, but in an exhilarating, nose-thumbing sense of tempting the fates. Dash a people's dreams often enough and you eventually kill their culture, which has depended for its sustenance on perpetuating the way of life that gave it birth. Overfishing at one point not only threatened the livelihood of thirty thousand fishers and cannery workers but it signalled the end of a unique way of living. Their life force was expressed less in words than in deeds—the compassion and humour they felt for one another when there was nothing else available to share.

The life of fishers is almost as rough as

the daily existence of coal miners, depicted in a photo taken aboard a primitive commuters' train that took the afternoon shift of the Dominion Coal Company to work at levels deep under the Atlantic Ocean at New Waterford, Nova Scotia. At the moment, more than three hundred thousand Canadians are employed across the country in mineral extraction and processing, which makes the industry worth about $85 billion a year. But mining also has $137 billion worth of future investment on its books and will be creating a hundred thousand new jobs over the next decade. That will make mining the country's largest industry.

A very different style of mining the earth's bounty is depicted in a photo of the Syncrude tar deposit near Fort McMurray, in northern Alberta. A patch of the most valuable acreage in the country, the oil sands evoke the most polarizing arguments about their environmental impact. Dead ducks can't testify, but the fact that so many died drinking local effluent speaks for itself. Similarly, the arsenic content in local moose is so high they are no longer edible. The sands' oil reserves top 180 billion barrels, covering thirty-seven of Alberta's townships. It's a long way from the historical application of the valued deposits. The gooey substance was first used to plug leaks in birchbark canoes.

It was once the dream of adventurous young Canadians to go north. *There was gold in them thar hills.* Now reduced to a permanent population of barely over a thousand, during the 1898 Gold Rush, Dawson City's headcount of would-be prospectors topped forty thousand. The photograph is of the Palace Grand Theatre, restored by the federal government, featuring *The Gaslight Follies*—with two of the troupers on view. Pierre Berton, Jack London, and Robert Service immortalized Dawson City, which still advertises itself with a strange sign: "Welcome to the town of the city of Dawson."

South of the gold rush country, Canada's pulp and paper industry ranks as one of the world's major industrial enterprises, with

many of the world's newspaper pages printed daily on Canadian stock. In a photo taken in Hull, Quebec, near the Parliament Buildings, a sea of timber is being guided into a newsprint mill, one that belched smoke as part of the conversion process. At one point, that facility was owned and operated by a staunch Tory who instructed his mill crew to keep blowing smoke into Liberal prime minister Mackenzie King's eyes.

The thought of someone blowing smoke in Ottawa served to remind me of Sam Bronfman, the former bootlegger who spent a large fortune trying to rehabilitate his reputation by being named to the Canadian Senate. On July 28, 1955, when David Croll became the country's first Jewish senator, Bronfman slow-marched around his office, wailing something like, "It should have been mine! I bought it! I paid for it! Those treacherous bastards did me in." His brother Allan Bronfman, meanwhile, became vice-president of Seagram-Distillers Company, which distilled and marketed six hundred brands of liquor in 175 countries.

The Bronfmans led alluring lives in the warming glow of material comforts and the sense of grandeur that comes from feeling part of a historic succession.

Fortune magazine reported that "the Bronfman fortune rivals that of all but a small number of American families." But the dream fell apart. When Edgar Jr., grandson of the founding family, was handed the keys to the kingdom in 1984, he immediately switched its emphasis from profitable booze to the risky music business. He eventually sold Seagram's surviving bits to a French company that went bankrupt, and in 2011 Edgar Jr. himself was convicted of insider trading.

Insider trading brings to mind stock exchanges, and included in the images that follow is one of the few photos still extant of the Montreal Stock Exchange in its heyday. The city's St. James Street, once the chief metaphor of Canadian capitalism, suffered an ignominious decline, so much so that the exchange's original pillar-free trading floor was eventually converted into a theatre. The

shift to the Toronto Stock Exchange actually dated back to the staid Montreal attitude that only Dickens might have found contemporary. Trade in mining stock was considered a bit undignified. Financing the developing mineral riches of the Canadian Shield occurred almost entirely in Toronto, as did the trade in speculative wealth that followed. There are still remnants of the Old English families in parts of Westmount who believe that Toronto is a place where only vulgar money managers want to live and that what lies west of Toronto's Humber River is something no civilized person would ever want to contemplate.

The new Canada that emerged in the 1940s consisted largely of immigrants seeking new horizons. The most distinguished of these was Thomas Bata, who might have been better suited to be a cardinal in fourteenth-century Florence, distributing tithes, negotiating quotas, and punishing the heretics. He possessed a powerful personal presence, which he needed to run his footwear-manufacturing empire that employed eighty-five thousand, included five thousand retail outlets, and turned out 350 million pairs of shoes annually. Now headed by Tom's capable widow, Sonja, the company has abandoned Canada but retains 4,600 stores in sixty-eight countries. with annual sales of $3 billion.

This flash overview of a few photographs of Canadian industry as seen by *The New York Times* says as much about the photographers who took them as it does about Canada. But that's the tragic fate of a people who live in a continent's attic. Down there in the good ol' US of A, they only hear us when we make noise. So if there is a message to impart, about industry or about us, it's that to be heard, and for us to count, we need to make much more noise.

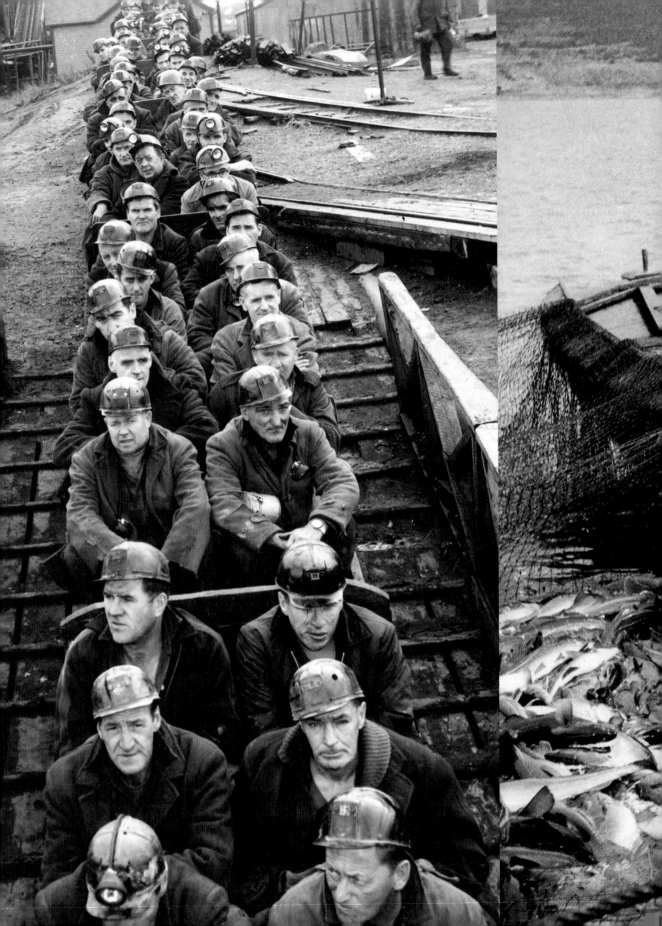

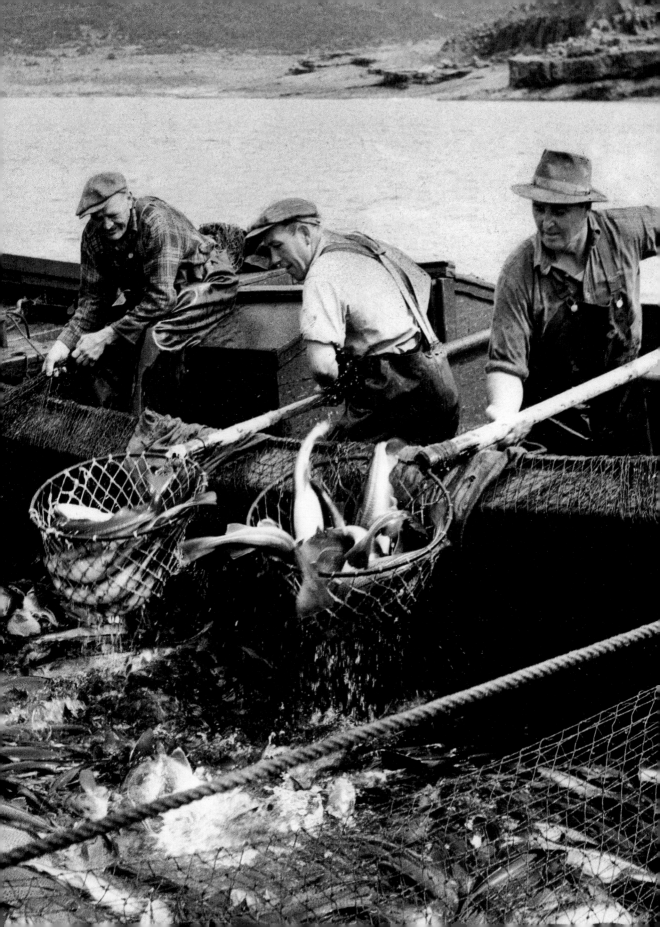

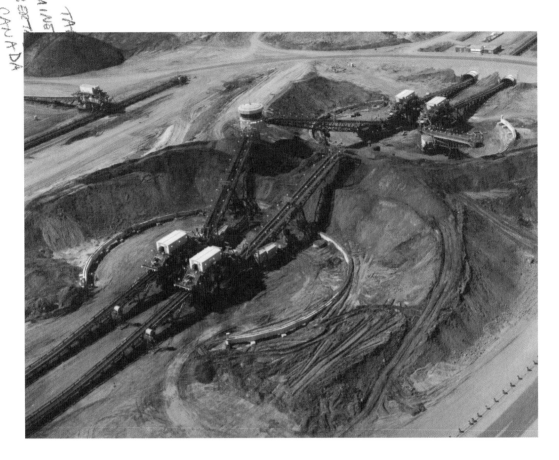

Preceding Page (left): This miners' commuter train—also called a man rake—takes workers under the Atlantic Ocean to mine for the Dominion Coal Company in October of 1966, in New Waterford, Nova Scotia. *(Right)* Off the coast of Newfoundland in 1968, fishers remove cod from traps set close to the shore. That year was the peak of the cod fishing industry, as fishers caught more than eight hundred thousand tons of cod. The industry slowed over the coming decades, and then collapsed in the 1990s because of overfishing.

(Above) Syncrude Canada's tar sands in Alberta, 1979.

(Opposite) Hostesses pose outside the Palace Grand Theatre in Dawson City, Yukon, in 1966. The two plaques that frame the door commemorate the Canadian government's help in refurbishing the theatre, as well as its historical significance.

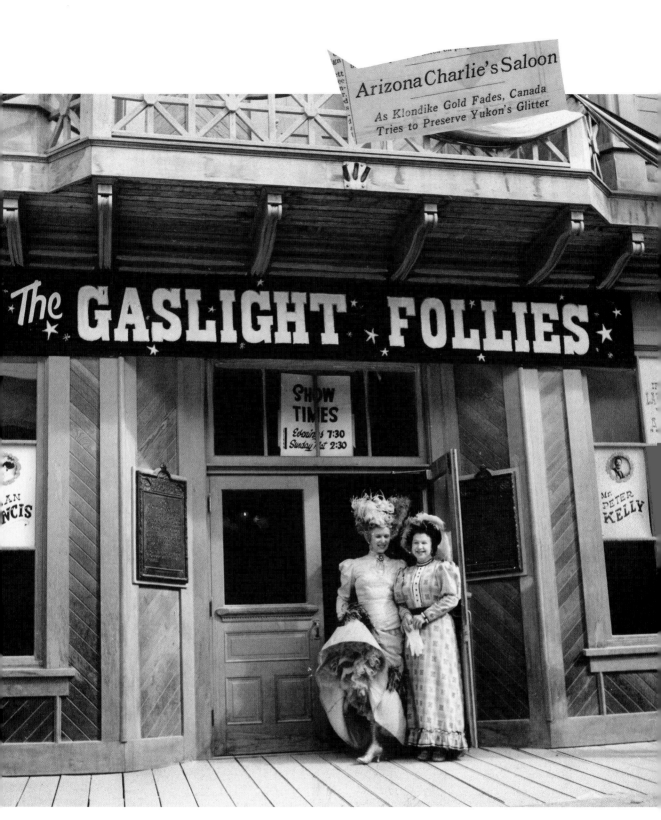

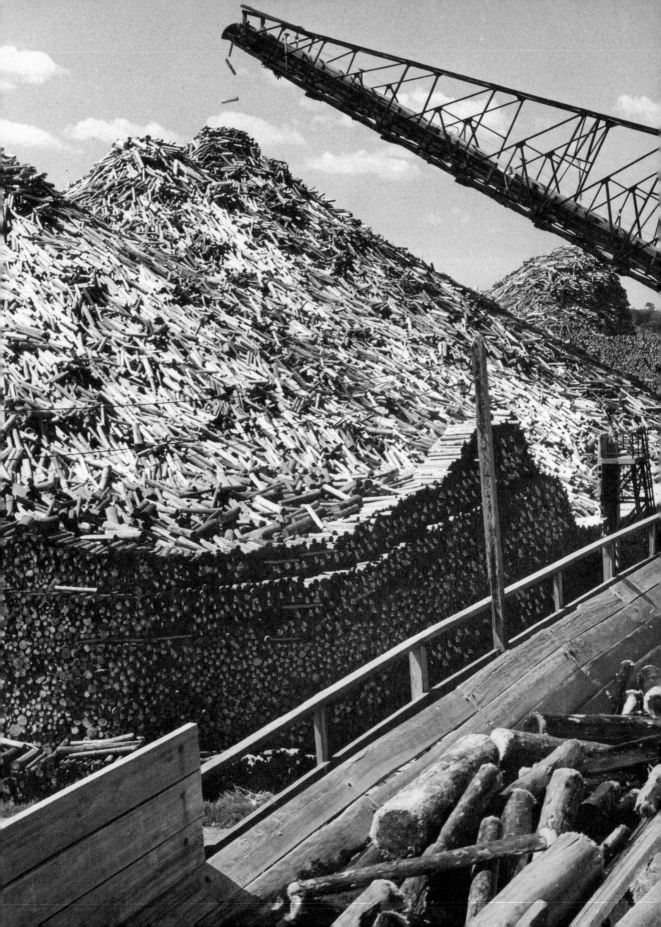

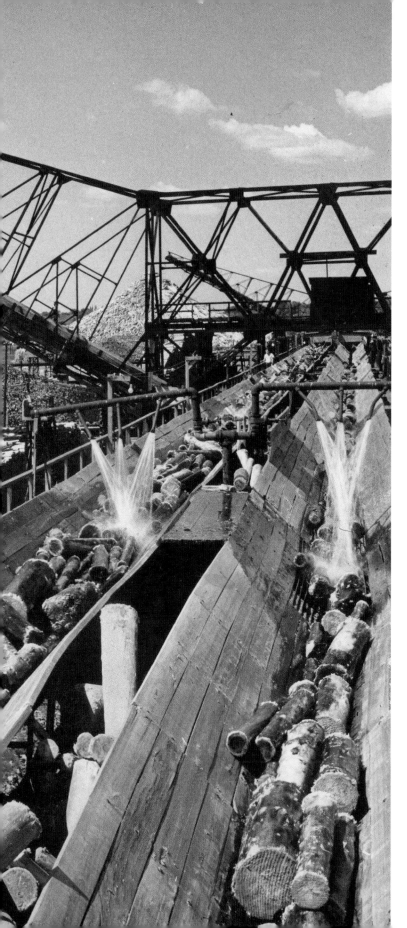

Logs are fed through chutes in a paper mill in Hull, Quebec, in 1956. They were then converted into pulp and paper.

Allan Bronfman, vice-president of
Seagram Distillers, in 1955.

Thomas Bata in 1941. At that time, Bata was the
largest shoe manufacturer in Europe.

The Montreal Stock Exchange, 1962.

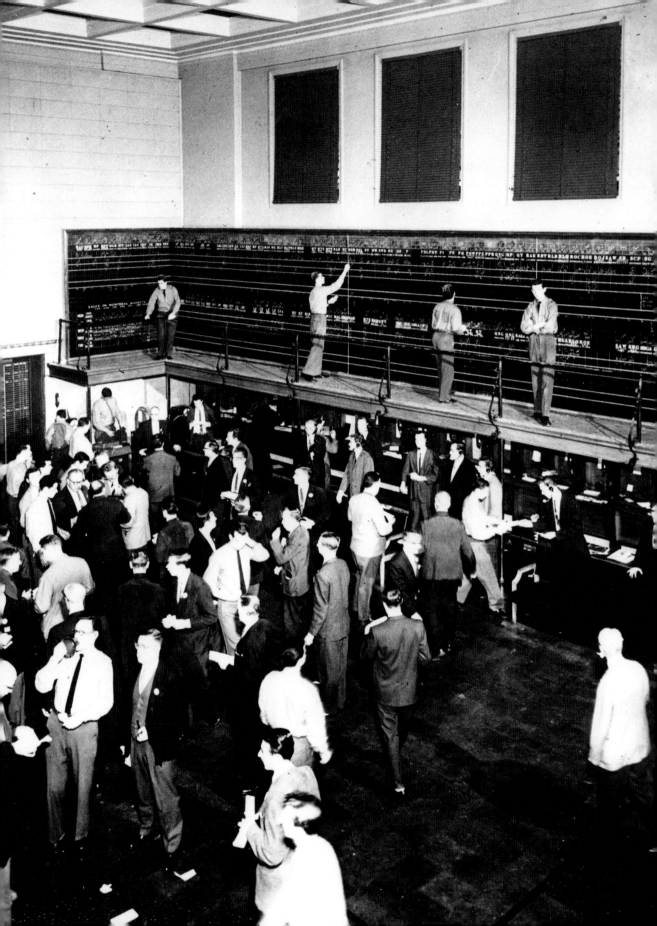

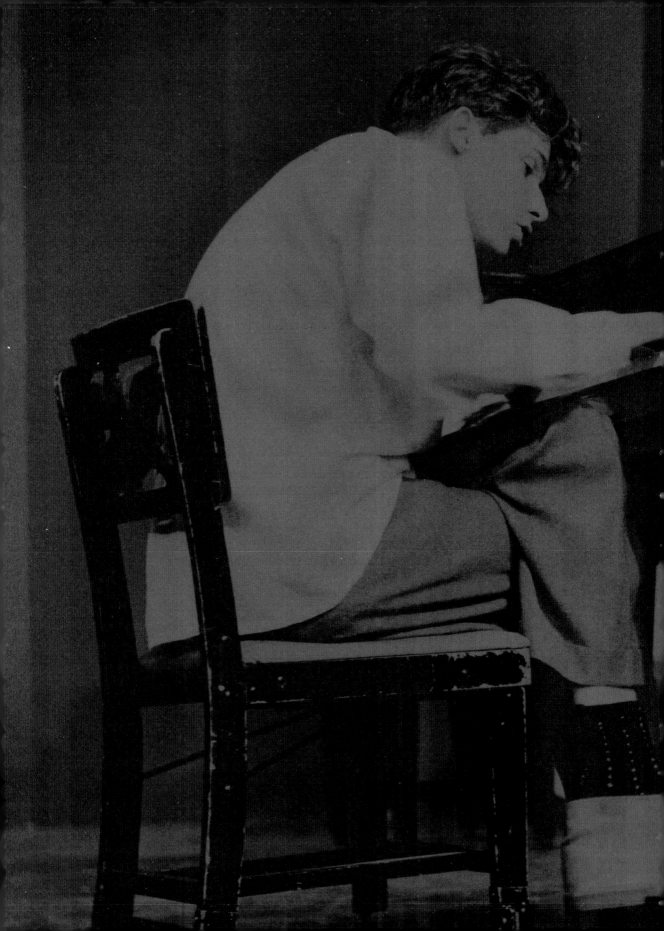

JOHN FRASER

ICONS

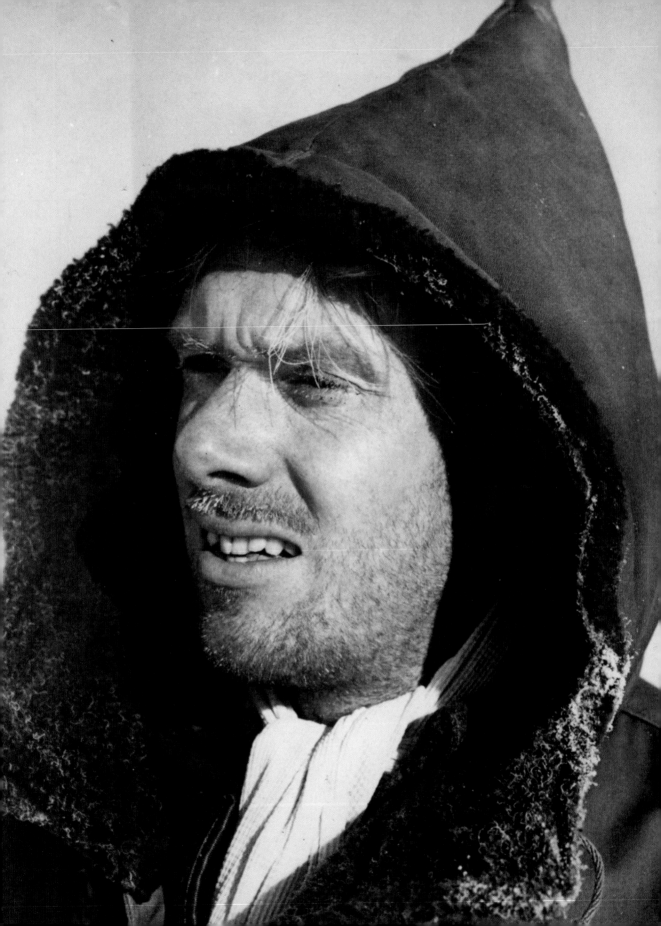

WHAT IS A CANADIAN ICON? In the pages of *The New York Times*, he or she is a pretty colourful figure, eccentric perhaps, definitely talented, and very creative in a quirky way, possibly royal, edgy too—and definitely cold.

Really cold.

Not cold in personality, just *cold*! Canada cold. The picture of Pierre Berton sends the thermometer shooting down well below zero centigrade. You can see the cold swooshing up his nostrils, berating his brow at the edges of his frost-limned parka hood. A man in his element.

But let's not stop with the obvious. Look at the under-jacket pullover Robertson Davies is wearing in his study; the heavy overcoat Stephen Leacock has kept on, even at his desk; the wool cape around Margaret Atwood's shoulders in the hallway of her hotel room; the heavy fleece dressing gown keeping Karen Kain from a chill in her ballet company dressing room; the steaming radiator immediately beside Marshall McLuhan's chaise longue, warming his bony frame. My god, even Queen Elizabeth, consort of King George VI, had her ermine stole to keep her shoulders warm in Montreal, and when the royal couple's eldest daughter and heir apparent, Princess Elizabeth, was in Canada square-dancing in 1951, she was outfitted in a heavy felt-wool poodle skirt. *Chacun à son goût froideur!*

The photographs of royalty in Canada are one of the big surprises to come from *The New York Times* archives. There are pictures of three generations, and, with the notable exception of the square-dancing shot of Elizabeth on the dance floor at Rideau Hall,

Well-known television personality and journalist Pierre Berton was an accomplished storyteller and one of Canada's most prolific and popular authors. He wrote fifty books, many about Canadiana and Canadian history. Berton is shown here while researching *The Mysterious North: Encounters with the Canadian Frontier, 1947–1954*, which went on to win the Governor General's Literary Award in 1956.

many of the images are not widely known in Canada. They don't figure in Canadian iconography, although they deserve to. The truly amusing image is of King George VI and Queen Elizabeth signing the guest book at Montreal's city hall. This is everyday work for sovereigns and their consorts, but take a second look at the host. This is Camillien Houde, four-time mayor of Montreal, decked out for his sovereign like a battle-ship, dripping in his chain of office, neck decorations, and anything else he can pin to his chest. You can't make the look of pride any prouder than that!

The biggest surprise was to see how much King George's older brother had woven himself into the very fabric of Canada. This is the beloved and wholly wonderful Edward, Prince of Wales (1894–1936), who became the disgraced and contemptible Duke of Windsor (1936–1972) after eleven months as the troubled King Edward VIII (January 20 to December 11, 1936).

It's lost history, miraculously revived in these old photos. Edward bought a ranch in Alberta in the 1920s, which he adored. He wrote his father, King George V, that he worked all day long at tedious jobs, from pitching hay to herding cattle. He did it with born-again vigour, and the very ordinariness of it made it hugely wonderful to him. At the time, it was the only property he actually owned in his own name, and he proudly ate with the farmhands in the ranch house.

Elsewhere, you can see the idol-prince in the Canadian wilderness, rifle across canoe thwarts. And there he is again, inspecting his beloved Quebec regiment, the Royal 22ᵉ Régiment (the famous Van Doos) in Quebec City, clad in tartan jodhpurs—Scotland, India, Canada in one amazing royal package. And then he is on the streets of Montreal in front of the Mount Royal Hotel, looking like the snappiest boulevardier in town. Damn that wicked Wallis Simpson anyway: she hated the farm in Alberta and robbed us of a sovereign who loved us at almost every corner of the Dominion.

Apart from the cold, the other leitmotif of

IT'S LOST HISTORY, MIRACULOUSLY REVIVED

IN THESE OLD PHOTOS.

the Canadian iconic figures I appreciated most was the distinctive hands and the roles they play. We all have hands, of course, but hands caught out in photographs tell you lots of things. The ease with which Stephen Leacock smiles for the camera is reinforced by the "at ease" posture of his hands: one upon his writing; the other, pen at the ready. The young Mordecai Richler's amanuensis—his perpetual cigarillo—is also at hand. Mary Pickford's entire subdued eroticism (well, for 1924) is entirely supported by her buttressing arms and sturdy hands. Robertson Davies proffers his latest book with hands that brook no refusals, and Margaret Atwood's proud and just slightly impish smile is completely underscored and reinforced by the rigour and determination of her directed hand.

On and on it goes: Karen Kain contemplates yet another ballerina tiara with insouciance and an uncommitted hand; First World War air ace and Victoria Cross–holder Billy Bishop sits humbly beside a war-recruitment poster featuring himself, the poster drawing martial, the war hero looking humble, with hands meekly crossed to offer not a hint of his steely courage.

Most of all, there are Glenn Gould's hands. On the piano, exactly where they should be. Young Gould in 1955, aged twenty-three, legs crossed, one Clarks desert boot on the damper pedal and the other almost mid-flight, playing Bach's *Goldberg Variations* for Columbia Records, a disc that shot him to worldwide fame that never left him. And then, twenty-seven years later in 1982, recording the *Goldberg Variations* again just weeks before his ridiculously early death at fifty, his left hand mid-flight this time, possibly en route to join Johann Sebastian. These are as haunting as any of the pictures in the archives.

The bric-a-brac is also fun in these photos, none more so than in Marshall McLuhan's study. The giant photograph of beat poet Allen Ginsberg hanging from his bookshelves bespeaks a sixties moment in time. Perhaps McLuhan liked Ginsberg's "global village" reach. Whatever. The iconic,

99

gay, Jewish Ginsberg seems a strange choice for this maverick Canadian icon of contemporary culture who tried to tie his devout Roman Catholicism to his eclectic universal gaze, while keeping lots of caffeine brewing on his serious coffee maker, just beside the carton of Gallo Vineyards, empty of its hooch but holding . . . papers that, as the box suggests, taste "as good as it gets"! And finally, the suspenders imply a man who doesn't take chances and knows to keep at least one foot firmly planted on the ground.

There's our basic image: deep in thought, carefully and safely grounded, and clinging to the warmth of a radiator.

In this photo, the celebrated and revered Canadian author Robertson Davies, founding master of Massey College (1963–1981) at the University of Toronto, proffers his latest work of fiction, the concluding novel to *The Cornish Trilogy*, published in 1988.

CAPTION INFORMATION (Photographed for The New York Times)

DATE 12

SLUG ▶ ROBERTSON DAVIES SACK NO. ▶ 8

PHOTOGRAPHER ▶ ANGEL FRANCO REPORTER Yolanda

SECTION ▶ BOOK REVIEW GENERAL DESCRIPTION

NO. OF ROLLS ▶ 3

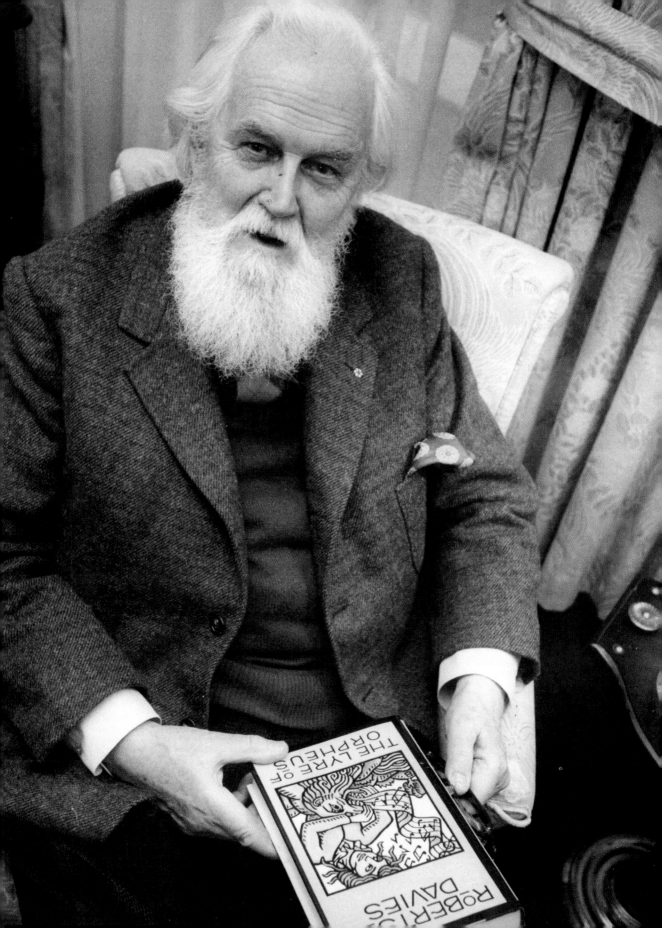

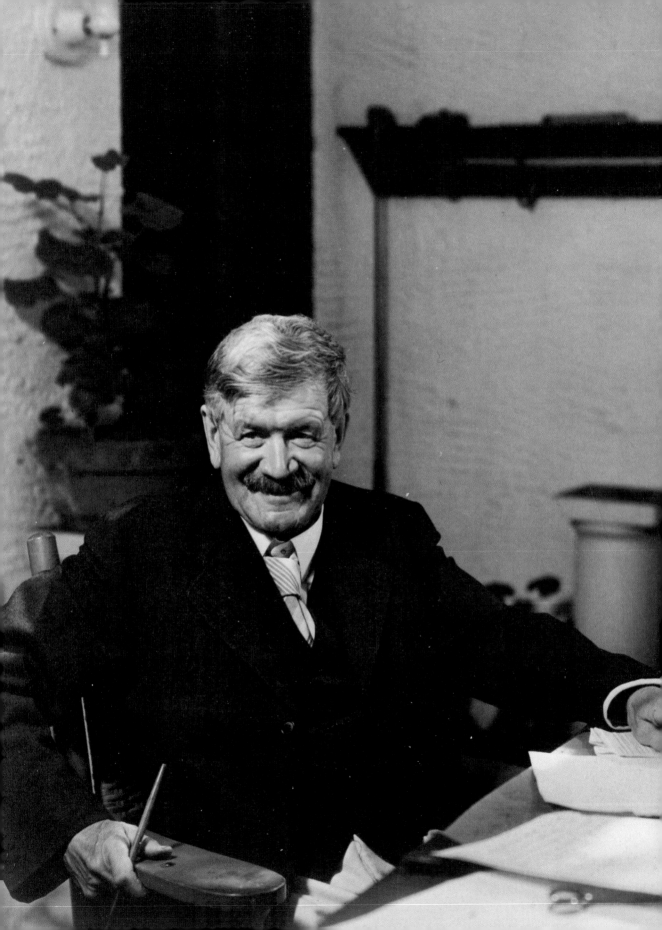

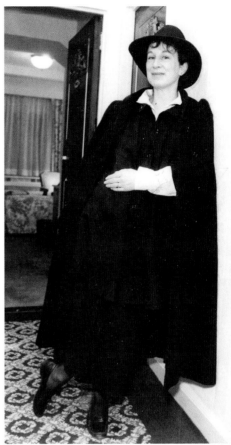

The celebrated Canadian novelist, poet, and essayist Margaret Atwood cuts a dashing figure as she enjoys the accolades and awards received for her "social science fiction" novel *The Handmaid's Tale* in January 1986.

Pictured here in his study in Orillia, Ontario, Stephen Leacock was one of the most popular humorists in the English-speaking world between the years 1915 and 1925.

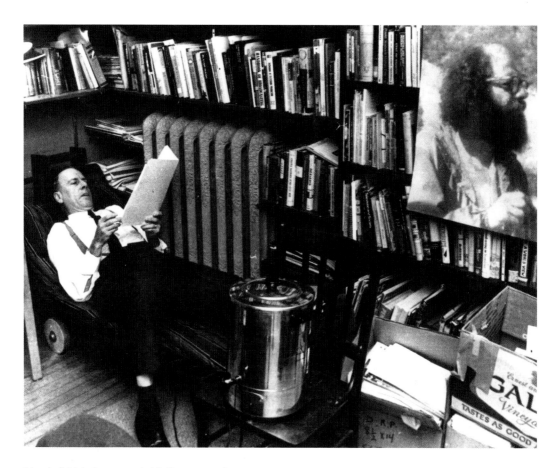

Marshall McLuhan, seen in his Toronto study.
Born in Edmonton, McLuhan grew up in
Winnipeg. In the 1960s, his work in media theory
spread around the globe.

In July of 1976, prima ballerina Karen Kain
prepares to go on stage with Rudolf Nureyev in
Sleeping Beauty at the Metropolitan Opera House
in New York.

BALLERINA

Left, the star dancer's legs were untaped after the performance.
Above: Karen Kain, the ballerina, preparing to put on costume.

105

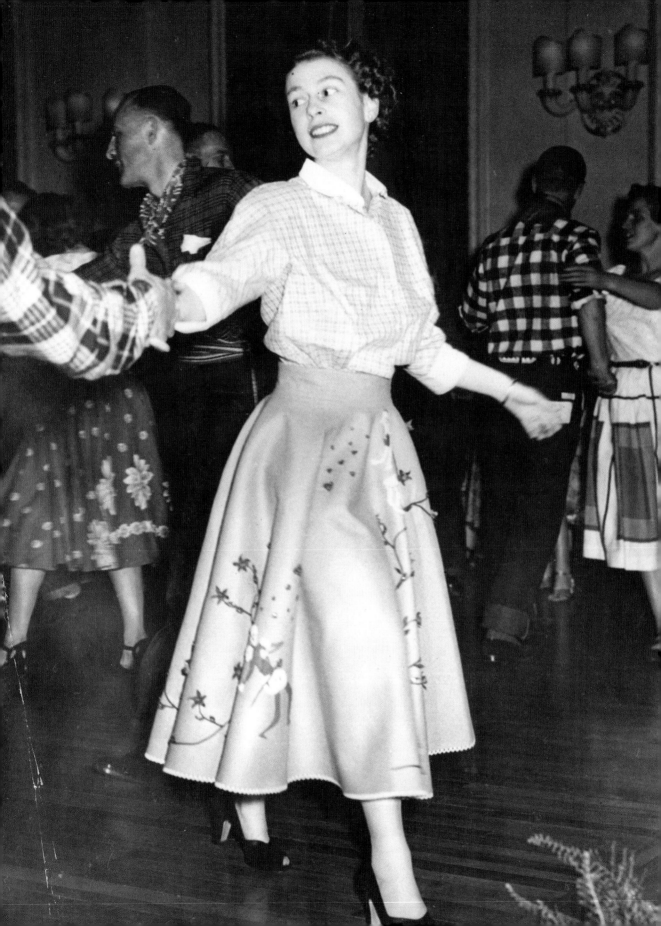

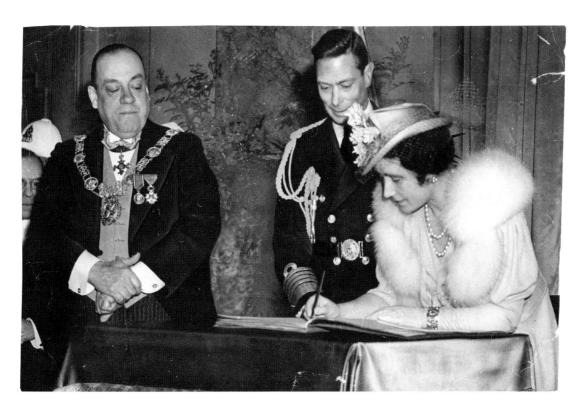

(Above) In May 1939, just before a British declaration of war against Nazi Germany, King George VI and Queen Elizabeth visited Canada. Stopping for a few hours in Montreal before travelling to Ottawa, they were photographed with Montreal Mayor Camillien Houde four months before his arrest on charges of sedition for his public support of fascism. Houde was released from a prisoner of war camp in 1944.

Three-and-a-half months before the death of her father, King George VI, brought her to the throne as Queen Elizabeth II, a young, carefree Princess Elizabeth enjoyed a tour of Canada, stopping at Government House in Ottawa, where she joined in some square-dancing. On the trip, her private secretary carried a draft accession speech for use if the King died while she was in Canada.

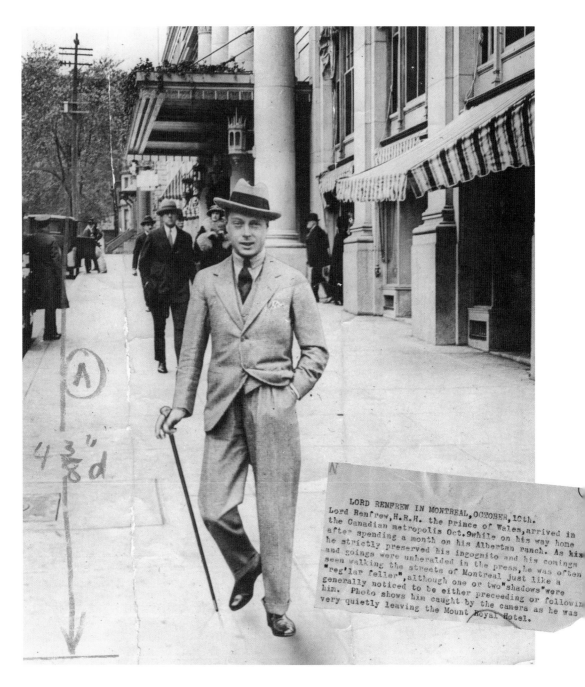

A jaunty Prince of Wales is seen walking along the sidewalk in front of the eleven-hundred-room
Mount Royal Hotel in Montreal. While at the hotel, the Prince was registered as Lord Renfrew,
a title he used when he wished to move about incognito.

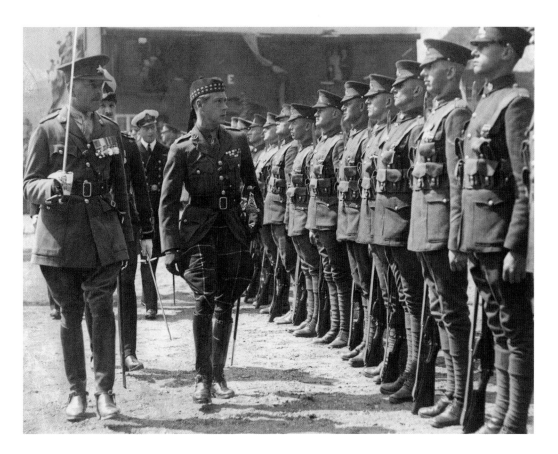

(Above) In Canada with his brother, Prince George, to help celebrate the country's sixtieth birthday in 1927, Edward, Prince of Wales, later King Edward VIII, inspects the Guard of Honour of the Royal 22nd Regiment in Quebec.

(Right) During his first official trip to Canada in 1919, Edward, Prince of Wales, purchased a ranch in Alberta and also fished along the Nipigon River in Ontario. Forty-three native guides, led by head guide Andrew Alexey (pictured in the stern), were there to assist the Prince and his entourage.

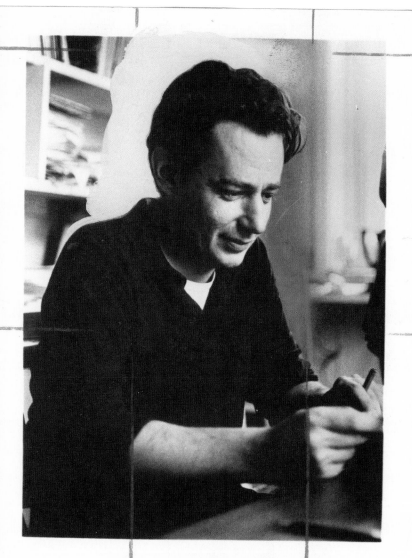

Credit: Fay Godwin

Mordecai Richler, author of COCKSURE, to be published by Simon and Schuster April 5, 1968 for $4.95.

Celebrated author and screenwriter Mordecai Richler is best known for *The Apprenticeship of Duddy Kravitz* and the Jacob Two-Two children's stories. His 1968 book, *Cocksure*, was declared obscene and banned by bookstores in Britain, Australia, New Zealand, and South Africa. More recently, it was selected in the 2006 Canada Reads competition, where it was championed by comedian Scott Thompson.

(*Right*) "America's Sweetheart," Canadian-born Mary Pickford was a silent-film actress who successfully transitioned to talkies and is considered one of the great film stars of all time. In 1932, she was among the first to help out at the Actors' Dinner Club, where out-of-work performers could get free meals during the Great Depression.

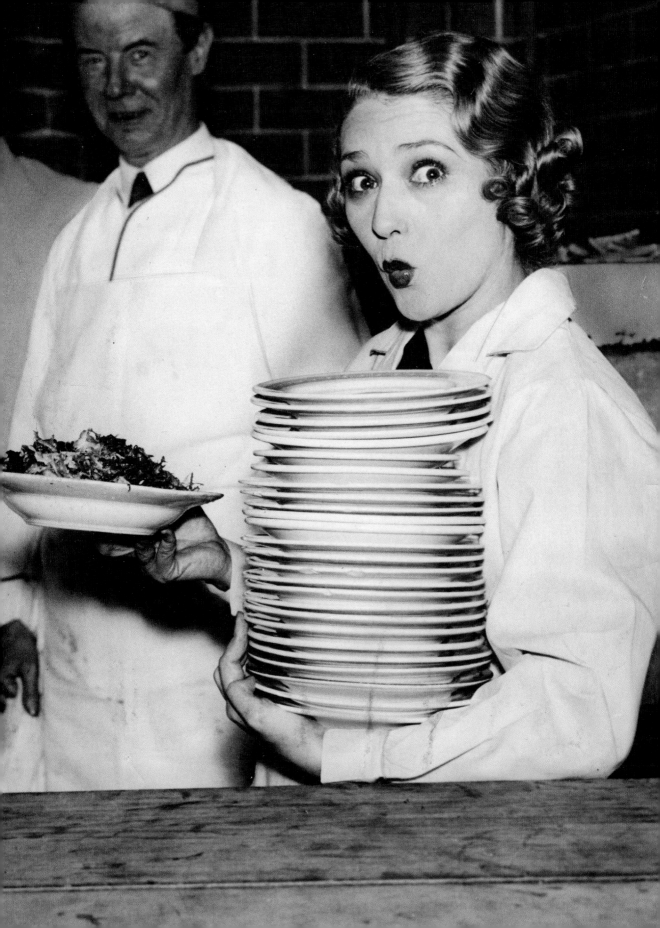

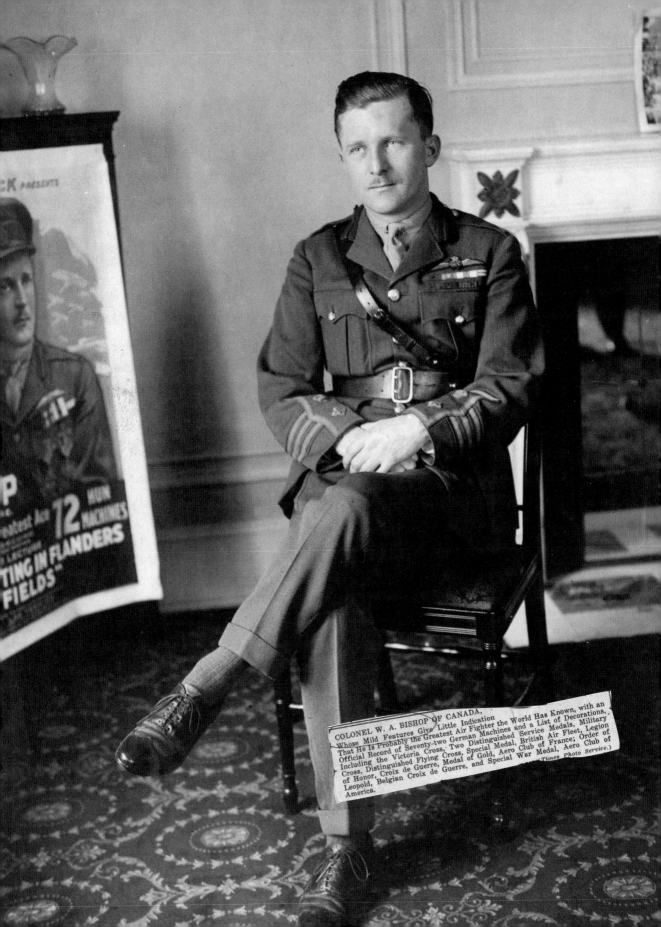

COLONEL W. A. BISHOP OF CANADA,
Whose Mild Features Give Little Indication
That He Is Probably the Greatest Air Fighter the World Has Known, with an
Official Record of Seventy-two German Machines and a List of Decorations,
Including the Victoria Cross, Two Distinguished Service Medals, Military
Cross, Distinguished Flying Cross, Special Medal, British Air Fleet, Legion
of Honor, Croix de Guerre, Medal of Gold, Aero Club of France; Order of
Leopold, Belgian Croix de Guerre, and Special War Medal, Aero Club of
America.
(Times Photo Service.)

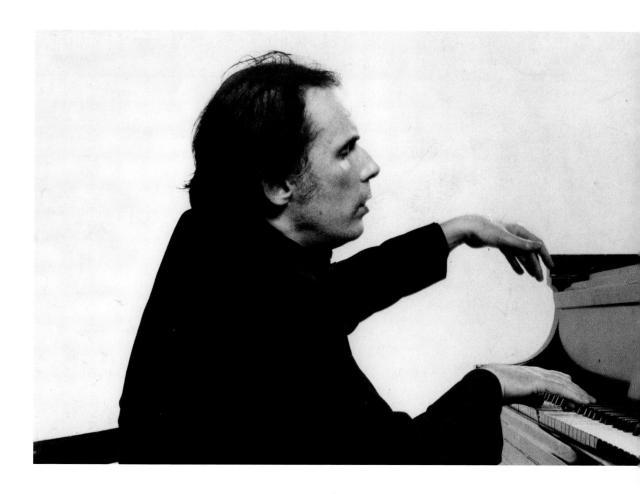

William "Billy" Bishop, from Owen Sound, Ontario, was a First World War military aviator, or flying ace. Credited with seventy-two victories, he was the top Canadian ace, and according to some sources, the top ace of the British Empire.

One of the best-known and most celebrated classical pianists of the twentieth century, Glenn Gould stopped giving concerts at the age of thirty-one so that he could concentrate on studio recordings. The eccentric genius always used the adjustable-height chair his father made for him when he was a child. This allowed him to pull down on the keys rather than striking them from above. Gould performed fewer than two hundred concerts over the course of his short-lived concert career.

OUR TOUT CANADIEN

A FOR CANADIANS

JUSTIN TRUDEAU

THE BODY POLITIC

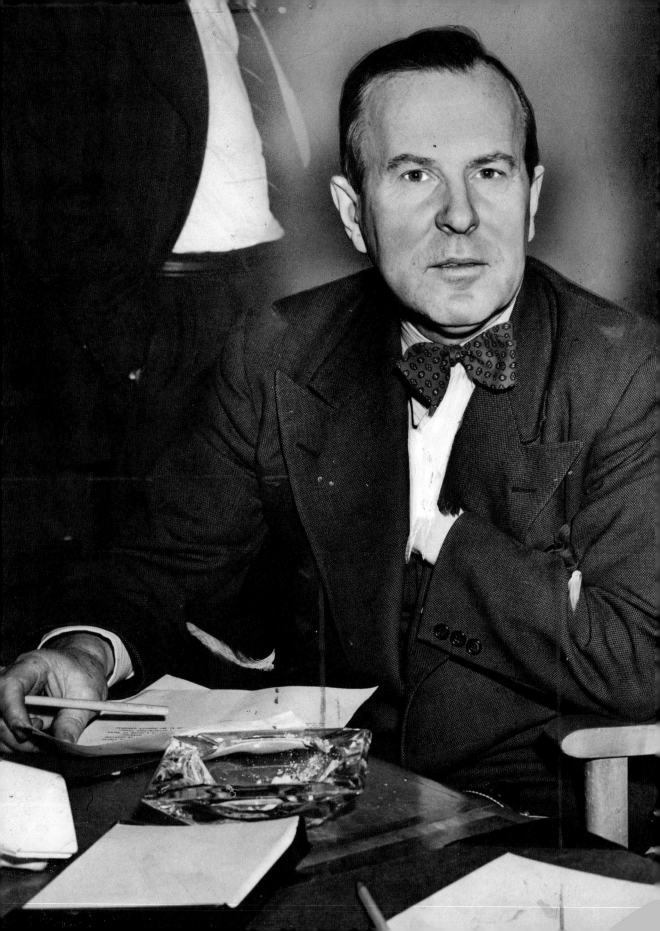

WHAT'S SIMILAR IN ALL THESE CIRCUMSTANCES
IS A COUNTRY DEFINED NOT BY ITS SCALE
BUT BY THE CONNECTIONS BETWEEN ITS PEOPLE.

FOR MANY PEOPLE, Canada is a land defined mostly by being too vast, too empty, and too cold for too many months of the year. Yet because of those conditions, Canadians have learned to lean on each other, to be there for each other, and to rely on the presence and support of each other. Whether it was two hundred years ago as a farmer trudged across open fields to check on a neighbouring homestead after a storm, or in the trenches and on the beaches during two world wars as Canadians from all backgrounds fought for cherished ideals and faraway places, or simply on a modern-day street corner as random passersby stop to push a senior's Buick out of a snowbank—what's similar in all these circumstances is a country defined not by its scale but by the connections between its people.

You can see this uniquely Canadian quality in our willingness to pay taxes that support our social programs: we work hard to succeed, but we feel a responsibility to the less fortunate. We believe in universal health care and access to education for all. Even on an issue as potentially controversial as gay marriage, our collective belief in protecting basic rights overcame resistance to change. When we are at our best, we are a society in which our diversity and differences are a source of strength, not weakness. But in other moments, divisions about our identity expose passions that run deep. The photographs in this section reflect relationships that have defined Canada and its politics—international relationships, domestic relationships, family relationships, some positive, some negative—revealing a people seeking to create a strong, stable society that, simply put, would allow us to thrive together through one more winter.

In this oddly doctored photo, Lester B. Pearson is shown in 1950, after discussing with the United Nations General Assembly Political Committee the possible cease-fire options in Korea.

We most often define ourselves against and through legendary figures from other countries, and in this archive, some familiar faces appear repeatedly: de Gaulle, Churchill, and Kennedy. In one photo, Prime Minister Mackenzie King beams as he greets General de Gaulle arriving in Canada in 1944. Perhaps the prime minister's pleasure in welcoming such a great war hero onto Canadian soil reflects our need for external validation. There is a stiffness in the posture of the French leader, despite King's warm welcome. Certainly de Gaulle was grateful for the valour shown by Canadians on the beaches and battlefields of Europe, but looking at this image, it's hard not to think about what was yet to come. Twenty years later, de Gaulle would announce his preference for a "Québec libre," a contentious declaration that stirred controversy in Canada and abroad.

There's something fitting about a figure as strong and as iconic as Winston Churchill measuring himself against the power of our landscape. He travelled many times to North America during the war, to thank and encourage Canadians for their steadfast involvement and sacrifice, and to coordinate the significant American war effort with President Roosevelt. Seen here on his way to Quebec City, for the first Quebec Conference in August, he made a special effort to share the splendour of Niagara Falls with his daughter Mary.

If France and Britain as founding nations shaped our past, our neighbours to the south have provided the benchmark for how we view ourselves in the present. As Canadians, we're proud of our social programs, our peacekeeping, our more cooperative view of success. However, we often envy Americans for their strength, their confidence, their unabashed patriotism, and their economic and cultural hegemony. We may even admit to ourselves that while Canada is undoubtedly the best country on earth, perhaps the United States is the greatest. It is therefore difficult to understate the impact of the president coming to visit. President John F. Kennedy addressed our Parliament in 1961,

but even Prime Minister Diefenbaker, always a strong presence in any photo, appears a mere observer of history unfolding. One might generously refer to it as politeness or modesty, or less charitably call it an inferiority complex, but whatever it is, as Canadians we are too often overly humble about our own successes and achievements.

So it was with a rare excess of emotion that Canada's centennial year, 1967, was celebrated across the country—including in Quebec, with Montreal hosting Expo 67. But it was also marked by a rise in nationalist passions in *la belle province*. The Quiet Revolution of the '60s was a coming of age for Quebeckers as they tossed off the double yoke of an overly powerful Catholic Church and an elitist, often oppressive state. Even in a climate of increased freedom, economic and cultural barriers remained. Many separatists longed to be *maîtres chez nous*— masters in their own house—and the nascent separatist movement gained popularity. In one photo from 1967, an RCMP staff sergeant, a potent symbol of

Canadian authority, is knocked down by a protestor. This presages the violence of the years that followed, violence that peaked (and ended) with the October Crisis of 1970, in which the Front de libération du Québec kidnapped and murdered Pierre Laporte, a Quebec cabinet minister.

The intensity of the 1960s also had young people interested in politics in a more positive way on the national stage. Engaging our youth has always been a challenge for politicians, but the wave of popularity that swept Pierre Elliott Trudeau into office in 1968 managed to touch all generations. The prime minister was surrounded by young people, as shown in one image where he is signing autographs. This relationship between a leader and youth is all too often absent today in political life. My father's popularity among young people wasn't only because of perceived "youthful vitality and good looks," but because he was offering Canadians a bold vision of concrete and fundamental change. Young people respond to politics when politics responds to them.

Political campaigns are a gruelling ordeal, but that usually makes the victory celebration all the more sweet. In 1970, a very young Robert Bourassa won his premiership in Quebec. His focus on his wife, Andrée, is more than just the recognition that spouses are an essential part of any political victory, whether behind the scenes or in a visible role. Women have increasingly become primary political players transforming Canadian politics as it enters a more modern era. That there were no pictures in this archive of those strong women says more, perhaps, about the choices of *The New York Times* and its photographers than anything else.

As a former journalist, Premier René Lévesque understood the potential of the media and its power to shape a narrative through compelling images and words. His skill as a communicator and his Everyman appeal belied a powerful mind and allowed him to evolve Quebec nationalism from a sentiment of opposition and protest into a transformative political force. In one photo

he is surrounded by reporters, and we see a hand-drawn Quebec flag being waved, an early version of the carefully staged photo-ops of later generations of politicians.

The Main Street parade in an old car. The proud local candidate. The genuine mirth in the smile of Prime Minister Turner in what was a very difficult campaign in 1984. The young boy caught in the middle of the picture trying to figure out what all the fuss is about. For me the never-ending busyness of the campaign trail goes to the heart of how politicians try to connect with people and persuade them to elect worthy representatives who understand their fears and will try to allay them, and understand their hopes and will try to fulfill them.

Carter and Trudeau, Clinton and Chrétien, Reagan and Mulroney. Every now and again there is a concordance between prime minister and president that goes beyond the job and reaches a personal level. This can be a double-edged sword, but against a backdrop of snow in Quebec City in 1985, a personal friendship reflects the

amity between two nations. The smiles are genuine. Prime Minister Mulroney leans toward President Reagan, who mugs for the camera in a gunner's pose, brought on no doubt by his enthusiasm for the cannons behind them.

Canada has always seen itself as a kinder, gentler, more peaceful country, free from the kind of violence that seems to fill up American newscasts. But that changed on December 6, 1989, as a lone gunman killed fourteen women at Montreal's École Polytechnique. In a desire to bring forth something positive from a terrible tragedy, the Canadian government created a mandatory registry for long guns. This, however, would become a political wedge between urban Canadians fearful of gun violence and law-abiding hunters and farmers for whom guns are an integral part of life.

One can't help but note with our more modern perspective that these photos of our political past, as seen through the lens of *The New York Times*, are almost entirely of white men in Ontario and Quebec. But does

that not aptly reflect the mainstream American perspective of us Canadians as safe, polite, boring? If that was the case through the twentieth century, it certainly will not be the case through the twenty-first. Today more than ever, our strength as a country rests on the diversity we have celebrated over the past few decades. We know that our politics have been marked by essential contributions from the eastern provinces and from the West Coast, by extraordinary women whose strength and leadership shaped the nation, by visionary First Nations and Inuit leaders, and by courageous citizens drawn from every corner of this planet working to build a better life for themselves and for their children in Canada. The present and future of politics in this country will be enriched by the many new voices yet to join our dialogue, voices that will contribute to keeping this country the very best in the world.

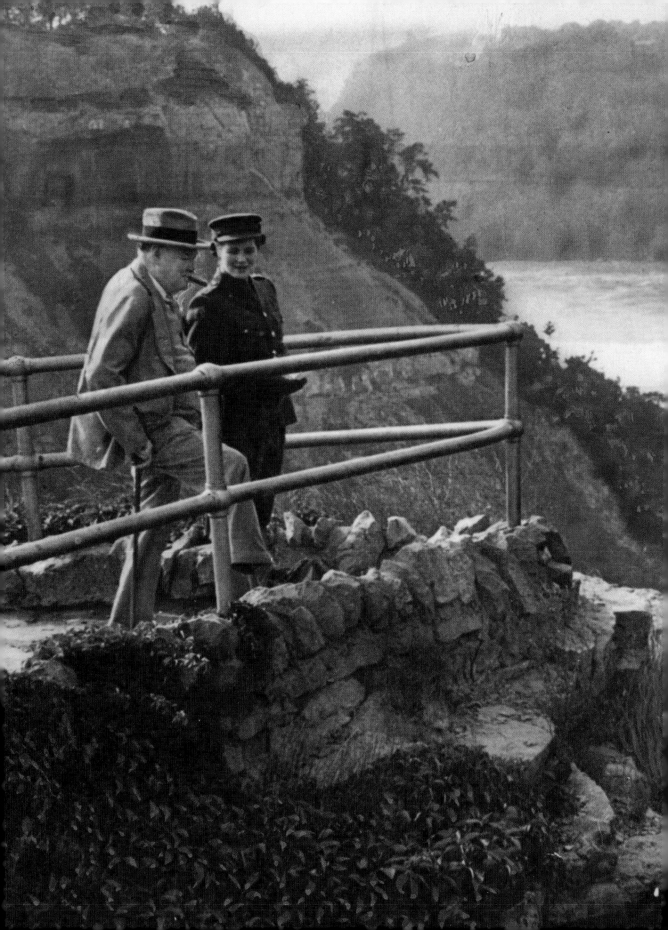

WAR OFFICE ~~~~~~ ~~~~~~ ~~~~~~
THE PRIME MINISTER AT NIAGARA FALLS.

In August 1943, while in Canada for the first of
two Quebec Conferences with President Franklin
D. Roosevelt and Prime Minister Mackenzie King,
Prime Minister Winston Churchill took his daughter
Mary to see the awe-inspiring beauty of Niagara
Falls. Irritated when a reporter asked if the Falls
looked the same as when he first saw them years
earlier, he famously replied, "Well, the principle
seems the same. The water still keeps falling over."

123

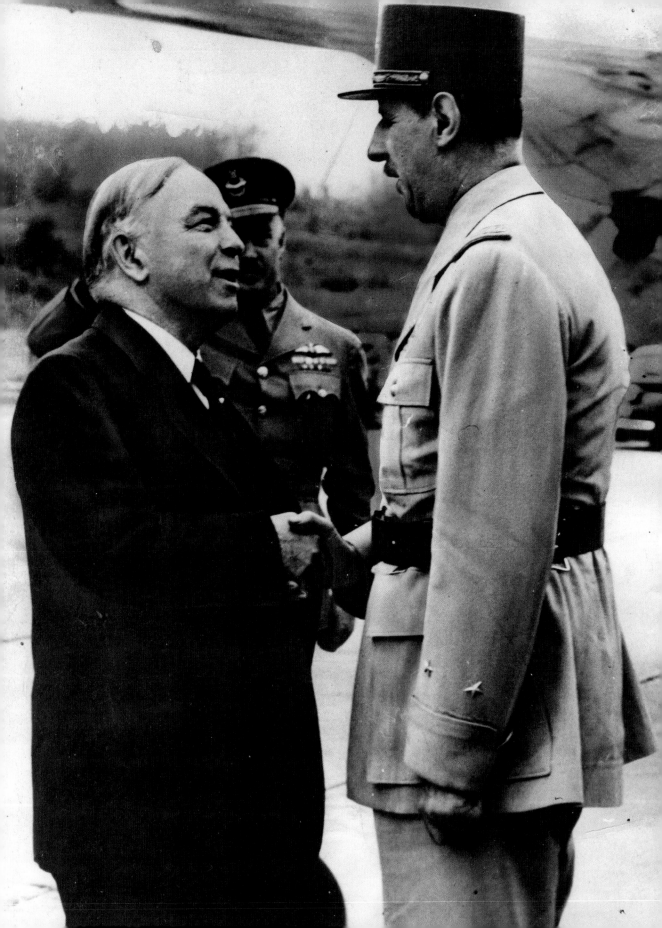

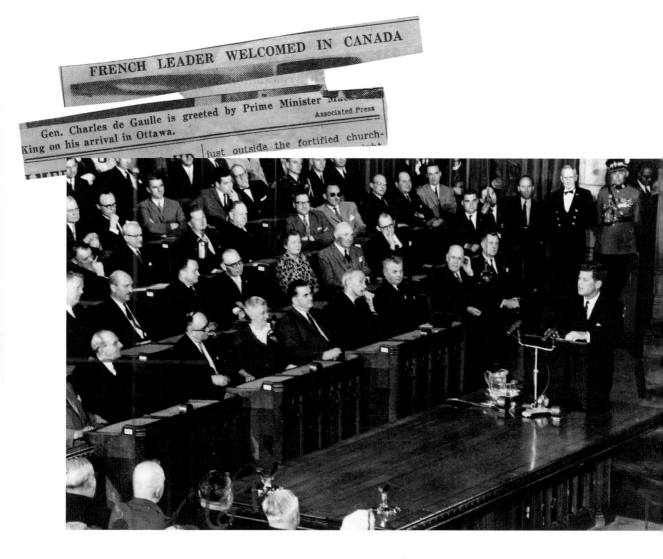

FRENCH LEADER WELCOMED IN CANADA

Gen. Charles de Gaulle is greeted by Prime Minister Ma...
King on his arrival in Ottawa.

Associated Press

...just outside the fortified church-

(*Left*) Arriving from his headquarters in London, Gen. Charles de Gaulle, the leader of the Free French Forces, towers over Prime Minister Mackenzie King as he is welcomed to Ottawa on July 11, 1944, almost ten months to the day before announcing the end of the Second World War to the people of France.

During a two-day state visit to Canada that was his first foreign trip as president of the United States, John F. Kennedy addressed a joint session of Parliament on May 17, 1961. "Geography has made us neighbours. History has made us friends," he said. It would be his only Canadian visit before his death two and a half years later.

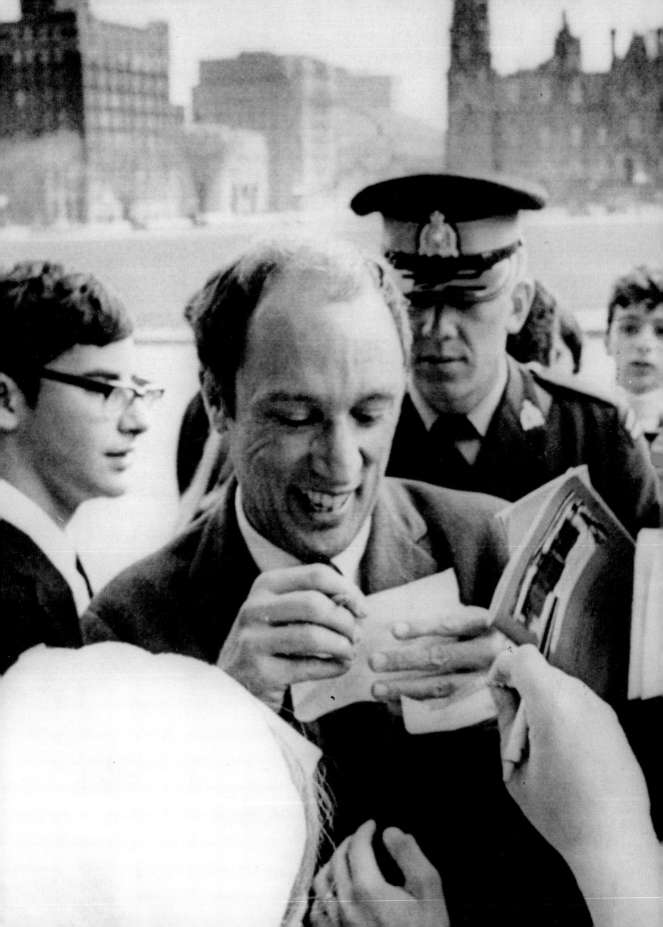

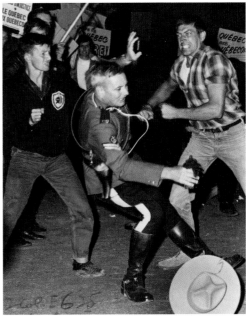

(Above) In 1967, two weeks after an inflammatory speech by French president Charles de Gaulle electrified the Quebec liberation movement, a member of the separatist group Rassemblement pour l'indépendance nationale (Rally for National Independence) strikes and knocks down an RCMP staff sergeant during a rowdy demonstration.

(Left) Two days after his election in 1968, Prime Minister Pierre Elliott Trudeau's star quality is on display as he is swarmed by young people wanting his autograph.

127

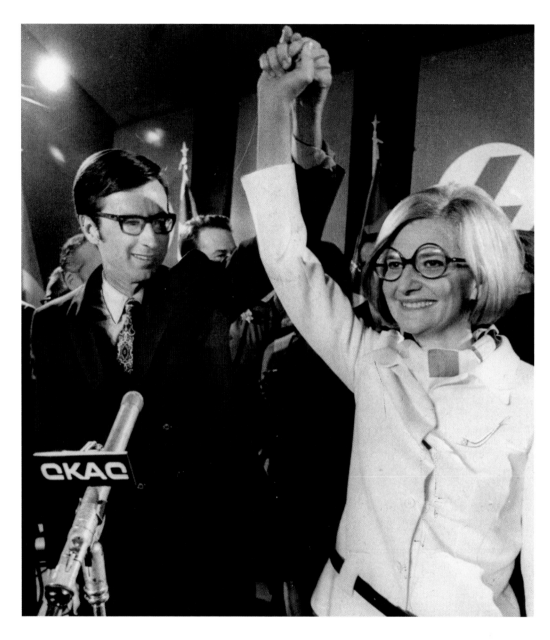

Robert Bourassa presents his wife, Andrée, to the media during a victory celebration following his election as premier of Quebec on April 29, 1970. He would win again fifteen years later, serving a total of almost fifteen years as provincial premier.

It's pandemonium as René Lévesque, founder of the Parti Québécois, speaks at a rally days before being elected premier of Quebec on November 25, 1976. He would later try to negotiate a political separation for Quebec through referendum.

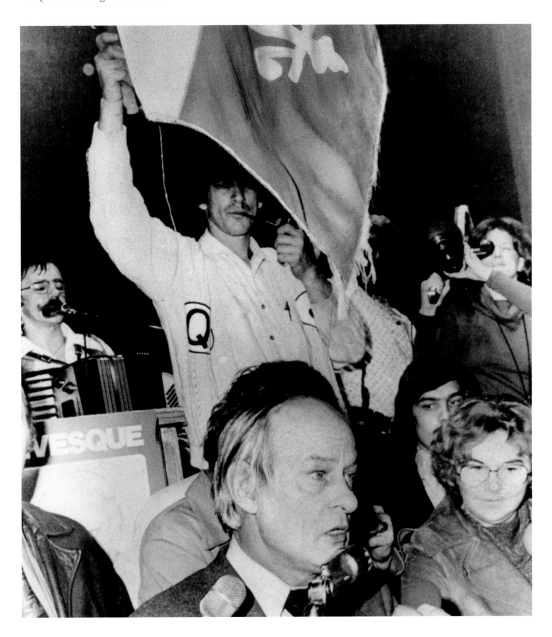

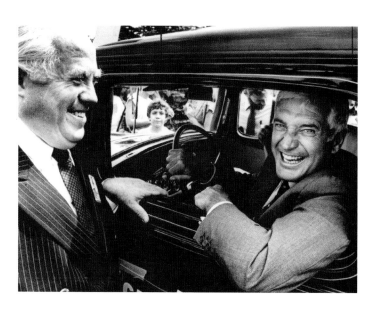

Days before the federal election on September 4, 1984, Prime Minister John Turner, on the cusp of defeat, smiles broadly as he lends his support to Terry Kelly, the Liberal candidate for the riding of Oshawa, Ontario. The Progressive Conservative Party, led by Brian Mulroney, won the largest majority in Canadian history, bringing to an end twenty years of Liberal government.

Prime Minister Brian Mulroney and President Ronald Reagan meet at the Citadel in Quebec City, a fort built in the 1800s to defend against American invasion. The press dubbed the meeting the "Shamrock Summit" after the two leaders of Irish background sang an impromptu duet of "When Irish Eyes Are Smiling."

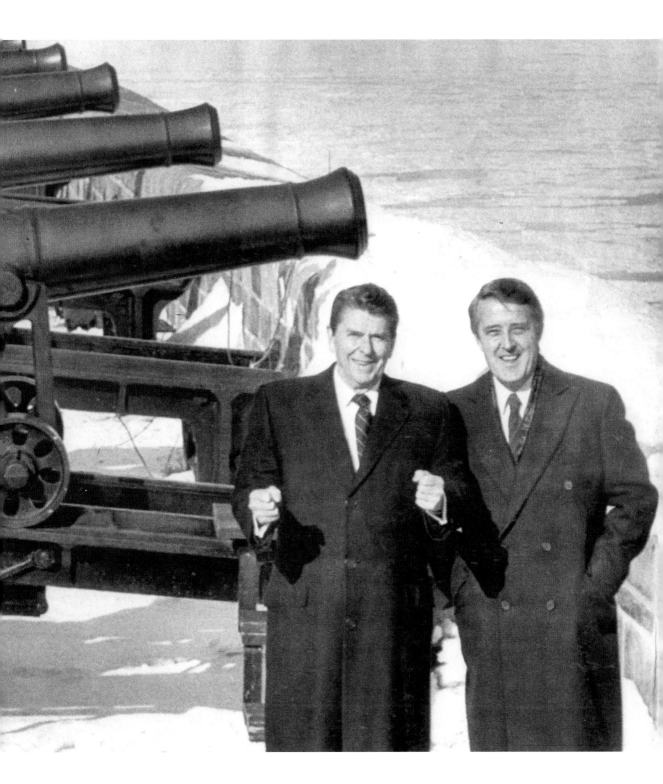

On December 6, 1989, Marc Lépine carried out Canada's worst shooting rampage inside the hallways and classrooms of Montreal's École Polytechnique, killing fourteen young women. The massacre marshalled public opinion with respect to violence against women. It also activated a nationwide campaign for tougher gun control measures that led to the establishment of a nationally divisive long-gun registry. The registry was scrapped by the federal government in 2012.

A TOUGH AND

STEPHEN BRUNT

BEAUTIFUL GAME

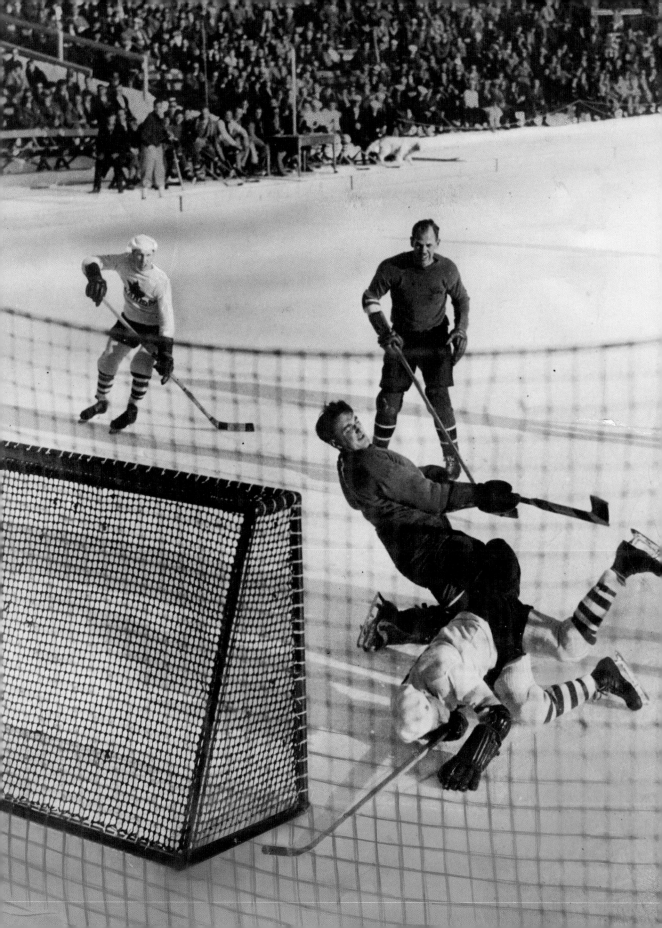

HOCKEY IS BORN OF A HARD CLIMATE, BORN IN PLACES
WHERE THE WINTER IS LONG AND COLD AND DARK,
A WAY TO EMBRACE THE SEASON,
TO BEAT IT BY MAKING IT A PLAYGROUND.

Hockey is a tough and beautiful boys' game played by men. It is a sport of speed and grace and flow and collision, a small-town Canadian passion that transferred beautifully even to the biggest stage in the biggest city in North America.

There is no soft place between the ice and the boards, between sticks and pucks and blades and fists. Hockey is born of a hard climate, born in places where the winter is long and cold and dark, a way to embrace the season, to beat it by making it a playground. Frozen pond and river and slough, artificial ice in the middle of Manhattan, in the most famous arena in the world, at the epicentre of the sport and entertainment universe: all part of the great hockey continuum.

The hockey men went to New York to ply their trade, arriving as teenagers barely needing a shave and walking away middle aged, often broken, creased and hobbled and looking like our dads. They mostly weren't supermen or superstars, more honest workers on the job, but still it's a game, and

so there are no Roberts in hockey, only Bobbys; the Martins are forever Martys, Terrances Terrys, and even when he had become a miraculous hockey-playing, grey-haired grandfather, suiting up with his sons at his side, Gordon Howe of Floral, Saskatchewan, was forever Gordie, scoring goals, spinning out little bits of shinny genius, dropping opponents with a subtle and deadly elbow, and then giving them that big old aw-shucks farm-boy grin. It must have made them crazy.

Other people in other faraway places play and love hockey as well, though it took us a long while to acknowledge that, the truth hammered home by a few hard lessons.

Watched by an enthusiastic crowd, the Winnipeg Monarchs approach a 4–2 victory over Great Britain at the outdoor Ice Hockey World Championships in Davos, Switzerland, in 1935. Fifteen countries took part in the championships that year. Coached by veteran Monarch player Fred "Steamer" Maxwell, Canada's team placed first.

(Same goes for those hockey-playing girls and women, who had to wait and wait way too long for their time on the ice.)

The first indoor ice rink in the United States was at the first Madison Square Garden, built in 1879. Sometimes they played hockey there. The big-league version came to New York City in 1925, a team called the Americans, who wore star-spangled uniforms, who never won a thing, who didn't last very long, who eventually died of indifference. A year later, the Amerks were forced to share the brand-new third incarnation of the Garden with the equally brand-new New York Rangers, who in the beginning made it look easy. In just their second season of existence, they beat the Montreal Maroons for the Stanley Cup and became the toast of the town, loyally supported by the swells sitting down close to the ice and the raucous gallery gods on high. In 1940, the Rangers won the Stanley Cup for a third time, and then commenced a walk in the desert fourteen years longer than the one by Moses' team.

Oh, they had their moments of hope. They reached the Stanley Cup finals in 1950, and lost in double overtime in the seventh game to Howe and the Detroit Red Wings. In 1972, they got to the finals again, only to fall at the hands of Bobby Orr and the Boston Bruins. In 1979, the insurmountable barrier was a great Montreal Canadiens team with Guy Lafleur at his peak. Bad timing, times three.

The Rangers had their glamour boys, like Rod Gilbert and Ron Duguay. They had their own boy-genius defenceman, Brad Park, who wasn't quite Orr, but close. They tried importing other small-town heroes, Phil Esposito and late-career Lafleur, but never found the magic combination.

In time, a new team appeared on Long Island and soon forged a dynasty, winning four consecutive Stanley Cups through the genius of Mike Bossy and Bryan Trottier and Denis Potvin and fierce Billy Smith and the rest; the Islanders in the early 1980s were the sport's gold standard, and during that time it was humble Nassau, not

glamorous Manhattan, that was the game's Gotham focus.

Later, another team arrived just across the Hudson River in the Jersey swamps, a franchise that had failed before in Kansas City and Colorado and was hopeless at first before adopting a distinctive style that was effective in a damn-the-aesthetics kind of way. (The New Jersey Devils won championships in 1995, 2000, and 2003: score three for the suburbs.)

The fans of those other New York/New Jersey teams knew exactly what to do when the Rangers were the crosstown opponent: play the history card. "Nineteen-For-ty, Nineteen-For-ty" was their taunting chant. There was no retort, other than the traditional hockey-fan epithets, at least until the magical spring of 1994.

Mark Messier of St. Albert, Alberta, was the captain and the catalyst. With the Edmonton Oilers in the glory years, he had mostly played second fiddle to Wayne Gretzky, but when he went to the Rangers, they were his team and his alone. He shaved his head; his eyes burned with a wild intensity; he had a smile that was at least half menacing; and he'd drop the gloves when he had to. He played the game with great skill and heart, and at times he seemed to have the power to simply will the Rangers to win.

In the semifinals, the Rangers matched up against the Devils, and were down three games to two. They were going to win the next one, Messier said, and the series after that. He guaranteed it.

Invoke the spirit of Joe Willie Namath in New York City or of Babe Ruth calling his shot and you're asking for it. But Broadway Mark delivered, scoring three in the game six win. The Rangers finished the Devils off in double overtime in game seven, and then they came through the storm again, in a classic Stanley Cup final against the Vancouver Canucks, the seventh and deciding game played on the Garden ice.

The Rangers in that moment of victory were the great city's pulse. The final seconds ticked down, the celebration began, and in

the end Messier held the battered old mug high for all to see, fifty-four years after the last time, at a different building bearing the same name, in a fundamentally different world.

The celebration that night spilled out onto the streets. The tickertape parade that came later, rolling through the Canyon of Heroes, put hockey players in the footsteps of astronauts and presidents. Who, pulling skate laces tight on a cold prairie morning, ever dared dream of that?

Abigail Hoffman, a nine-year-old girl, pretended to be a boy so that she could play hockey. Once her hockey league discovered her gender, she was banned from her team. She went on to a distinguished career in track and field, and competed in four Olympic Games, four Commonwealth Games, and two Pan-American Games.

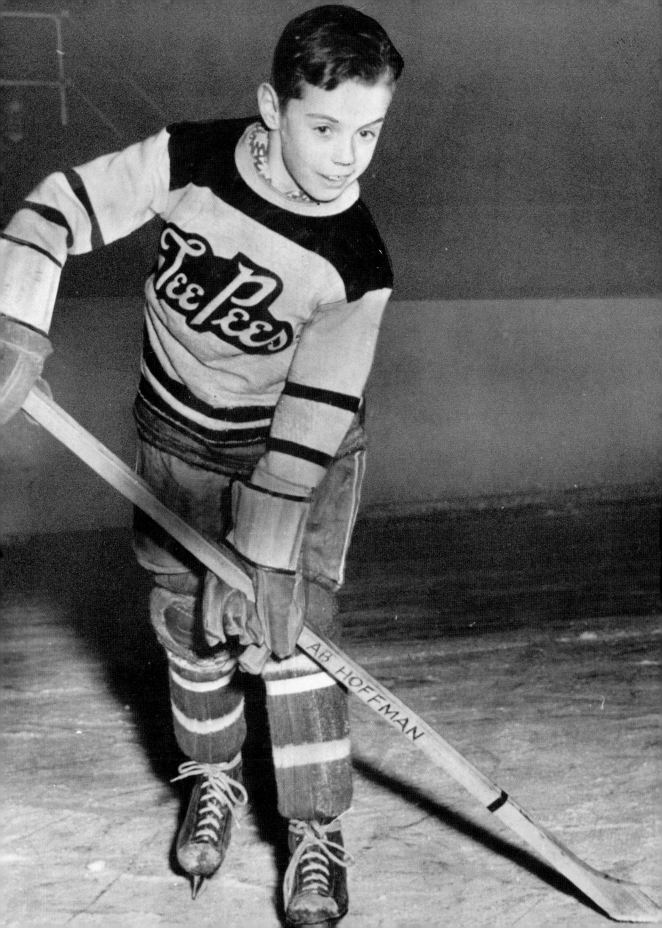

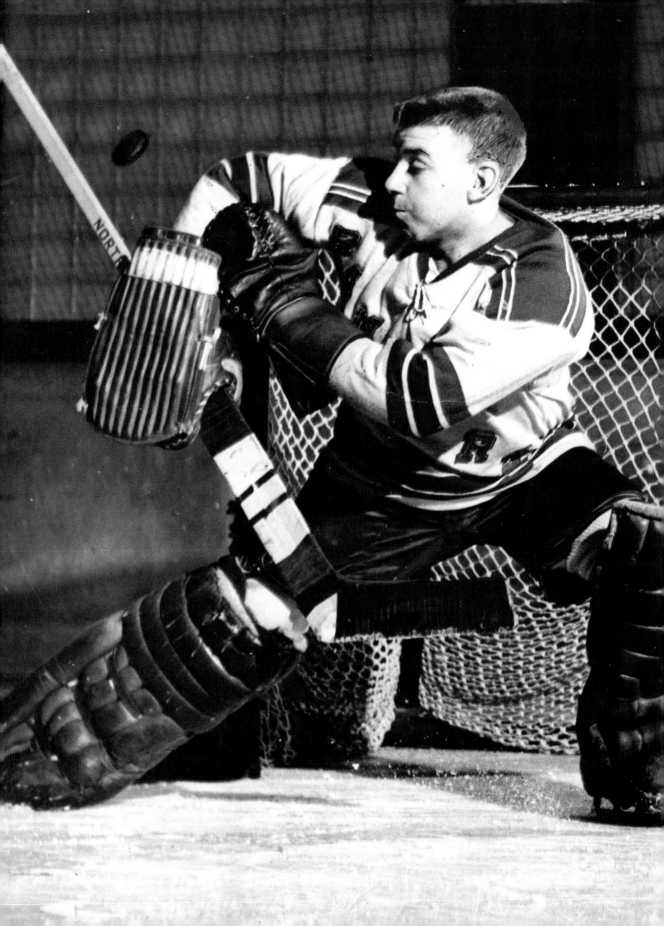

(Opposite) Lorne "Gump" Worsley earned his nickname because friends thought he looked like popular comic-strip character Andy Gump. Here he stops a puck during the New York Rangers' 1952–53 season, in which Gump saw his first NHL shutout, against the Montreal Canadiens in his hometown of Montreal. He would go on to earn forty-three shutouts. He was the second-last professional netminder to play without facial protection. In fact, he wore a mask only in the last six games of his distinguished twenty-two-year career. He was inducted into the Hockey Hall of Fame in 1980.

(Above) Twenty-five-year-old Gordon "Gordie" Drillon (left) and twenty-four-year-old Sylvanus "Syl" Apps (right) are pictured here in 1939. Before becoming a hockey player, Apps won a gold medal in pole vaulting at the 1934 British Empire Games. Apps's grandson Darren Barber followed in his footsteps, winning a gold in rowing at the 1992 Barcelona Olympics. Drillon played only seven seasons with the NHL, but his unique style of play and excellent shooting skills made him a lead scorer. He was inducted into the Hockey Hall of Fame in 1975.

(Above) During a March 1959 game against the New York Rangers in Madison Square Garden, Chicago Black Hawks forward Ted Lindsay climbed the boards and leaned over the glass to confront a fan who had berated him for missing an easy goal. This was not the first time Ontario-born "Terrible Ted" had threatened a fan. Four years earlier, playing with the Detroit Red Wings, he had been suspended for five games for leaning over the glass at Maple Leaf Gardens and striking a fan with his stick.

(Right) New York Rangers Earl Ingarfield (#10) and Larry Mickey (#9), both from Alberta, climb the glass at Madison Square Garden to rescue fellow-Canadian general manager Emile Francis from a beating by three irate hockey fans in November 1965. The skirmish broke out after Francis complained to the goal judge who had mistakenly activated the red light. Ingarfield and Mickey were later joined in their rescue mission by eight more Rangers. The riot lasted about fifteen minutes.

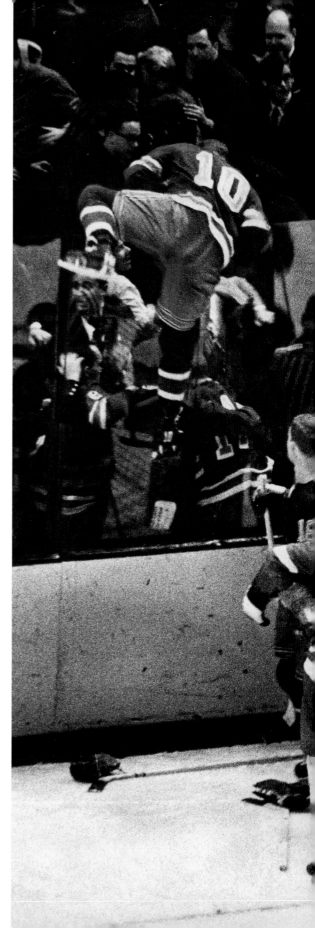

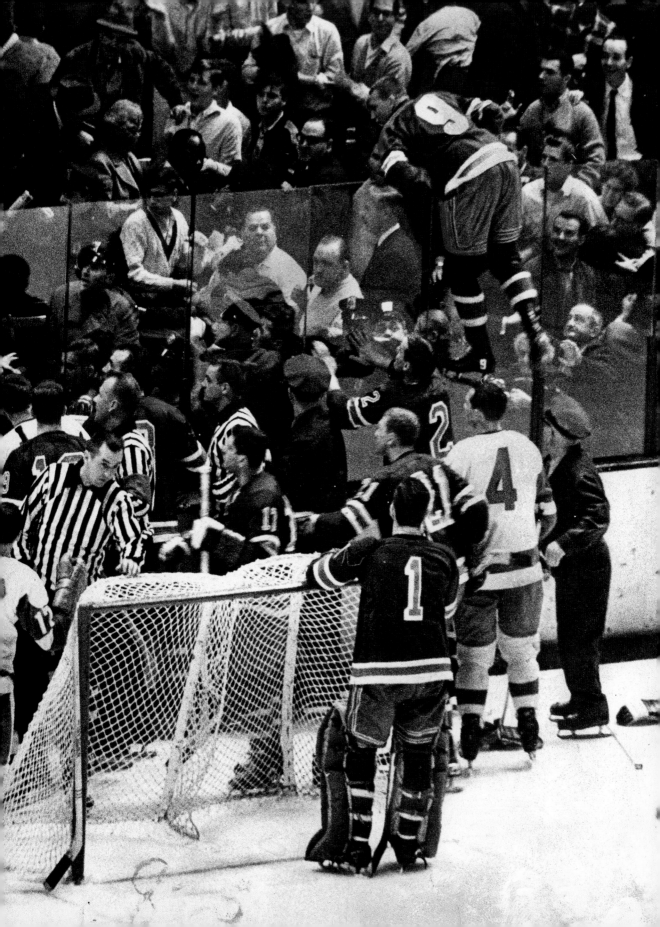

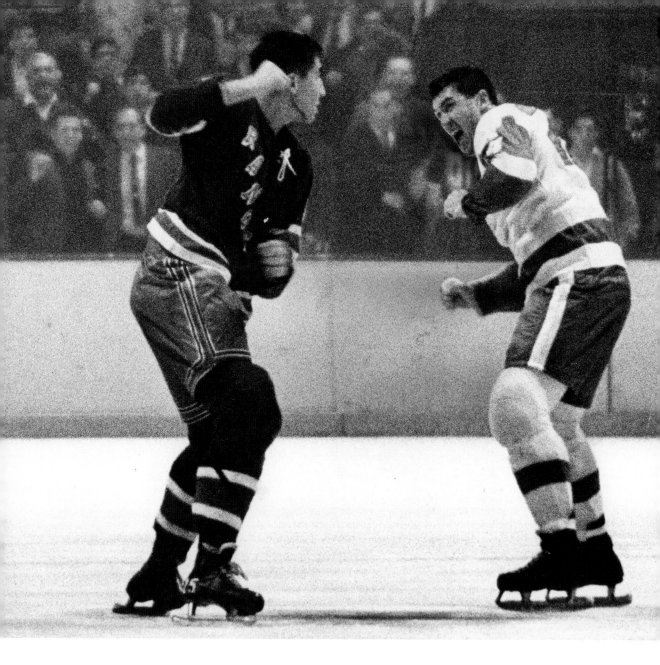

Just shy of his twenty-sixth birthday, six-foot-two, 205-pound Jim "Chief" Neilson of the New York Rangers (*left*) had the upper hand over thirty-two-year-old Detroit Red Wings player Bob McCord (*right*). The bare-fisted brawl broke out at Madison Square Garden during a Sunday-night game in November 1966. Neilson's power over McCord foreshadows the Rangers' 5–2 victory over the Wings. A tremendously strong skater, the Saskatchewan-born Neilson was regarded as a gentleman of the sport, a player who rarely fought. He acquired fewer than 95 penalty minutes in any one season and a total of only 755 penalty minutes in all his sixteen NHL seasons.

On the first day of training in 1966, Phil Goyette (*left*), centreman with the New York Rangers, appears shocked by what he hears in the head of "rookie" teammate Bernie "Boom Boom" Geoffrion (*right*). After playing with the Montreal Canadiens for fourteen years, Boom Boom quit the game he loved in 1964, only to return again in 1966. Geoffrion scored more goals than all but four players in the history of the game, was the second player in NHL history to score fifty goals in a season, and won six Stanley Cups, two Art Ross trophies, a Hart trophy, and a Calder trophy. Geoffrion was inducted into the Hockey Hall of Fame in 1972.

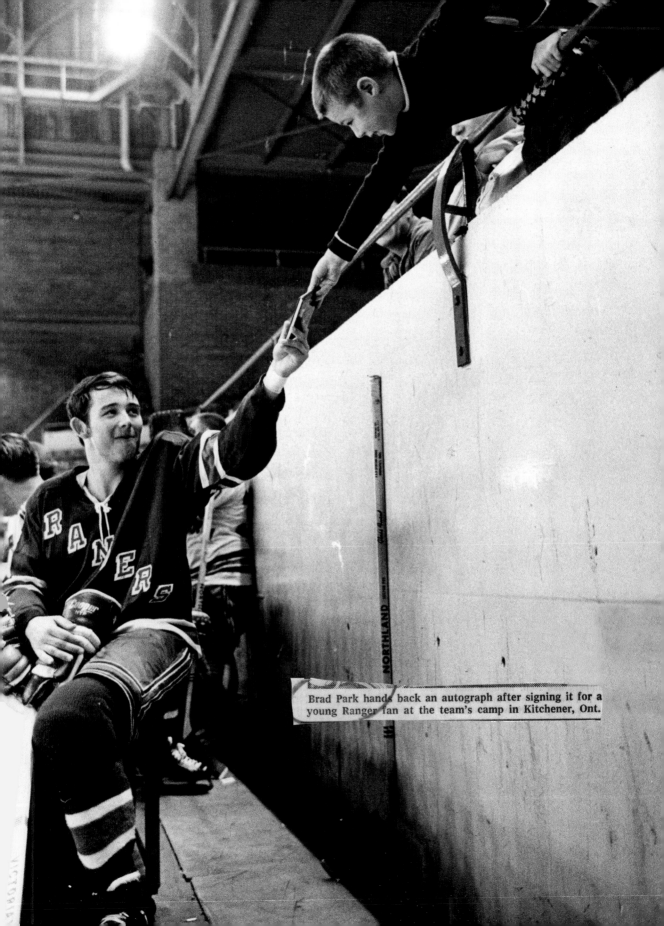

Brad Park hands back an autograph after signing it for a young Ranger fan at the team's camp in Kitchener, Ont.

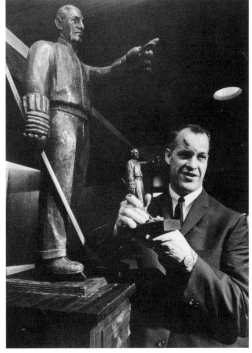

(Right) Gordie Howe holds the Lester Patrick Memorial Trophy, which was awarded to him in 1967. The trophy honours those who have made significant contributions to ice hockey in the United States.

Gordon "Gordie" Howe—aka "Mr. Hockey"—and his sons Marty (left) and Mark (right) sport bold fashions popular in the fall of 1973. Mark would go on to have a long NHL career, playing sixteen seasons and being one of the dominant two-way defencemen of the 1980s. He followed his father into the Hockey Hall of Fame in 2011.

(Opposite) Twenty-one-year-old Brad Park of Toronto, a rising-star defenceman for the New York Rangers, hands an autograph to a young fan during play at training camp in 1969.

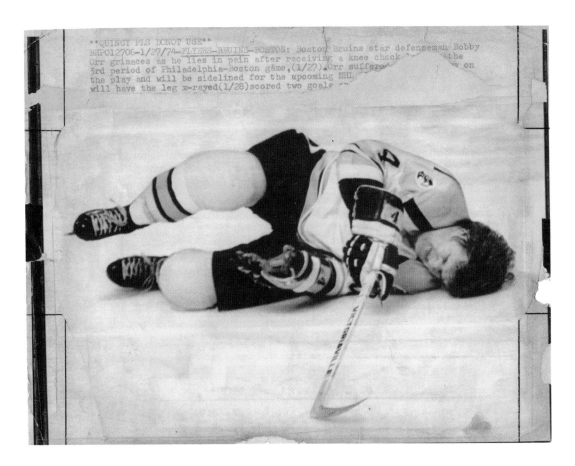

Because Bobby Orr suffered injuries to his left knee, it was a constant target for his opponents. Here he lies on the ice in 1974 after receiving a knee check. Four years later, at age thirty, after twelve surgeries on the vulnerable joint, he retired. The following year, the Hockey Hall of Fame waived the normal three-year waiting period for Orr's induction. Only ten players have ever received early induction to the Hall of Fame.

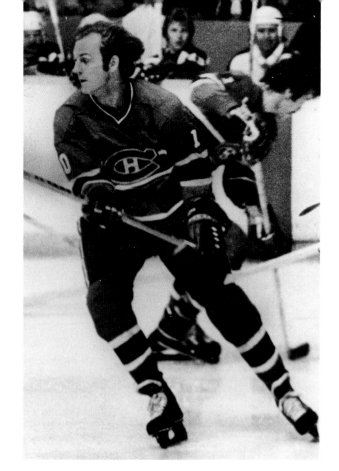

Twenty-seven-year-old Guy Lafleur, aka "The Flower," led the Montreal Canadiens to their third straight Stanley Cup win in 1978. His off-ice pursuits that year included launching a line of toiletries for men. The cologne was called Guy Lafleur No. 10, after his jersey number. The line also included a soap-on-a-rope in the shape of a hockey puck. Between 1971 and 1991, Lafleur played for the Montreal Canadiens, the New York Rangers, and the Quebec Nordiques.

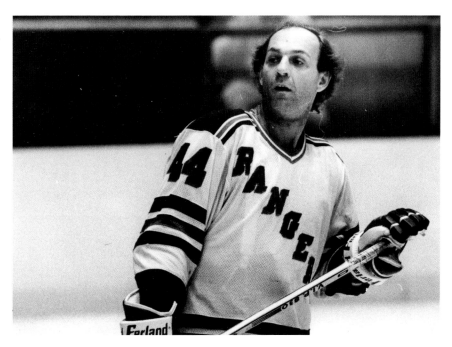

Some Montreal fans paid $600 to scalpers in hopes of seeing Rangers' Guy Lafleur at Forum last night, but an injured foot kept him out.
The New York Times/G. Paul Burnett

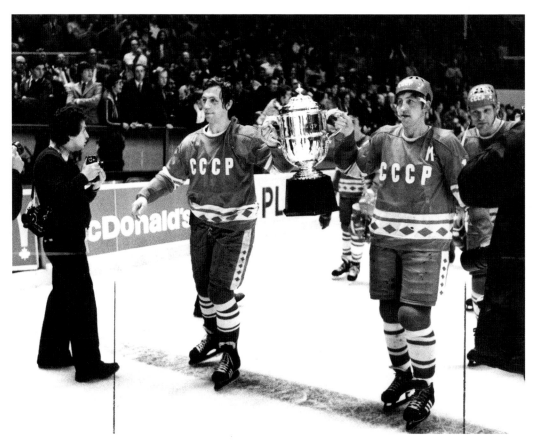

Played in Madison Square Garden in New York City, the 1979 Challenge Cup was a series of three games between the Soviet national team and a team of NHL All-Stars. The Soviets won, two games to one. With three players from Sweden on the NHL team, this was not a Team Canada event like the previous two Summit Series in 1972 and 1974.

(Opposite) Wayne Gretzky, shown here at age 18 in his famous #99 Edmonton Oilers jersey.

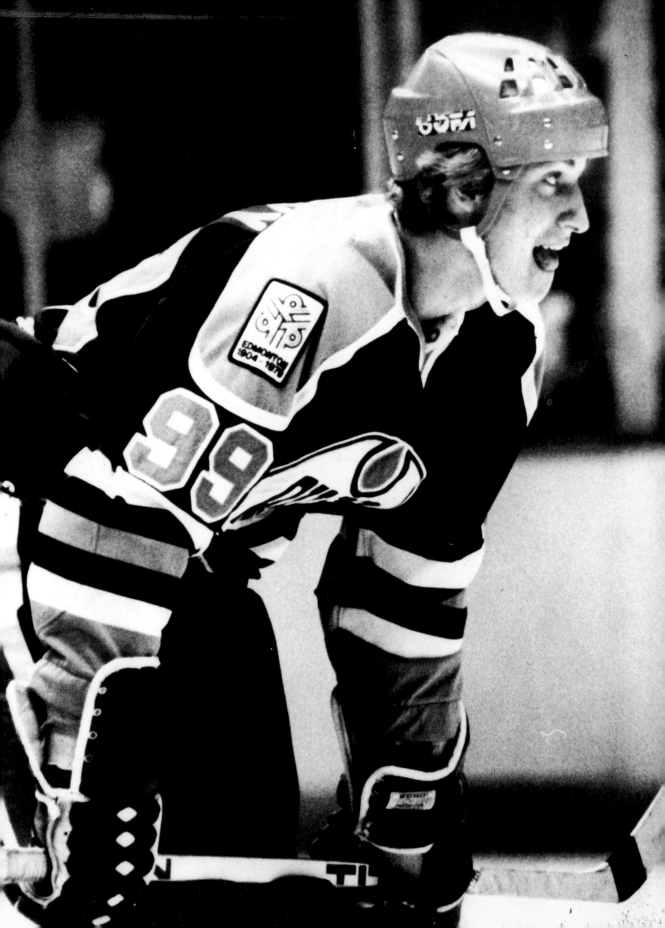

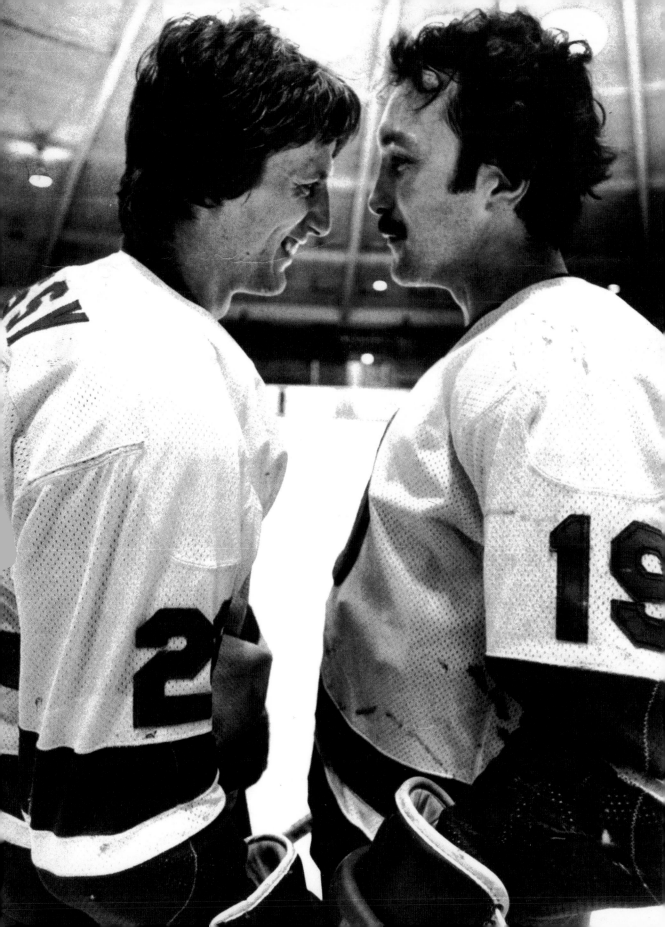

(*Opposite*) During a practice game on March 31, 1982, long-time roommates on the road and a classic offensive pairing on the ice, goal scorer Mike Bossy (*left*) and playmaker Bryan "Trotts" Trottier (*right*) hold a staring contest for the amusement of the photographer. Forty-six days later, these two players would lead the New York Islanders to win their third Stanley Cup in a row. Along with Clark Gillies, they were known as the Trio Grande, one of the most feared lines in NHL history.

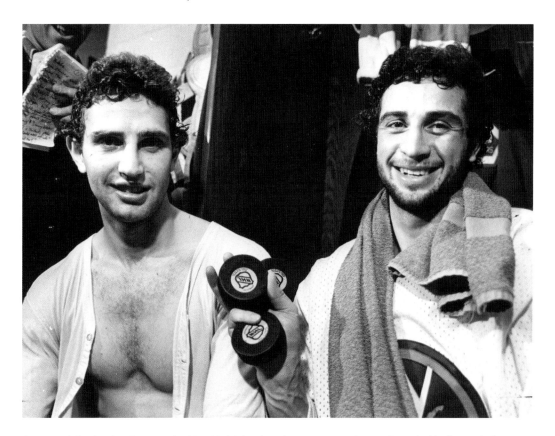

Sitting with his brother Brent in the New York Islanders dressing room, Duane Sutter holds the pucks from his first NHL hat trick on April 16, 1983. Six out of the seven Sutter brothers from Viking, Alberta, played simultaneously in the NHL during the 1980s. Collectively, they played over five thousand games and captured six Stanley Cups.

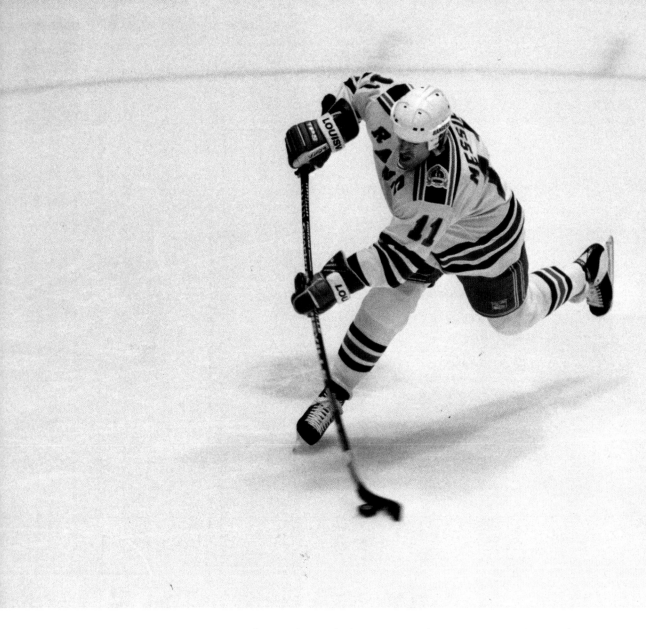

On June 2, 1994, during game two of the Stanley Cup finals in Vancouver, fans were treated to the beautiful sight of New York Rangers captain Mark Messier taking a slapshot. The Rangers won their first Stanley Cup in fifty-four years after a goal scored in game seven by the thirty-three-year-old "Messiah." These seven games are still regarded as some of the most thrilling Stanley Cup finals ever played.

William "Billy" Smith, also known as "Battlin' Billy," had a ritual of carefully laying out his gear before each game. This remarkable goaltender from Perth, Ontario, helped the New York Islanders win the Stanley Cup four times in a row from 1980 to 1983. In the 1982–83 season, the Islanders triumphed against the Edmonton Oilers, four games to none. Smith was named the Most Valuable Player of the playoffs.

(Overleaf) High above Broadway on June 17, 1994, an office worker holds a phone out the window so his fiancée can hear the roar from the canyon as New York City celebrates its first Stanley Cup win in fifty-four years. The Rangers defeated the Vancouver Canucks 3–2 in game seven. Many excited Rangers fans can be seen perched on window ledges contributing to the blizzard of twenty and a half tons of paper tossed during the tickertape parade.

157

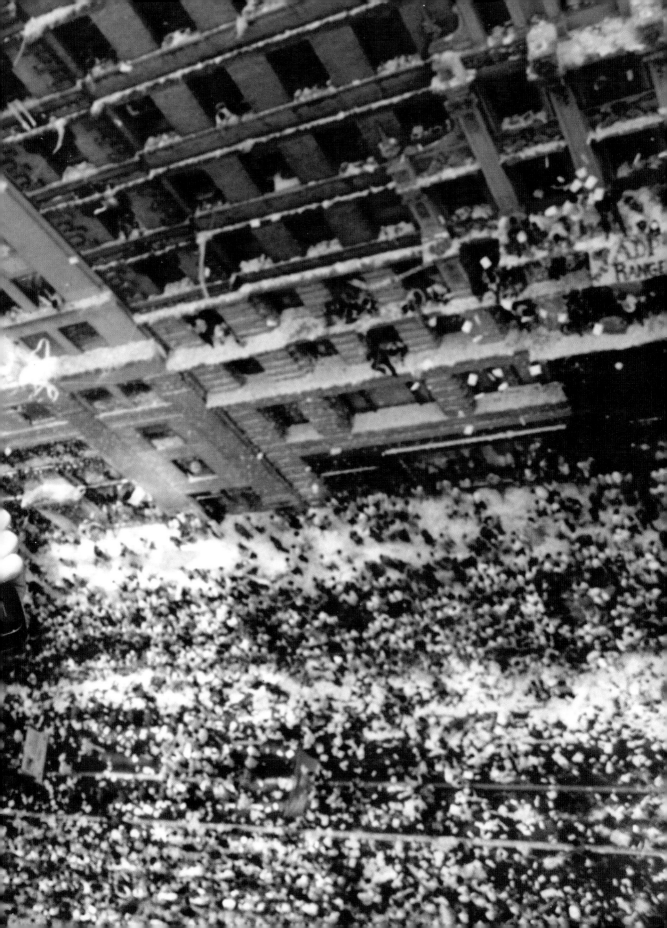

CHARLOTTE GRAY

THE CHANGING

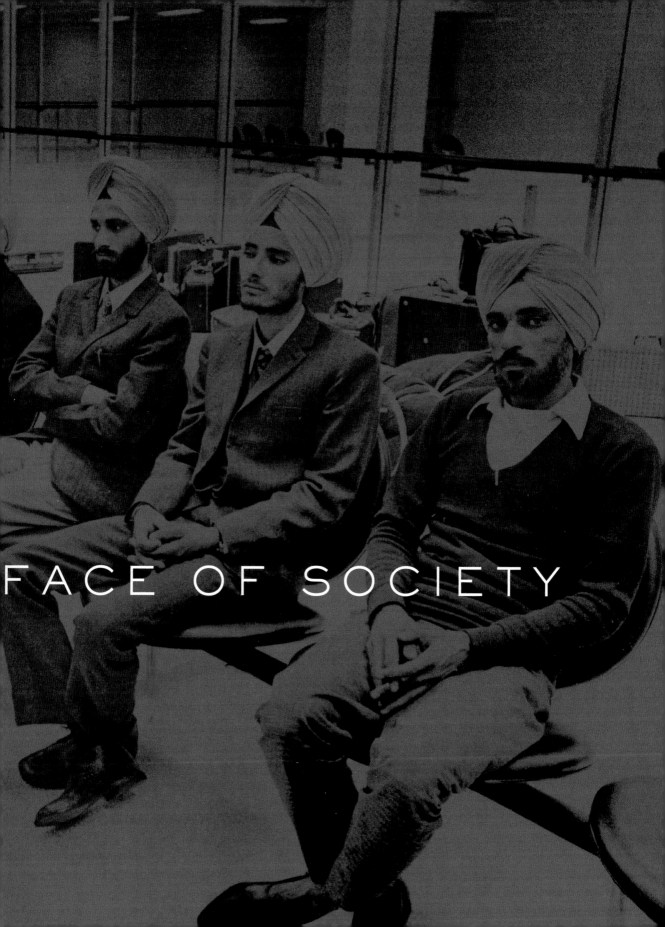

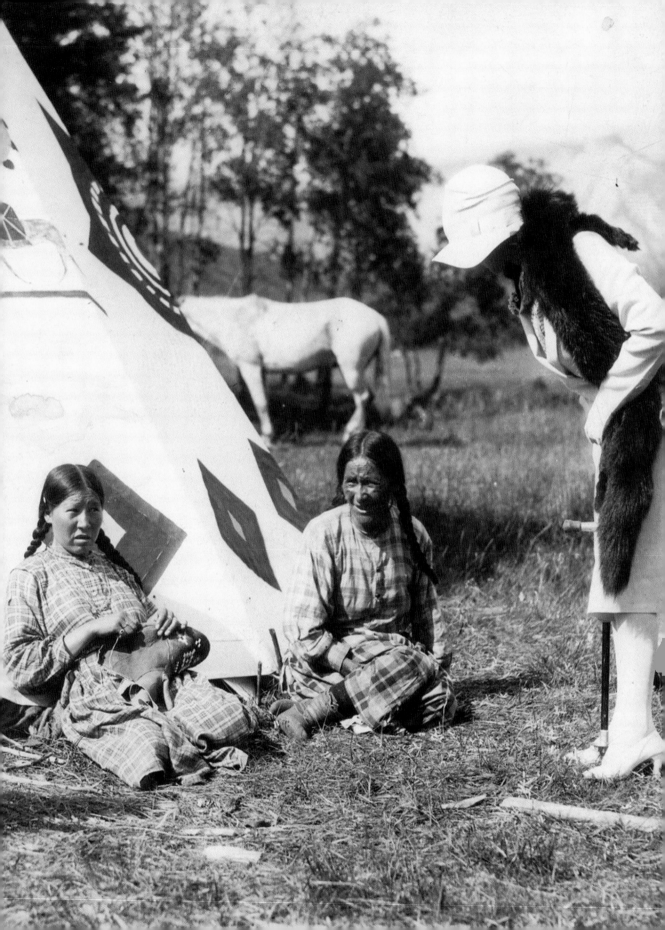

PHOTOJOURNALISM WAS ALREADY IN ITS INFANCY WHEN
THE DOMINION OF CANADA WAS BORN IN 1867,
SO CAMERAS HAVE CLICKED AS THE NATION MATURED—
ALTHOUGH THE IMAGE AND THE REALITY
HAVE NOT ALWAYS MESHED.

WITHIN 150 YEARS, Canada has developed from a collection of shabby British colonies to one of the wealthiest, healthiest, and most diverse countries in the world. Photojournalism was already in its infancy when the Dominion of Canada was born in 1867, so cameras have clicked as the nation matured—although the image and the reality have not always meshed.

Take, for example, images of Canada's three founding peoples—First Nations, scattered over the vast landscape for centuries; the French, who arrived in the St. Lawrence Valley four hundred years ago; British colonists who imported the culture of their Empire and clung to its customs. A dramatically lit portrait of a grizzled habitant, quietly smoking after a day in the fields, captures the rural nature of Quebec society in 1929. Until the mid-twentieth century, most French Canadians were locked into a traditional way of life, yet no photo could catch the deeper currents under the surface—the will to survive on an English-speaking continent, the brewing intellectual ferment.

In contrast, a 1927 photograph of a group of Stoney women and their children at a festival in Banff implicitly tells a story of cultural supremacy. Draped in a fur that was almost certainly the product of a native trapper's labours, a non-native visitor leans down to speak (presumably in English) to the women, who look discomforted by her presence. The cringe-inducing caption reads: "Group of Stoney Indian Squaws and a White Sister." There is nothing sisterly in

From 1907 to 1945, First Nations people gathered and set up villages outside Banff for what was called "Indian Week," during which they hosted events and displayed their goods. Begun by tourist promoter Norman Luxton and sponsored by the Canadian Pacific Railway, Indian Week was most popular through the 1920s and '30s. Sunday was traditionally the day for white people to visit the Indian camp, where they could take photographs and purchase goods.

163

GROUP OF STONEY INDIAN SQUAWS AND A WHITE SISTER.

anybody's body language here: the white-clad figure is so graciously patronizing.

For today's reader, the most ludicrous yet touching of the early photographs is perhaps the 1919 picture of Edward, Prince of Wales, dressed in an elaborate feather bonnet and buckskin suit beautifully decorated with quillwork. The prince was twenty-five years old when he embarked on an eight-week state visit to the distant dominion over which he would reign as Edward VIII for a brief few months. He represents, physically and symbolically, British rule. But the doubt on the face of this vulnerable young man perhaps reflects as much uncertainty about the future of the Empire as about himself masquerading as a chief. During the 1919 visit, Edward endeared himself to most Canadians by breaching protocol, reaching out to people, and even buying a ranch in Alberta. But did this exercise in, as he would have put it, "going native" commend him to the makers of his fringed buckskin?

These three groups represented the official face of Canada until the mid-twentieth century. Even as the camera fixed these static images, however, new faces were arriving. The total population of Canada in 1901 was less than 5.5 million, and if the young Dominion, which stretched five thousand kilometres sea to sea, was to resist fragmentation and the pull to join the United States, it needed more people. Before the First World War, immigrants were welcomed in their thousands—as long as they came from Europe. Ukrainians arrived to settle the Prairies; Italians and Greeks helped construct such cities as Toronto, Winnipeg, and Vancouver; Swedes and Finns were recruited to log and mine the north. Compassion was shown to groups such as the Doukhobors, a radical religious sect fleeing Russian persecution, even when they ignored local laws.

But non-Europeans were a different matter. When large numbers of Sikhs and Japanese arrived at Vancouver's docks in 1907, the city erupted in riots. And residents who didn't fit the official Canadian mould were treated little better. Black Americans

who had fled north from slavery, and Chinese labourers shipped in to build the Canadian Pacific Railway, suffered.

With the outbreak of war in 1914, and the faltering economy of the 1930s, the rate of immigration slowed dramatically. Quotas, segregations, and prohibitions multiplied as another European conflagration triggered xenophobic panic. Some refugees from the Nazi threat were admitted to Canada, particularly those who already had family here. But restrictions were harsh. In 1939, the *St. Louis* sailed from Hitler's Germany with 930 Jews on board. Prime Minister Mackenzie King declared that the *St. Louis* was "not a Canadian problem," and the passengers were returned, ultimately to the gas chambers of the Third Reich. Two years later, twenty-two thousand Japanese Canadians, the majority born in this country, were expelled from coastal British Columbia and crowded into tarpaper shacks in the Interior that were little more than doghouses.

This was the low point. A new Canada emerged after the war, characterized by humanity and generosity, perhaps in reaction to the shameful racism of previous years. A booming economy required another surge of immigrants, and plenty of people grabbed at the chance to leave a devastated and hungry Europe behind. By 1961, of more than eighteen million Canadians, one in six had been born outside the country. Benevolence as well as economic need inspired the postwar welcome to strangers. Asylum seekers arrived from countries as diverse as Nigeria, Uganda, and Tibet, diluting the old stereotypes. In 1980, the immigration minister recalled the *St. Louis* incident as he opened Canadian borders to thousands of boat people escaping the horrors of Vietnam.

Growing diversity played into a new confidence, as the cultural divide between Canada and the United States widened. Demonstrations erupted on Parliament Hill against U.S. foreign policy, and draft dodgers crossed the border to join the newly activist student movement here. The image of Canada shifted from a white outpost of the

rapidly dissolving British Empire to a country that valued social programs and resisted becoming involved in aggressive overseas adventures.

Most dramatically, the rules on who would be admitted changed in 1980, and the word *multiculturalism* entered our vocabulary. As the percentage of immigrants from China, the Philippines, and India edged up, the face of Canada was irrevocably transformed. Today, there are close to thirty-five million Canadians—a sixfold increase within a century during which this country absorbed immigrants at a rate unequalled elsewhere. With one in five citizens born outside the country, and one in six belonging to a visible minority, one-quarter of Canadians speak languages other than English or French.

We've evolved in other ways too. At the start of the twentieth century, most Canadians lived in rural areas, went to church, had three or four children, and died in their fifties or sixties. Today, we look different— richer, fatter, and older. The birth rate has fallen to an all-time low, and most of us reach our eightieth birthdays and live in cities where the evidence of new Canadians is all around us—mosques, temples, ethnic restaurants, saris, hijabs, kippahs and kufis. A century ago, no Toronto streetcars ran on Sundays, and a British visitor described the city as "alive, but not kicking." Today, one of the biggest events in the city is the annual Gay Pride Parade.

But some things have not changed. Canada has always prided itself on being not a melting pot, on the American model, but a mosaic, where newcomers could continue to celebrate their own traditions within the framework of the British system of government. The Queen, niece of that awkward young man in feathers and buckskin, remains on our money and is the titular head of state. However, the new multicultural reality has yet to show up in our democratic institutions. Walk into any municipal council room, provincial legislature, or the House of Commons in Ottawa, and an almost homogenous array of white faces will greet you.

In July 1982, I was one of two dozen immigrants who trooped along to a downtown Ottawa office block for a citizenship ceremony. The room was plain, with bare walls and folding chairs for us and our friends and relatives. A red-coated Mountie was in attendance; the citizenship court judge welcomed us in both French and English; in front of the judge's dais stood a line of provincial flags that included emblems resonant with Canadian history—a stoop of wheat, a buffalo head, fleurs-de-lys, Union Jacks. But of all the newly minted immigrants that day, only two of us came from the British Isles—"the Motherland," as it was known to earlier generations. The rest of my new fellow Canadians came from Sri Lanka, China, Germany, and elsewhere.

Two aspects of that day particularly impressed me. Each new Canadian stepped forward when his or her name was called. "Gray" is a plain-vanilla name, but many of the others were multisyllabic and complicated, consonants swamping the vowels. The court official did not stumble on a single one of them. After such ceremonies, local groups host a reception. Our group came from Ottawa's Chinatown, and its members welcomed us to our new country with warm smiles and served muffins with green icing, for good luck. I felt a long way from the land of my birth, the country that had dominated Canada for two hundred years. This was a brave new world.

Overleaf (left): For almost two hundred years, the Lachance family has been closely associated with the Isle-aux-Grues archipelago in the St. Lawrence River. Here, in 1929, on Île d'Orléans, where Jacques Cartier first set foot in 1535, a pipe-smoking member of this farming family sits on a rocking chair, with bunches of raw fleece on the floor around him. *(Right)* During his visit to Canada in 1919, Edward, Prince of Wales (later King Edward VIII), was made a chieftain and given native names at Banff and elsewhere. On most of these occasions, the twenty-five-year-old heir to the throne dressed in traditional First Nations garb.

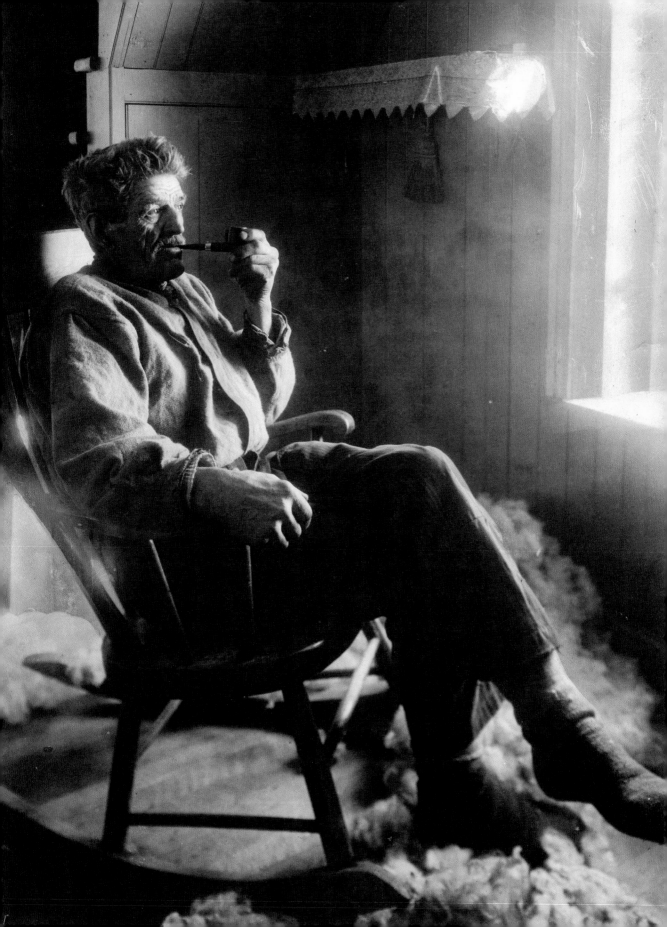

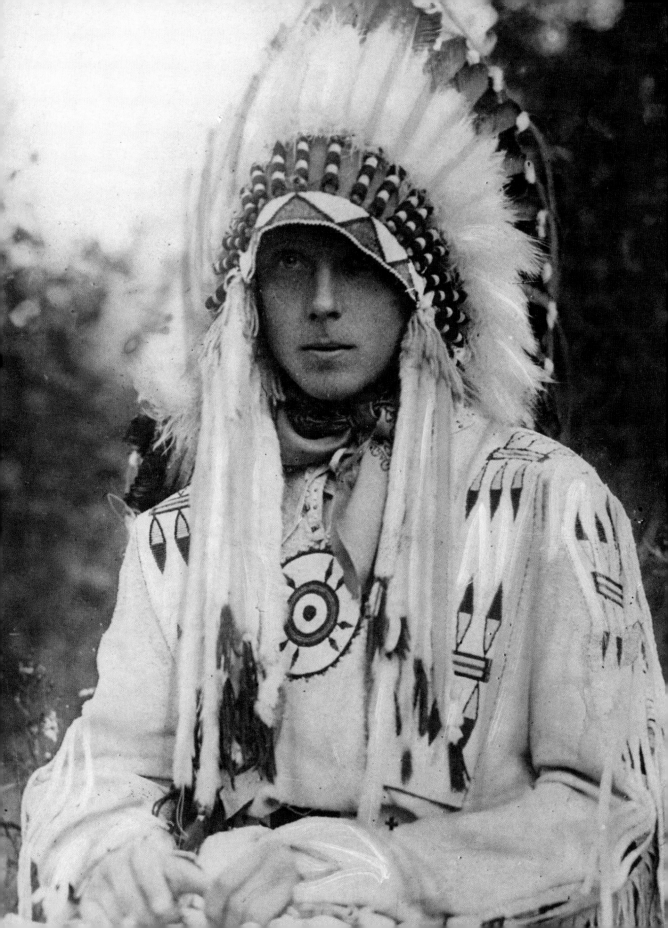

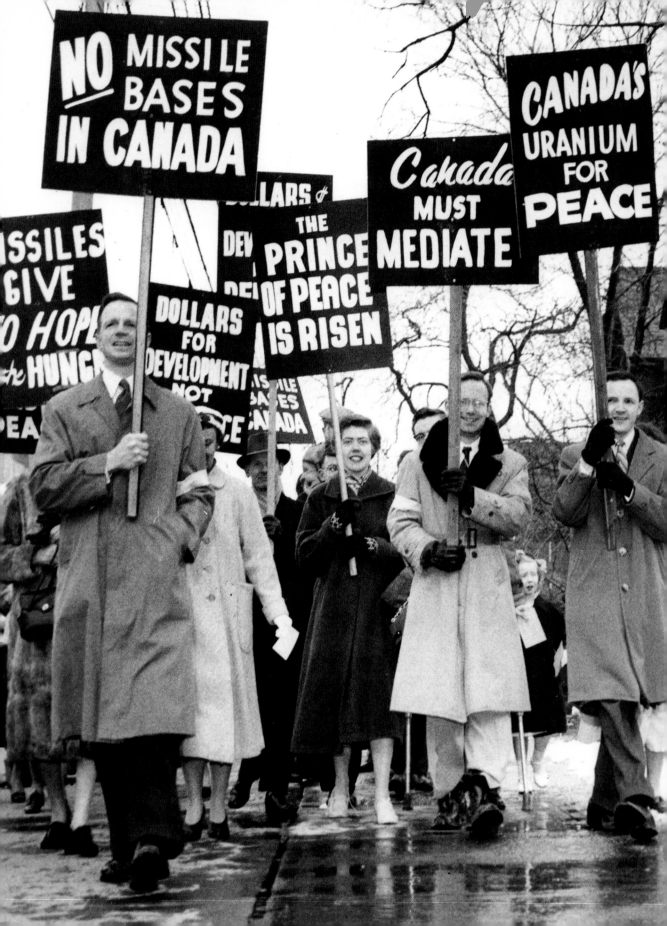

(Opposite) In Toronto, during the Easter Parade of 1959, the non-denominational Christian organization Church Peace Mission protested the use and manufacturing of weapons of war. The Church Peace Mission disbanded in 1967.

(Above) Members of the American Deserters Committee of Toronto hold a poster advertising a talk given by Canadian journalists June Callwood and Stanley Burke in 1969. Thousands of draft dodgers fleeing mandatory recruitment into the U.S. Army bound for service in Vietnam took up permanent residence in Canada.

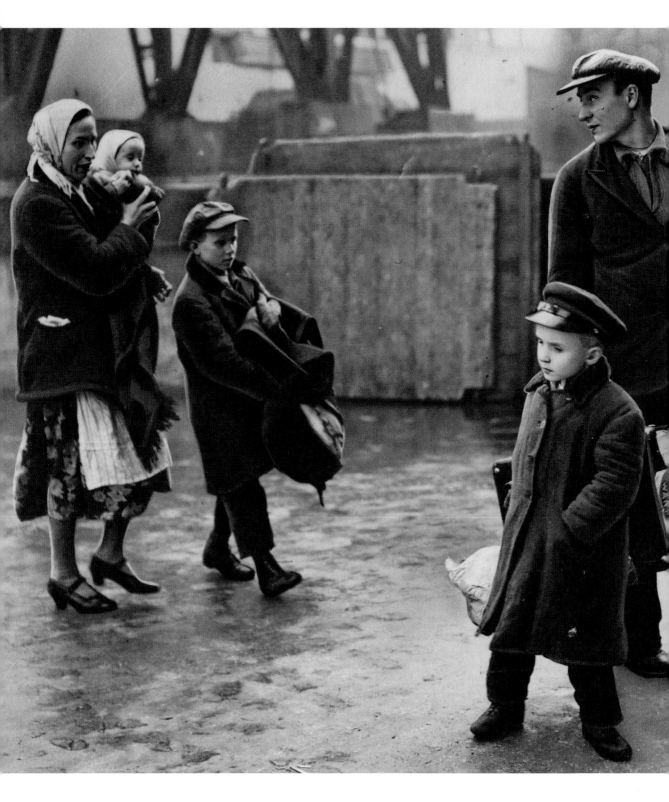

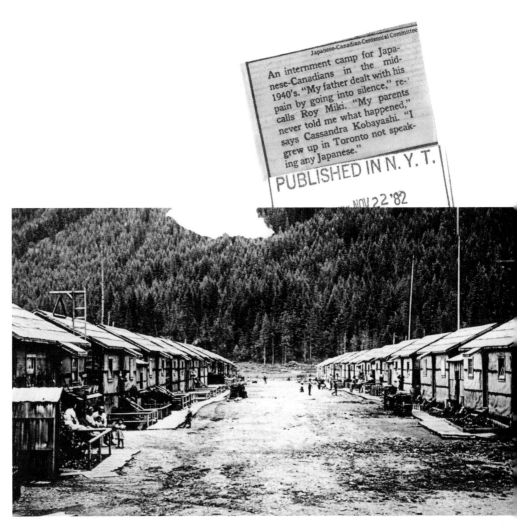

An internment camp for Japanese-Canadians in the mid-1940's. "My father dealt with his pain by going into silence," recalls Roy Miki. "My parents never told me what happened," says Cassandra Kobayashi. "I grew up in Toronto not speaking any Japanese."

Japanese-Canadian Centennial Committee

PUBLISHED IN N.Y.T.

NOV 22 '82

After the attack on Pearl Harbour in 1941, many Japanese Canadians were forced into internment camps. In 1988, Prime Minister Brian Mulroney issued a formal apology to them, and offered compensation for lost wages and property that had been confiscated during the war.

A refugee family arrives from Europe in November, 1938.

Britons for Canada

The 'Ontario Plan' of immigration by air helped to solve two population problems.

By CHARLES J. LAZARUS

TORONTO.

SOME weeks ago, a waiter at a London hotel left his job at noon on Saturday and a few hours later boarded the transatlantic plane at Prestwick, Scotland. Just over twenty-four hours later, he landed at Malton Airport near Toronto, Ontario, was checked in by immigration and customs officials, and applied that same day—Sunday—for a waiter's job at a Toronto hotel. He started to work on Monday morning.

The immigration of this young man without so much as an hour's loss of work is an indication of how a practical, streamlined immigration policy, such as that of the Province of Ontario, can work.

The Ontario

Let us see why Ontario

British citizens arriving in Canada aboard a Transocean Airlines DC-4 at Malton Airport in the summer of 1948, are part of a wave of immigration. Between July 1947 and November 1948, more than fifty thousand people displaced by the European conflict arrived in Canada under the direction of Prime Minister Mackenzie King's order-in-council. However, these British citizens were not displaced persons—they were actively recruited to settle in Canada.

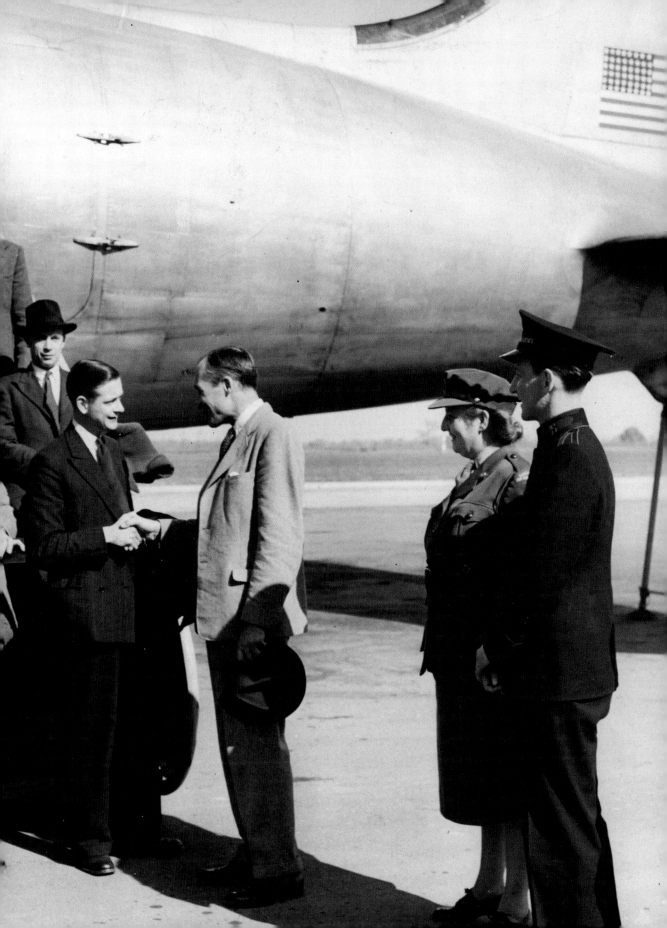

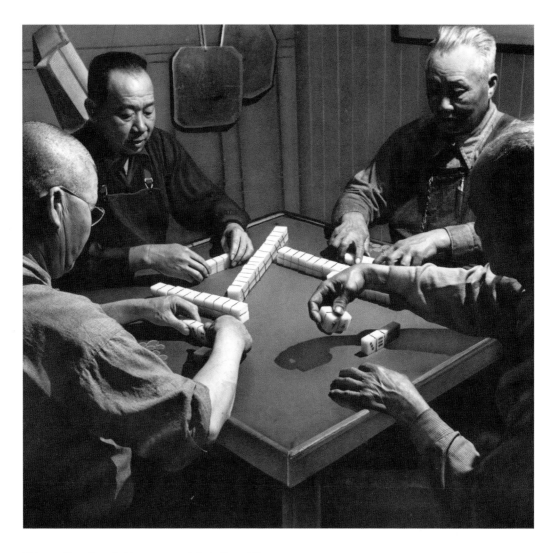

Chinese Canadians in Vancouver sort their tiles while
playing a game of mah-jong in 1961.

The Underground Railroad was a network of
clandestine routes and hiding places used by
thousands of black slaves during the nineteenth
century to escape from the United States into
Canada. Many refugees who escaped enslavement
settled in the triangular region bounded by Toronto,
Niagara Falls, and Windsor, Ontario.

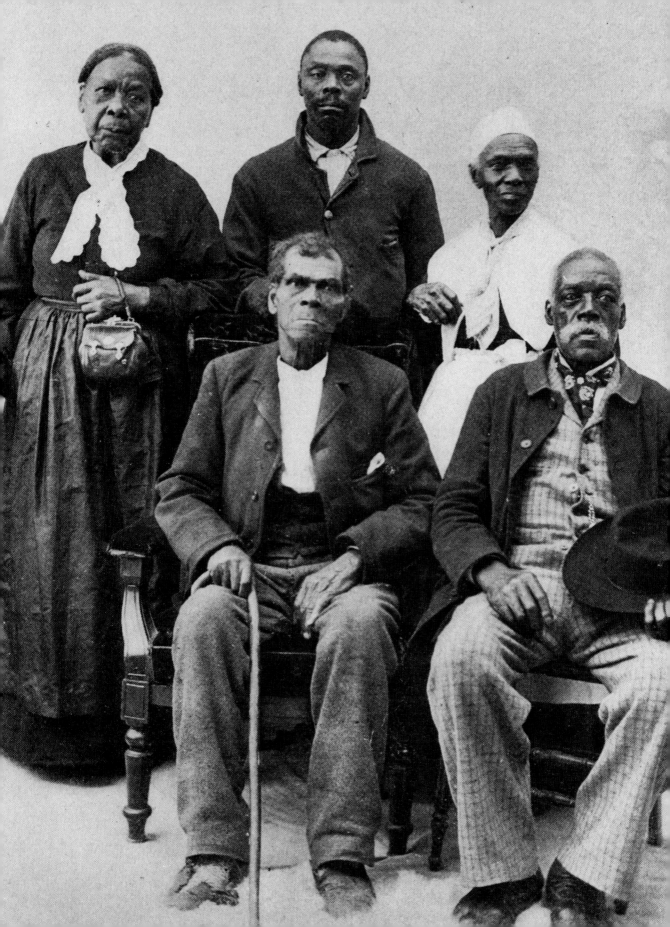

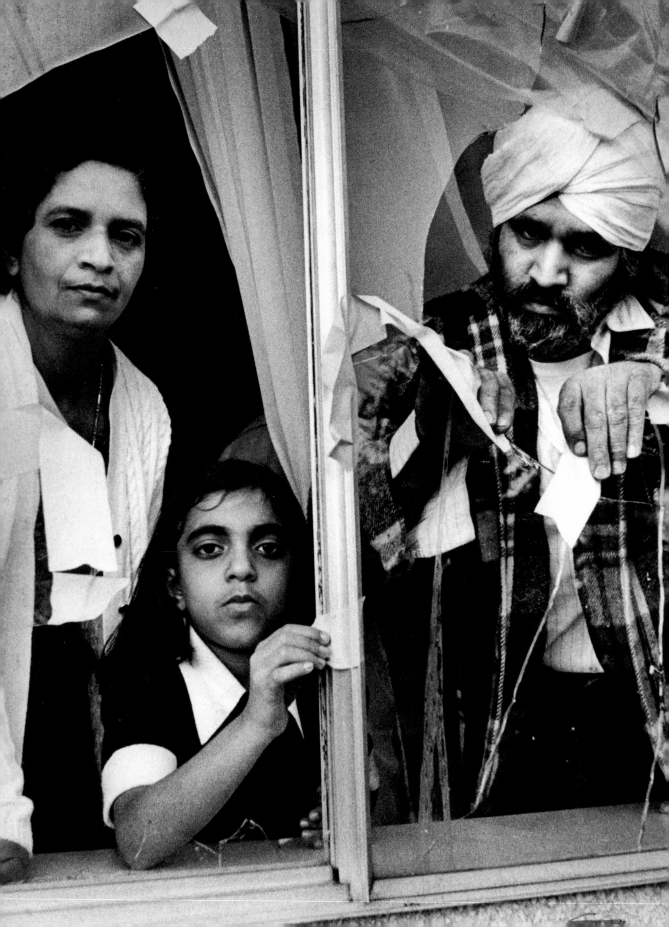

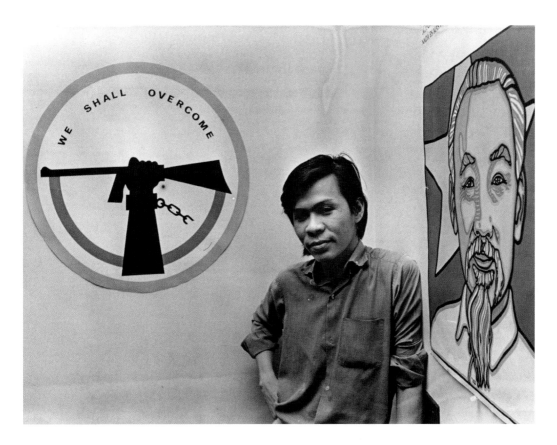

(Opposite) A Vancouver family looks out their broken window, smashed in the spring of 1975. The previous seven years saw more than fifty-five thousand Sikhs adopt Canada as their new home, with most settling in Vancouver. Today, the city has the largest Sikh community in North America.

While war rages at home, Vietnamese immigrant Luang Chau Phoc learns he is allowed to remain in Canada. The news arrived on May 19, 1970, the eightieth anniversary of Ho Chi Minh's birth.

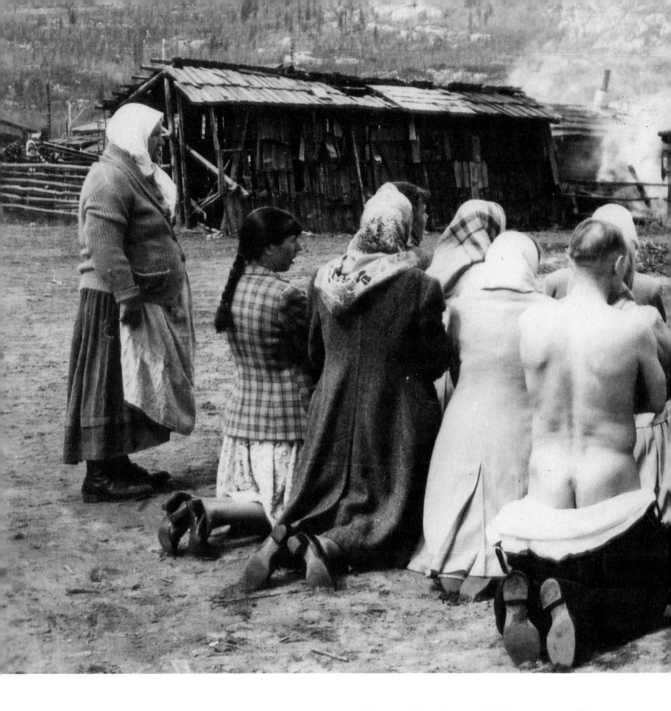

The Sons of Freedom, a radical minority sect of the
Doukhobors, demonstrated their renunciation of the
"outside world" through public displays of nudity
and by torching and dynamiting hundreds of public
and Doukhobor-owned buildings and utilities.

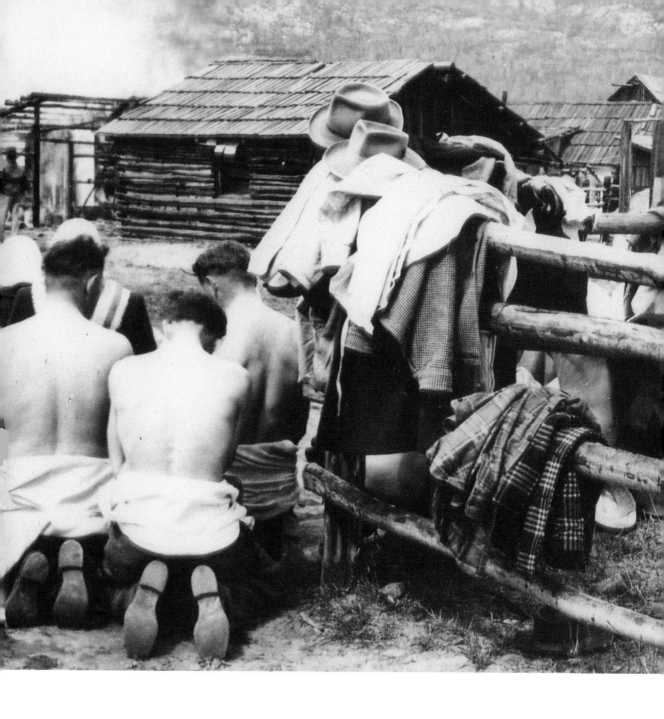

I GREW UP SURROUNDED by writers—
quite literally; in our home shelves, mantel-
pieces, credenzas, cabinets, sideboards, and
dressers overflowed with books. I quickly
took to reading and soon began hanging out
with reprobates like Mordecai Richler and
Fyodor Dostoevsky far before I was old
enough to understand what it was they
were trying to tell me. Nonetheless,
a portal had opened—and so I begin
these acknowledgements by thanking my
parents for their far-reaching library.

I must also thank Chris Bratty for
purchasing this extraordinary photo archive
from *The New York Times*. I've known Chris
since the day he was born, and in the past
decade, he and I have embarked on a
number of bracing journeys. Together we
got the ball rolling to create the print
TORO Magazine and, on its heels, a digital
incarnation of the same brand. This book—
the book itself, the e-book, the events, photo
exhibitions, speaking engagements, and
everything else that will arise in tandem—
represents the third editorial brand that

Chris and I will have worked to build, and I
have a hunch that third time will be the
charm. Chris is, among other things, a true
patron of the arts—and I thank him, in
equal measure, for his broad vision and his
generosity of spirit.

Imagining Canada is the work of many
hands . . .

Scott Sellers was the first person I
pitched at Random House of Canada.
Scott immediately saw the potential and
introduced me to Doubleday's Lynn Henry
and Kristin Cochrane. Not only did Lynn and
Kristin recognize the possibilities but during
my presentation we were finishing one
another's sentences. They immediately got
it, as did Brad Martin in a subsequent

Captain "Bronco" Nagurski, fullback for the
University of Minnesota football team, hurls himself
after an opponent in one of his famous flying tackles
in 1929.

meeting. I thank each of these senior publishing executives for their abiding support and enthusiasm for this project.

Imagining Canada would not exist in its present state without Lynn Henry's wise guidance, sharp mind, and kind spirit. Lynn is a gem, as is Nita Pronovost. If this book has a guardian angel, it's Nita. She has been tireless and eagle-eyed, an unrelenting advocate for the high standard that we set out to achieve. It has been a privilege to work in such fine collaboration with Lynn and Nita.

I must thank the gifted writers from all across our country who contributed essays to this volume. Their words lend context, depth, and meaning to the iconic photographs contained herein—and to those *New York Times* photographers too (named and unnamed, staffers and freelancers, living and deceased)—we are all much obliged for your exceptional work. Sincere thanks also to Jim Mones, director of *The New York Times* Photo Archives, for his stalwart support of this endeavour. Not only was Jim a great advocate for this book within *The New York Times*, he also proved an invaluable resource for tracking the provenance of each and every photo.

I want to thank CS Richardson for his stellar design; this book, quite simply, is a beautiful artifact—and it more than does justice to the striking imagery it enfolds.

Susan Burns played a key role shepherding the manuscript through various drafting stages and provided important council on style and visual components of the book.

My thanks to Flavio Belli for his work on the captions and for his valuable assistance during pre-production. Sincere thanks also to Doubleday's Zoe Maslow, whose organization and help behind the scenes of *Imagining Canada* have been exemplary. Catherine Dean played a crucial role as photo editor on this project, helping us connect the final dots.

Constance MacKenzie and Adria Iwasutiak are to be commended for their

important role in getting this book into the hands of readers and booksellers across Canada. Adria's resourceful and inventive work with the media has been instrumental to the success of this book.

Special thanks to Michael Levine, not only for his contribution to the business end of this project but also for his encouragement, counsel, and wit.

This book, much like our nation, is a collective effort. Canada is a result of the hard work and fierce spirit of generation after generation. And what's even more extraordinary is that we've carved out such a distinct and independent existence while living in the shadow of the United States.

Imagining Canada chronicles not only the evolution of our country during the twentieth century but also how we have been perceived by America. As a result, it creates a remarkable paradigm: Canadians contemplating Canada as imagined by Americans via the photographers of *The New York Times*. It's a cultural-political Möbius strip, a playful half-twist on the question of Canadian identity.

Finally, from the collective to the personal: my deepest gratitude and sincerest thanks go to my family—to my wife, Mary, and our children, Sophia and Michael—the microcosm dearest to my heart.

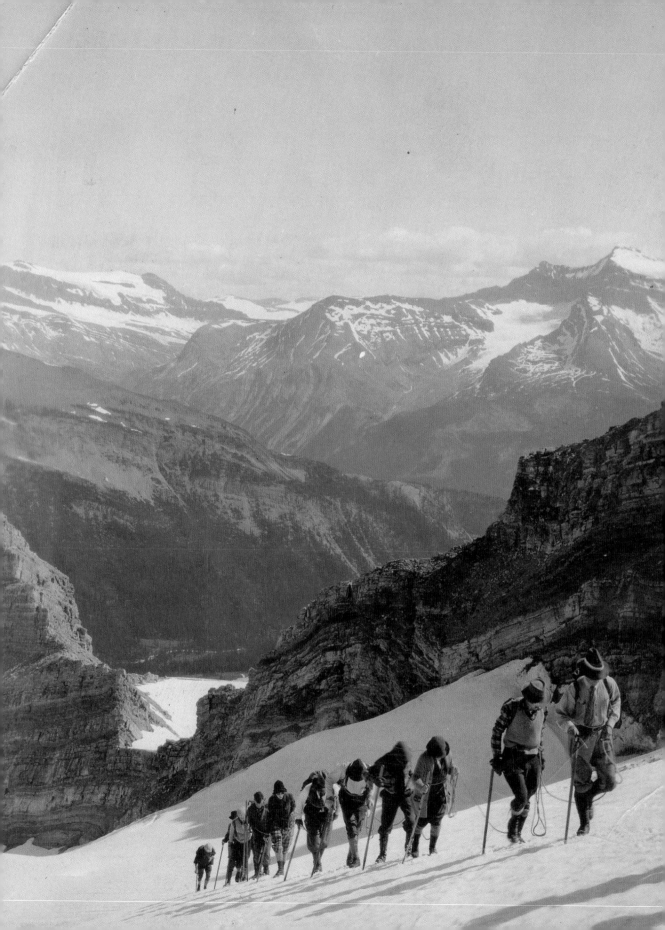

NATIONAL CHIEF SHAWN A-IN-CHUT ATLEO is a hereditary chief from the Ahousaht First Nation. In July 2009, A-in-chut was elected to a three-year mandate as national chief to the Assembly of First Nations. A-in-chut served two terms as regional chief of the British Columbia Assembly of First Nations. In this time, he committed to the principles of working together through inclusion and respect. In March 2005, a historic Leadership Accord was signed, overcoming decades of discord among First Nations leadership in British Columbia. A-in-chut graduated in 2003 with a master of education in adult learning and global change from the University of Technology, Sydney, Australia (in partnership with the University of British Columbia, University of the Western Cape, South Africa, and University of Linköping, Sweden). In 2008, A-in-chut's commitment to education was recognized in his appointment as chancellor of Vancouver Island University, becoming British Columbia's first indigenous chancellor. He received an honorary doctorate of laws in education from Ontario's Nipissing University in 2010. A-in-chut is supported by and gains strength from his partner of twenty-five years, Nancy, and their two adult children, Tyson and Tara. Traditional teachings have guided A-in-chut to serve First Nations as a leader, facilitator, mediator, planner, and teacher.

Hamilton-born STEPHEN BRUNT started at *The Globe and Mail* as an arts intern in 1982, after attending journalism school at the University of Western Ontario. He then worked in news, covering the 1984 election, and began to write for the sports section in 1985. His 1988 series on negligence and corruption in boxing won him the Michener Award for public service journalism. Currently, he writes for *Sportsnet Magazine*

An early photograph of climbers of The Alpine Club of Canada. The Club is Canada's national mountaineering organization, and has been in operation since 1906.

and is a broadcaster on the Sportsnet Network. Nominated for several National Newspaper Awards, Brunt is also the author of nine books, including *Facing Ali*, which was published in Canada, the U.S., the U.K., Japan, Australia, and Norway. It was named one of the ten best sports books of the year by *Sports Illustrated*. His book *Searching for Bobby Orr* was a number-one national bestseller, and *Gretzky's Tears*, a look at the trade that changed hockey, was published in the fall of 2009.

IAN BROWN is an author and a feature writer for *The Globe and Mail* whose work has won nine Gold National Magazine and National Newspaper Awards. He was the host of CBC Radio's *Talking Books* for more than a decade, and he currently anchors TVO's two documentary series, *Human Edge* and *The View from Here*. His non-fiction book *The Boy in the Moon* won the 2010 Charles Taylor Prize for Literary Non-Fiction, the B.C. National Award for Canadian Non-Fiction, and the Trillium Book Award.

It was named one of the Top Ten Books of 2011 by *The New York Times*.

TIM COOK is the First World War historian at the Canadian War Museum and an adjunct research professor at Carleton University. He was the curator of the First World War permanent gallery in the Canadian War Museum and has produced temporary, travelling, and virtual exhibitions. Tim has published five books, including the two-volume history of Canadians fighting in the Great War, *At the Sharp End*, which won the 2007 J. W. Dafoe Book Prize and 2008 Ottawa Book Award, and *Shock Troops*, which won the 2009 Charles Taylor Prize for Literary Non-Fiction. His newest book, *The Madman and the Butcher: The Sensational Wars of Sam Hughes and General Arthur Currie*, was published by Allen Lane in 2010 and was a finalist for several awards, including the Shaughnessy Cohen Prize for Political Writing, the J. W. Dafoe Book Prize, and the Ottawa Book Award. Tim is a frequent commentator in the media and is a

director for Canada's History Society, which publishes *Canada's History* magazine.

Born in Montreal, JOHN FRASER was raised in Toronto and attended universities in Newfoundland, Norwich, and Oxford. Mr. Fraser was elected the fourth Master of Massey College in 1995 and has since been re-elected twice. Before this, he was the editor of *Saturday Night*. He continues a freelance career, contributing feature articles to *Maclean's, The Globe and Mail*, and numerous magazines and journals. The author of nine books, Fraser's works include the internationally acclaimed *The Chinese: Portrait of a People* and *Private View: Inside Baryshnikov's American Ballet Theatre*. His most recent works include *Eminent Canadians: Candid Tales of Then and Now* and *Mad About the Bay*, written with his wife, broadcaster and writer Elizabeth Scott MacCallum. Mr. Fraser has twice been honoured by the Queen (Silver Jubilee Medal in 1977 and Golden Jubilee Medal in 2002). He has received three National Newspaper Awards and eight National Magazine Awards. In 2002, he was appointed a Member of the Order of Canada.

CHARLOTTE GRAY is one of Canada's best-known writers and the author of eight acclaimed books of literary non-fiction. Her most recent book is *Gold Diggers: Striking It Rich in the Klondike*. Her previous seven books, which include *Reluctant Genius: The Passionate Life and Inventive Mind of Alexander Graham Bell* and *Sisters in the Wilderness: The Lives of Susanna Moodie and Catharine Parr Traill*, were all award-winning bestsellers. Born in Sheffield and educated at Oxford University and the London School of Economics, Charlotte came to Canada in 1979. She worked as a political commentator, book reviewer, and magazine columnist before she turned to biography and popular history. She chairs the board of Canada's History Society and is a Member of the Order of Canada.

LISA MOORE has written two collections of short stories, *Degrees of Nakedness* and *Open*, and two novels, *Alligator* and *February*. She has edited *The Penguin Anthology of Canadian Short Fiction by Women* and co-edited with Dede Crane *Great Expectations: Twenty-Four True Stories about Childbirth*. *Open* and *Alligator* were shortlisted for the Giller Prize, and *Alligator* won the Commonwealth Book Prize (Canadian and Caribbean Region) and was longlisted for the Orange Prize. *February* and *Open* were shortlisted for the Winterset Award, and *February* was shortlisted for the Commonwealth Book Prize and longlisted for the Man Booker Prize. Lisa's work has been translated into French, Italian, Spanish, Turkish, Dutch, and German. She has written for *Chatelaine*, *Elle Magazine*, *The Walrus*, *The Globe and Mail*, the *Toronto Star*, the *National Post*, and *Canadian Art*. She has also written for radio and television. Lisa holds a BFA from the Nova Scotia College of Art and Design. She lives in St. John's, Newfoundland.

WILLIAM MORASSUTTI is a media executive with a career that spans advertising, television, publishing, and digital media. He was one of the founding members of *TORO Magazine*, serving as editorial and executive director. *TORO*, a men's lifestyle publication, was nominated for over sixty National Magazine Awards during its four-year print run. Morassutti co-founded Black Angus Media in 2006, a full-service digital media company offering blue-chip clients a unique combination of technological and editorial solutions. Black Angus also owns and operates the web-only *TORO Magazine*, a digital publication Morassutti conceived and launched in 2008. Black Angus manages the *New York Times* Canadian Photo Archive, a one-of-a-kind resource introduced to Canadians via digital media, gala events, and photography exhibitions.

PETER C. NEWMAN has been writing about Canadian politics and the business establishment for more than half a century. In *Flame of Power* (1959), he profiled the first generation

of Canada's business magnates, later exploring the lives of the financially powerful in his three-volume set *The Canadian Establishment* (1975, 1981, and 1998), as well as in *The Bronfman Dynasty* (1978) and *The Establishment Man* (1982). His *Renegade in Power* (1963) revolutionized Canadian political reporting with its controversial "insiders tell all" approach. He did it again four decades later with *The Secret Mulroney Tapes*, a number-one bestseller that became one of the most controversial books ever published in Canada. Newman's expertise in the business world has given him opportunities to point his critical eye at a number of leading Canadians, most famously Conrad Black. He has penned biographies on prime ministers John Diefenbaker, Lester B. Pearson, Pierre Elliott Trudeau, and Brian Mulroney. The author of twenty-five books that have sold over 2.5 million copies, Newman has won a half-dozen of the country's most illustrious literary awards. A former editor-in-chief of the *Toronto Star* and *Maclean's*, Newman has been honoured with a National Newspaper Award, is a Companion of the Order of Canada, and has earned the informal title of Canada's "most cussed and discussed" political commentator.

JUSTIN TRUDEAU currently serves as a member of Parliament for Papineau, Quebec. Through his work with the Liberal Party, Justin champions a greater commitment to Canada's youth, to cultural diversity and social justice, and to the environment. Justin began his career as a high school teacher. He currently serves as the Liberal Party Critic for Youth, Post-Secondary Education, and Amateur Sports. In addition, he has served on the Standing Committee on Environment and Sustainable Development in the House of Commons. He previously chaired for four years Katimavik, Canada's national youth service program. Eldest son of former Canadian prime minister Pierre Elliott Trudeau, Justin is married to Sophie Grégoire and is the proud father of two children.

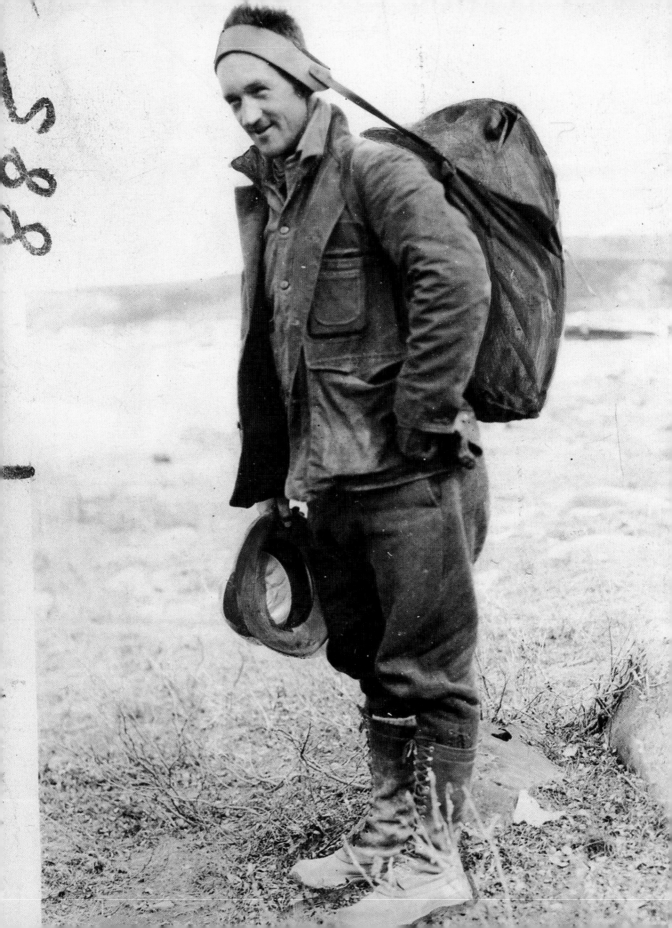

JACKET

Front jacket—top

A Royal Canadian Mounted Police officer explores the Saskatchewan Glacier in Banff National Park, Alberta, in 1933.

Bottom—from left to right

A chief of the Nuu-chah-nulth people wears a magnificent carved Thunderbird headdress and a cloak with eagle feathers in 1929 in Tofino on Vancouver Island, British Columbia. The photo's original caption refers to exclusive fishing rights allegedly granted to the chief's people. Until contact with the Europeans, the Nuu-chah-nulth had sustainably fished the Pacific Northwest for countless generations.

In mid-June of 1951, days before Korean peace talks are proposed, and yet two years before fighting came to an end, a comrade-in-arms helps a wounded Canadian soldier to a medic tent behind the front lines. Approximately twenty-five thousand Canadian army and navy personnel fought with U.N. forces to protect the Republic of Korea against invading North Korean forces.

"America's Sweetheart," Canadian-born Mary Pickford was a silent-film actress who successfully transitioned to talkies and is considered to be one of the great film stars of all time. In 1932, she was among the first to help out at the Actors' Dinner Club, where out-of-work performers could get free meals during the Great Depression.

A boy does a handstand by Niagara Falls in January 1924.

Spine—top

Donald Smith would later be known as Lord Strathcona. The financier from Montreal is seen hammering the last spike of the Canadian Pacific Railway into place at Craigellachie, British Columbia, on November 7, 1885.

Spine—bottom

A borderline was cut through the forest along the Montana–British Columbia border, under the direction of the International Boundary Commission. The United States is to the left, and Canada to the right.

Back jacket—from left to right

Bobby Hull in 1962 when he scored his 50th goal of the season against the New York Rangers. His goal tied the record for most goals in a season, and came in the last game of that year's regular season. Hull, the Chicago Wing, was 25 years old.

Loggers clear their way through a sea of timber in Hull, Quebec, in 1946. The timber would be converted to newsprint.

In 1915, the Canadian Cavalry at Salisbury Plain, England, cheer on King George V and Secretary of State for War Lord Kitchener as the train they travel on passes the troops. This was a year after King George had gone to war against his first cousin, Kaiser Wilhelm of Germany. A year later, Lord Kitchener would die an untimely death aboard a ship sunk by a German mine.

HALF TITLE PAGE
First row—from left to right
This abandoned farm, shown here in 1965, was typical of many in eastern Ontario. Farmers had the lowest incomes in the country. The government, at the federal and provincial levels, began preliminary studies with the intent of rehabilitating some of the area.

A snow fight in full swing on the frozen slopes above the St. Lawrence river in Montreal, 1926.

Excursion steamer passengers in 1947 are met at Skagway, Alaska, and ride to Whitehorse, Yukon.

Second row—from left to right
Bobby Hull in 1962 when he scored his 50th goal of the season against the New York Rangers. His goal tied the record for most goals in a season, and came in the last game of that year's regular season. Hull, the Chicago Wing, was 25 years old.

Loggers clear their way through a sea of timber in Hull, Quebec, in 1946. The timber would be converted to newsprint.

Some of the Canadian Royal Air Force photographed on their arrival to England in April, 1940.

Third row—from left to right
A borderline was cut through the forest along the Montana–British Columbia border, under the direction of the International Boundary Commission. The United States is to the left, and Canada to the right.

A boy does a handstand by Niagara Falls in January 1924.

A chief of the Nuu-chah-nulth people wears a magnificent carved Thunderbird headdress and a cloak with eagle feathers in 1929 in Tofino on Vancouver Island, British Columbia. The photo's original caption refers to exclusive fishing rights allegedly granted to the chief's people. Until contact with the Europeans, the Nuu-chah-nulth had sustainably fished the Pacific Northwest for countless generations.

Fourth row—from left to right
A wounded rifleman is helped to an aid station behind the front-line in Korea, 1951.

Workmen carrying British and American flags meet high above the rapids of the Niagara River to celebrate the construction of the Rainbow Bridge in 1941.

In 1957, 17-year-old Ottawa native Paul Anka was just beginning his rise to musical stardom. He wrote his own songs, which was unusual for singers of that time period.

Fifth row—from left to right
American tourists stop along the Queen Elizabeth Way in 1941. At that time, the highway was lit for 119 kilometers between Toronto and Niagara Falls, and was later expanded to cover both the Fort Erie Bridge and the Peace Bridge.

In 1967, two days after President Charles de Gaulle of France concluded a speech at Montreal City Hall with "Vive le Québec libre!," a diverse group of Université de Montréal students display their homemade sign.

Captain "Bronco" Nagurski, fullback for the University of Minnesota football team, hurls himself after an opponent in one of his famous flying tackles in 1929.

OPENING GALLERY, *page ii–xii*
Loggers clear their way through a sea of timber in Hull, Quebec, in 1946. The timber would be converted to newsprint.

Aboriginal girls enjoy playing outside in 1972, despite the temperature—38 degrees Fahrenheit below zero.

The Toronto subway system under construction in 1952.

John Pristow and his family migrated to Canada from Poland in the early 1940s. Their land near Leduc, Alberta, pictured with an oil well in the background, brought Mr. Pristow royalties of $225 daily, an astonishing amount of income at the time.

In 1932, screen legend Mary Pickford is welcomed in Los Angeles by her husband, Douglas Fairbanks, and by famous flyer Amelia Earhart.

Oliva Dionne is surrounded by his celebrated quintuplet daughters in August 1941.

Barbara Ann Scott in the Hollywood Ice Revue in 1953.

George Chuvalo, pictured here on July 19, 1967, was a Canadian heavyweight fighter who had never been knocked down. In his fight against Joe Frazier that night, Frazier didn't knock him down, but won by scoring a technical knockout.

A felled Sitka spruce, 16 feet in diameter and 250 feet long, towers over Verna Maynard, daughter of the Queen Charlotte Island Camp superintendant in 1956.

The Totem of the One Legged Fisherman of Yac-a-Tat in 1909. The eagle on the top is meant to symbolize the fisherman, and the lower carved animals are meant to symbolize other members of his family.

William Shatner pictured in his role in the 1962 film, *The Intruder.*

Christopher Plummer portrayed a modern-day pirate in the 1980 television movie *Desperate Voyage.*

TITLE PAGE
A Royal Canadian Mounted Police officer explores the Saskatchewan Glacier in Banff National Park, Alberta, in 1933.

ESSAY OPENERS
IMAGINING CANADA, page xviii–xix
Workers atop the Rainbow Bridge in Niagara Falls exchange flags to celebrate the placing of the centre span in 1941.

LANDSCAPES FAR AND WIDE, page xxvi–1
The Cabot Trail in Cape Breton Highlands National Park, Nova Scotia, in 1968.

FIRST NATIONS, page 28–29
First Nations set up camp near Banff, circa 1930, after arriving from across the region to collect their annual treaty money. The tradition goes back to the signing of treaties, beginning in 1874. Each First Nations person received five dollars and the chief twenty dollars from the Canadian government. The ritual and amount remain almost the same today.

A WARRIOR NATION, page 46–47
In 1915, the Canadian Cavalry at Salisbury Plain, England, cheer on King George V and Secretary of State for War Lord Kitchener as the train they travel on passes the troops. This was a year after King George had gone to war against his first cousin, Kaiser Wilhelm of Germany. A year later, Lord Kitchener would die an untimely death aboard a ship sunk by a German mine.

THE WAR MACHINE, page 64–65
March, 1942. Young women prepared explosives of quick-fire cordite, which was used to propel heavy-calibre land and naval gun shells.

AN INDUSTRIOUS NATION, page 78–79
Donald Smith would later be known as Lord Strathcona. The financier from Montreal is seen hammering the last spike of the Canadian Pacific Railway into place at Craigellachie, British Columbia, on November 7, 1885.

ICONS, page 94–95
Pianist Glenn Gould was known for his many eccentricities. Beyond his adjustable-height chair, he often hummed while playing and was sometimes criticized for the "background vocals" that could be heard on his recordings.

THE BODY POLITIC, page 114–115
In 1967, two days after President Charles de Gaulle of France concluded a speech at Montreal City Hall with "Vive le Québec libre!," a diverse group of Université de Montréal students display their homemade sign.

A TOUGH AND BEAUTIFUL GAME, page 134–135
In 1970, the National Hockey League started a contest for children called Skate, Shoot and Score. Pictured here are a group of youngsters waiting to take to the ice.

THE CHANGING FACE OF SOCIETY, page 160–161
Held in a locked room in the brand-new Terminal 2 building of the Toronto International Airport, a group of recently arrived South Asians await deportation. Suspected of coming to Canada with the intention of applying for landed immigrant status, they are the victims of a 1972 crackdown on "backdoor immigration."

PHOTO CAPTIONS AND CREDITS, page 192–201
A trapper in the Northwest Territories uses the tumpline method to carry supplies, in 1931.

A group of sealers slowly moves across the ice off the coast of Labrador in 1930.

A borderline was cut through the forest along the Montana–British Columbia border, under the direction of the International Boundary Commission. The United States is to the left, and Canada to the right.

CLOSING GALLERY, page 202–213
Dawson City, Yukon, circa 1890s.

German and Canadian wounded soldiers received hot coffee and biscuits from the YMCA in 1917. They were standing approximately one thousand yards from the front line.

A snow fight was in full effect on the frozen St. Lawrence River in Montreal, Quebec, in 1926.

Maligne Lake, located in Jasper National Park, Alberta, in 1941.

American tourists stop along the Queen Elizabeth Way in 1941. At that time, the highway was lit for 119 kilometers between Toronto and Niagara Falls, and was later expanded to cover both the Fort Erie Bridge and the Peace Bridge.

An Aboriginal chief looks out over the mountain ranges in Banff National Park, Alberta, in 1941.

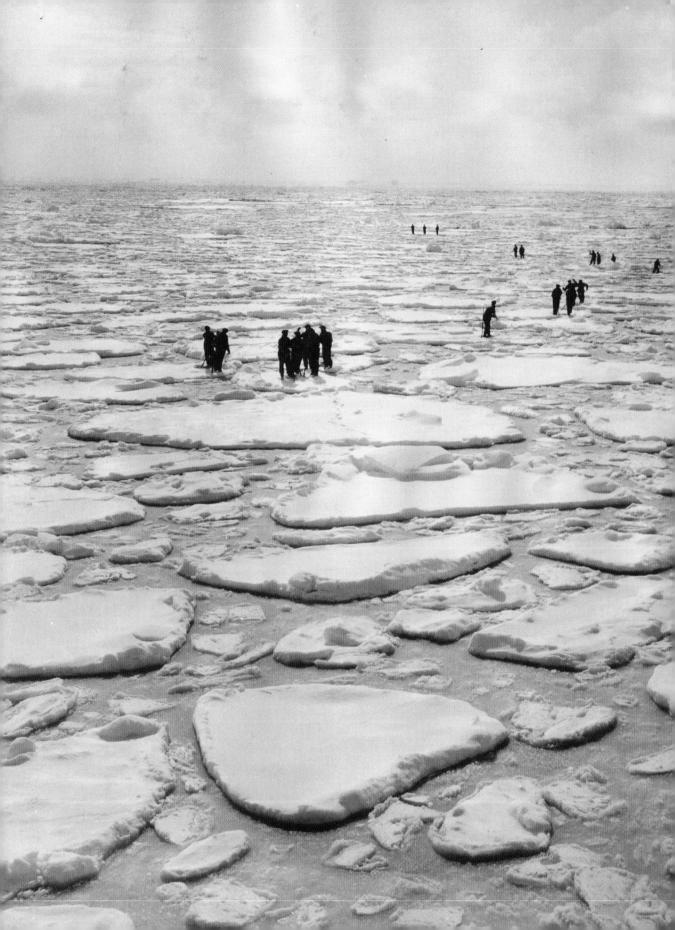

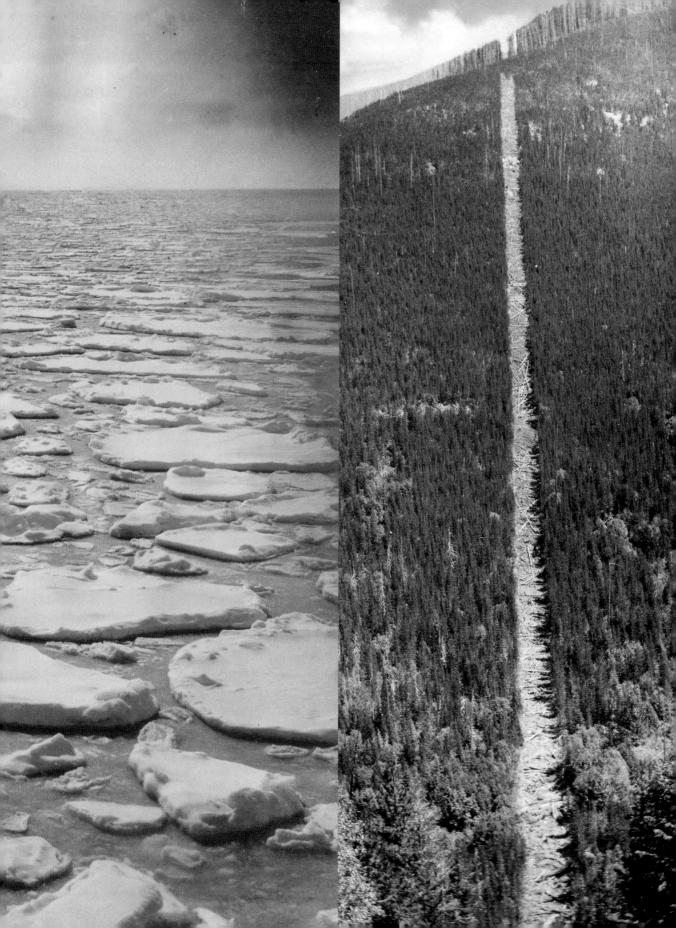

PHOTO CREDITS

HALF-TITLE PAGE

Row 1 (far left) © National Film Board of Canada; Row 2 (far left) © The Associated Press; Row 4 (far right) © Federal News. All other images appear elsewhere in this book. Please see below for more information.

FRONT GALLERy

Page i (left) © Hamilton Wright (right) unpublished, courtesy of *The New York Times* archive (hereinafter referred to as "NYT"); Page ii (left) © Canada Pictures Ltd./ Toronto Archives (right) © The Associated Press; Page iii (left) © NYT (right) © King Features Syndicate Inc./ Hearst; Page iv (left) © William N. Jacobellis (right) © NYT; Page v (left) © NYT (right) © H.J. Goetzman/ William E. Meed Photograph Collection/University of Washington Libraries; Page vi (left) © Pathe America (right) © CBS/Getty Images

IMAGINING CANADA

Essay Opener © Frank O. Seed/Times Wide World; Page xx © Three Lions Inc.; Page xxv © Nancie Battaglia

LANDSCAPES FAR AND WIDE

Essay Opener © The Canadian Government Travel Bureau; Page 2 © International Newsreel Photo; Page 8 © Canadian Pacific Archives; Page 9 © NYT; Page 10 © Canadian Pacific Archives; Page 11 photographer unknown; Page 12 © Canadian Pacific Archives; Page 14 © NYT; Page 16 © Federal News; Page 18 photographer unknown; Page 19 © Canadian Mountain Holidays; Page 20 © E. A. Hegg/Library and Archives Canada; Page 22 © Canadian Pacific Archives; Page 24 © NYT; Page 25 © The Canadian Government Travel Bureau; Page 26 © National Film Board of Canada

FIRST NATIONS

Essay Opener © James Montagnes/Ontario Archives; Page 30 © NYT; Page 35 © National Film Board of Canada; Page 36 © Federal News/National Archives; Page 37 © Canadian Pacific Archives; Page 38 © National Film Board of Canada; Page 39 © W.J. Oliver/Glenbow Museum; Page 40 © National Film Board of Canada; Page 41 © NYT; Page 42 photographer unknown; Page 43 © Ramme Photo; Page 44 © Canadian Pacific Archives; Page 45 © NYT

A WARRIOR NATION

Essay Opener © American Press Association; Page 48 ©
Western Newspaper Union; Page 54 © Western Newspaper Union; Page 55 © NYT; Page 56 © NYT; Page 57 ©
Topical Press; Pages 58–59, 61 © NYT; Page 62 © The
Associated Press; Page 63 © United Nations

THE WAR MACHINE

Essay Opener, Page 66 © NYT; Page 71 © Underwood &
Underwood; Pages 72–73, 74 © NYT; Page 75 (top) © NYT
(bottom) © The *Toronto Star* Archives; Page 76–77 © The
Associated Press

AN INDUSTRIOUS NATION

Essay Opener © Canadian Pacific Archives; Page 80 ©
Richard Harrington/Hudson's Bay Company Archives;
Page 86 © NYT; Page 87 © DFO; Page 88 © Syncrude;
Page 89 © NYT; Page 90 © Malak (Karsh)/National
Archives; Page 92 (left) © Seagram Distillers (right) ©
NYT; Page 93 photographer unknown

ICONS

Essay Opener © Don Hunstein; Page 96 © Artray Ltd.;
Page 101 © NYT; Page 102 © NYT; Page 103 © NYT; Page
104 © The Associated Press; Page 105 © NYT; Page 106
© The Associated Press; Page 107 © NYT; Page 108
photographer unknown; Page 109 (top) © NYT (bottom)
photographer unknown; Page 110 © Fay Godwin; Page
111–112 © NYT; Page 113 © Don Hunstein/Glenn Gould Ltd.

THE BODY POLITIC

Essay Opener photographer unknown; Page 116 © NYT;
Page 122 © NYT; Page 124 © The Associated Press;
Page 125 © Federal News; Page 126 © UPI; Page 127 ©
Montreal Star/The Woodbridge Company Ltd.; Page 128
© UPI; Page 129 photographer unknown; Page 130 ©
Charles Mitchell/Canadian Press Images; Page 131 © Tim
Clary/UPI/Reuters; Page 132 © Shaney Komulainen/
Canadian Press Images

A TOUGH AND BEAUTIFUL GAME

Essay Opener, Page 136 © NYT; Page 141 © The
Associated Press; Pages 142–149 © NYT; Page 150 (top)
© NYT (bottom) © Bob Glass; Page 151–158 © NYT

THE CHANGING FACE OF SOCIETY

Essay Opener © Ron Bull/The *Toronto Star* Archives; Page
162 © Canadian Pacific Archives; Page 168 photographer
unknown; Page 169 © NYT; Page 170 © Federal News;
Page 171 © Doug Bailey; Page 172 © Central Press Photo
Ltd.; Page 173 © Japanese Canadian Centennial Committee; Page 175 © Alexandra Studios/The *Toronto Star*
Archives; Page 176 © National Film Board of Canada; Page
177 © Shomburg Centre for Research in Black Culture;
Page 178 © *Vancouver Sun*; Page 179 © Canada Wide
Photo; Page 180 © RCMP

ACKNOWLEDGEMENTS

Page 182 © International Newsreel

CONTRIBUTORS

Page 186 © Canadian Pacific Archives

PHOTO CAPTIONS

Page 192 © James Montagnes/Ontario Archives; Page 198
© Frank Kirby/Newfoundland & Labrador Film Co.;
Page 199 © NYT

BACK GALLERY

Page 202 © UPI; Page 204 © Western Newspaper
Association; Page 206 © NYT; Page 208 © Globe Photo
Service; Page 210 photographer unknown; Page 212 ©
James Montagnes/Ontario Archives

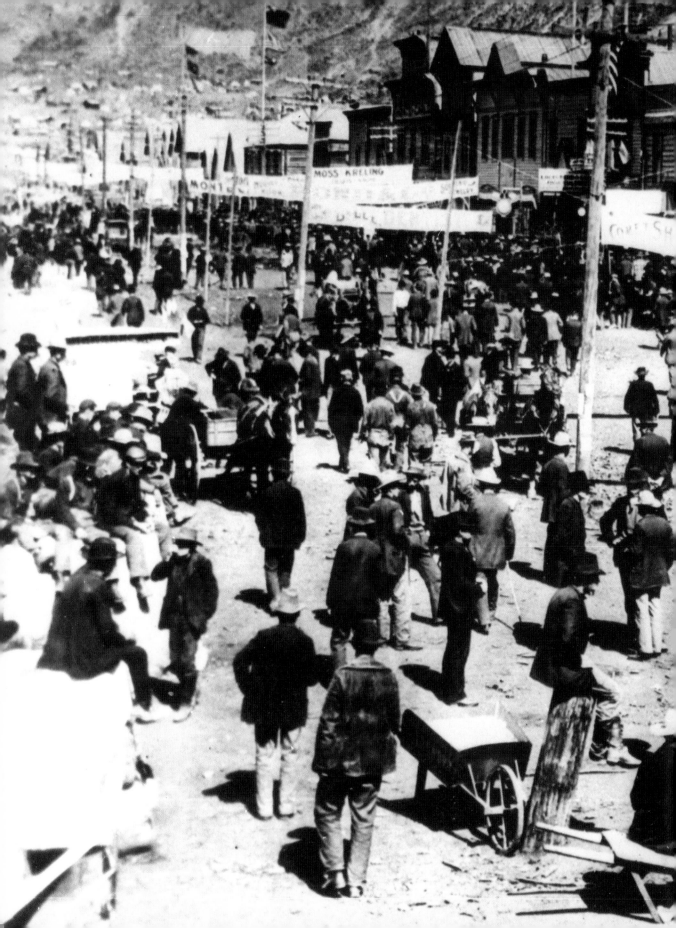

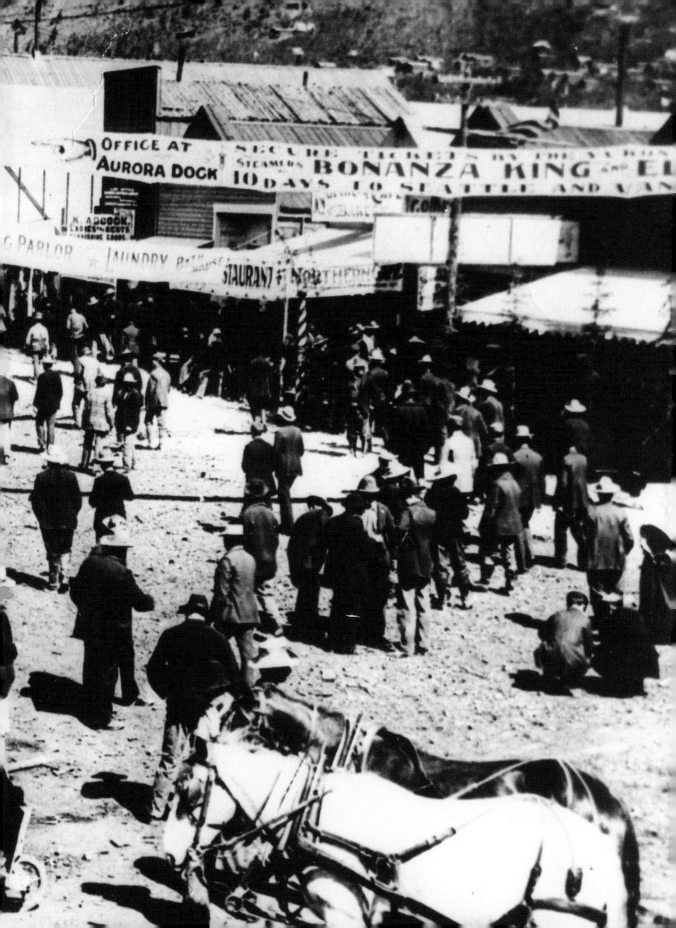

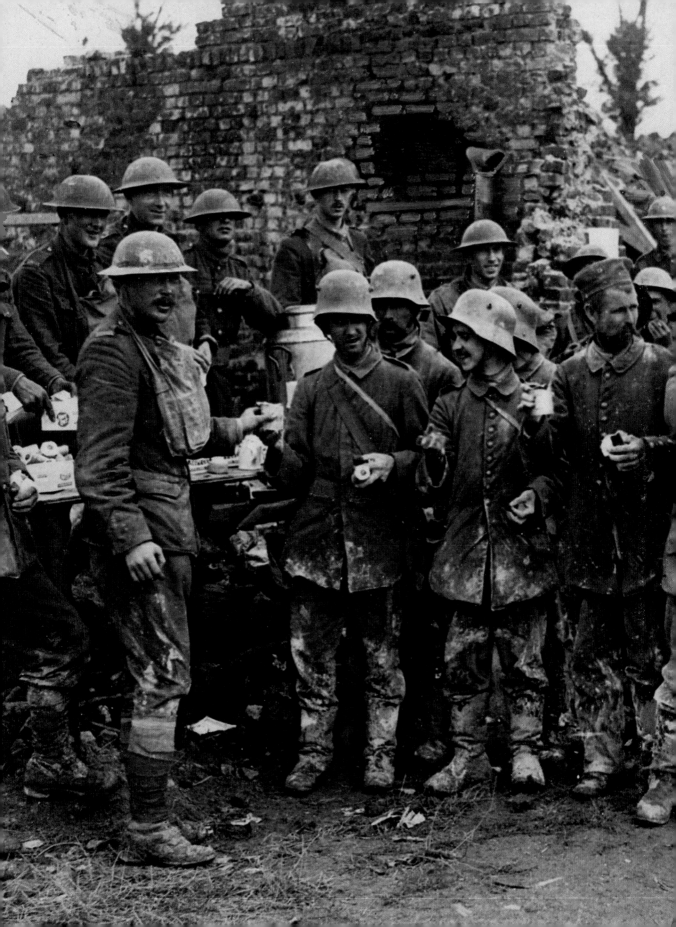

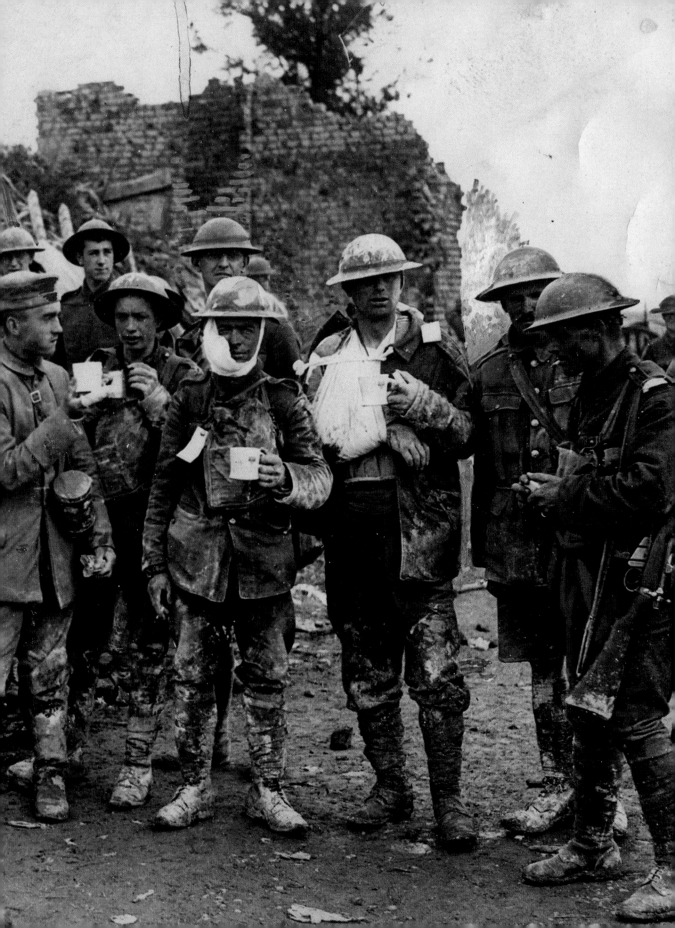

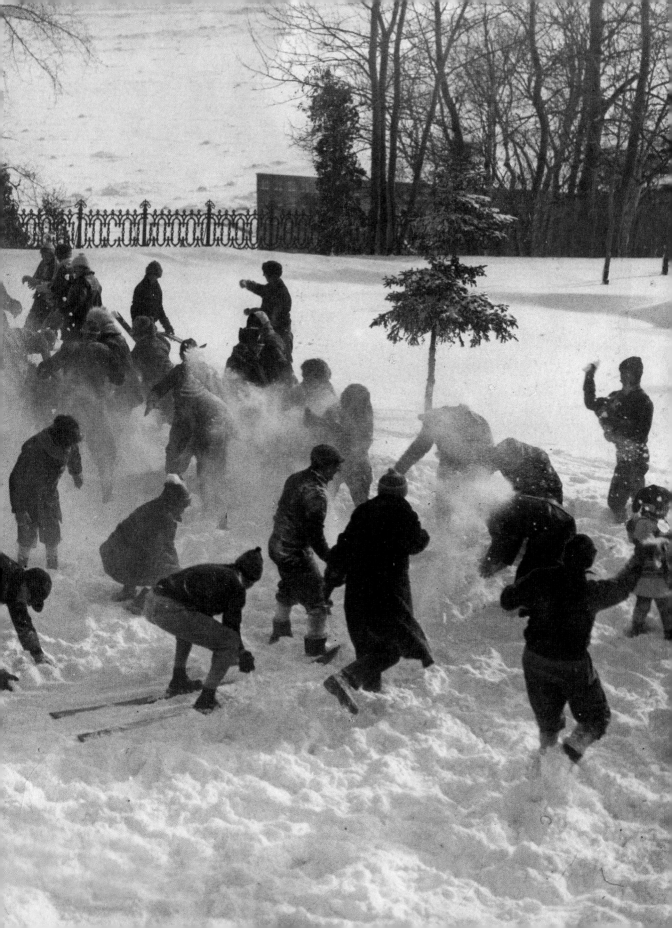

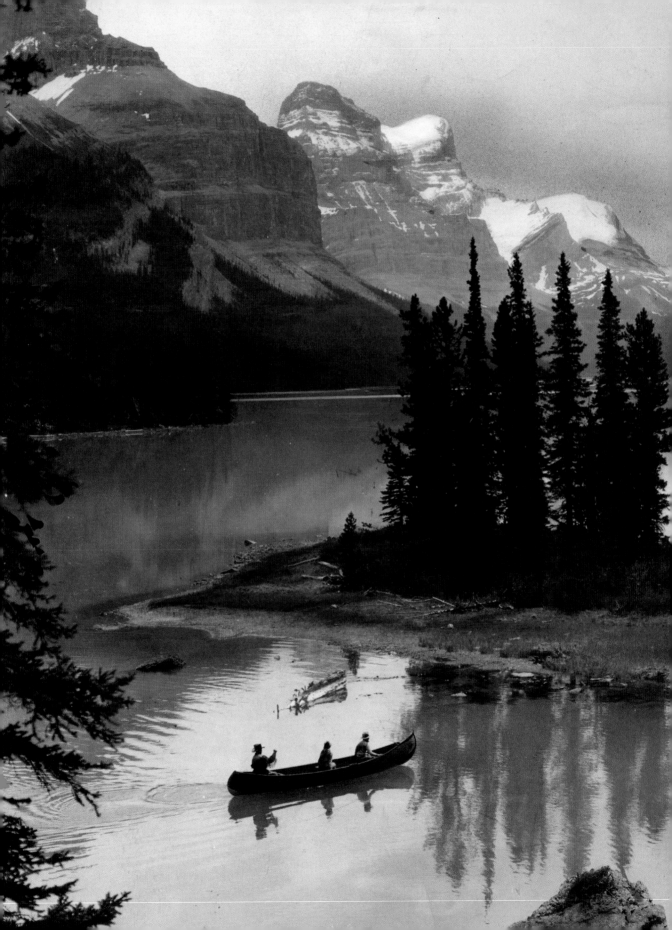

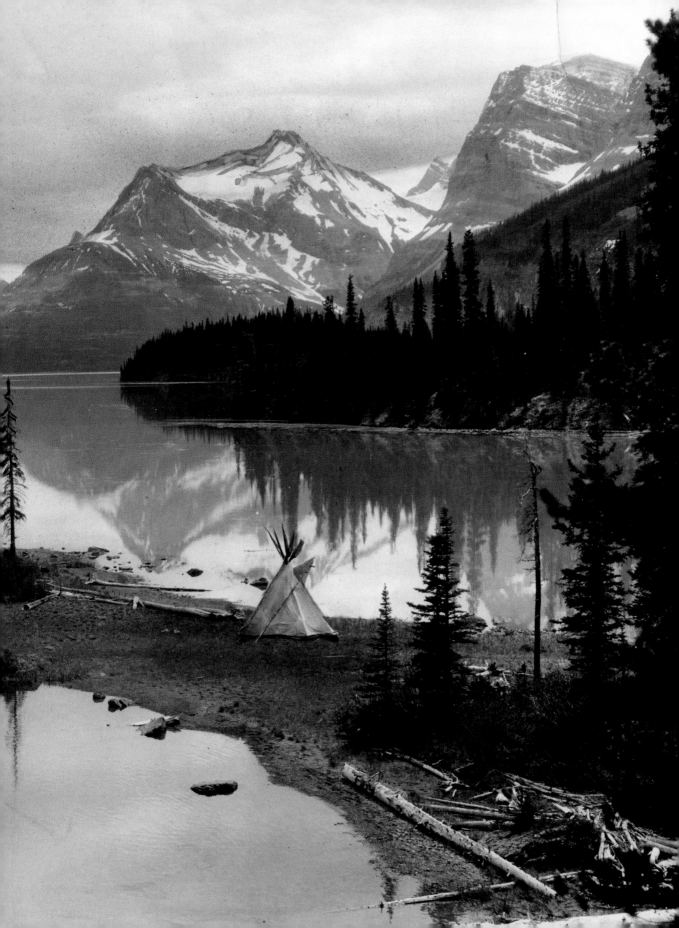

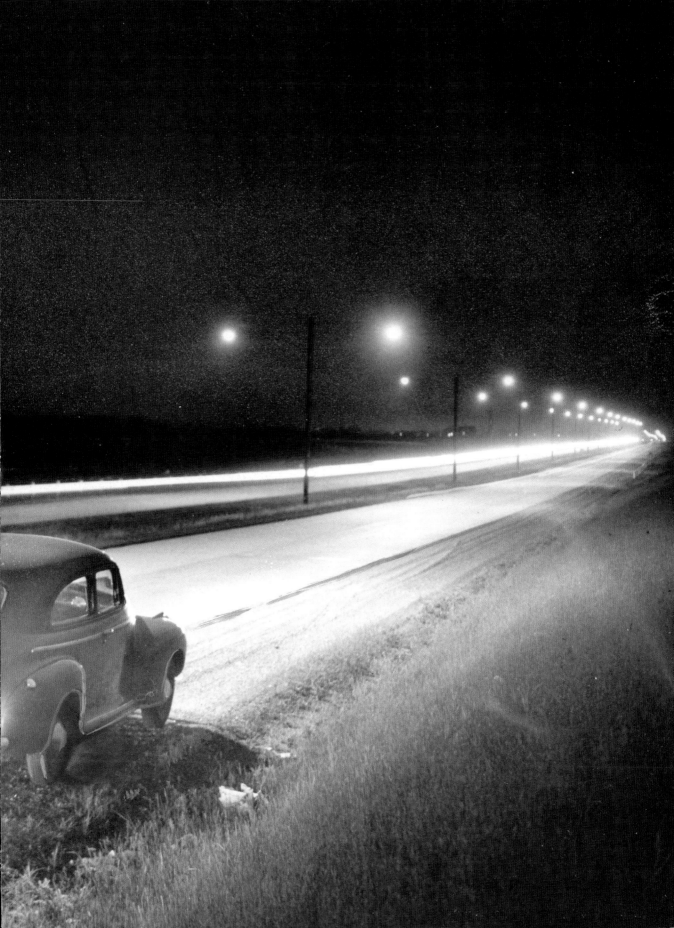

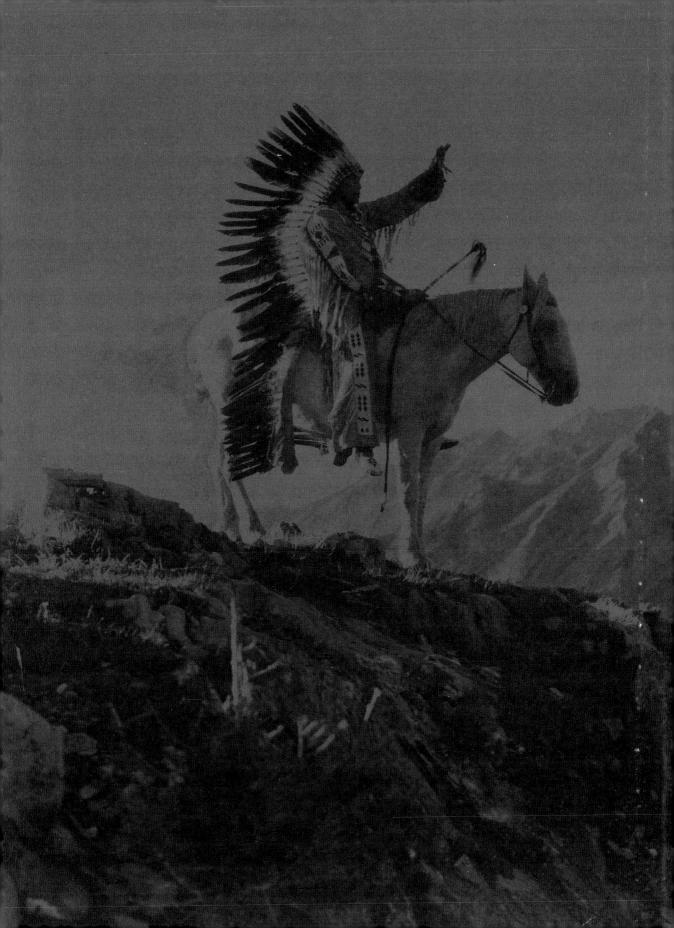